WILD ASIA

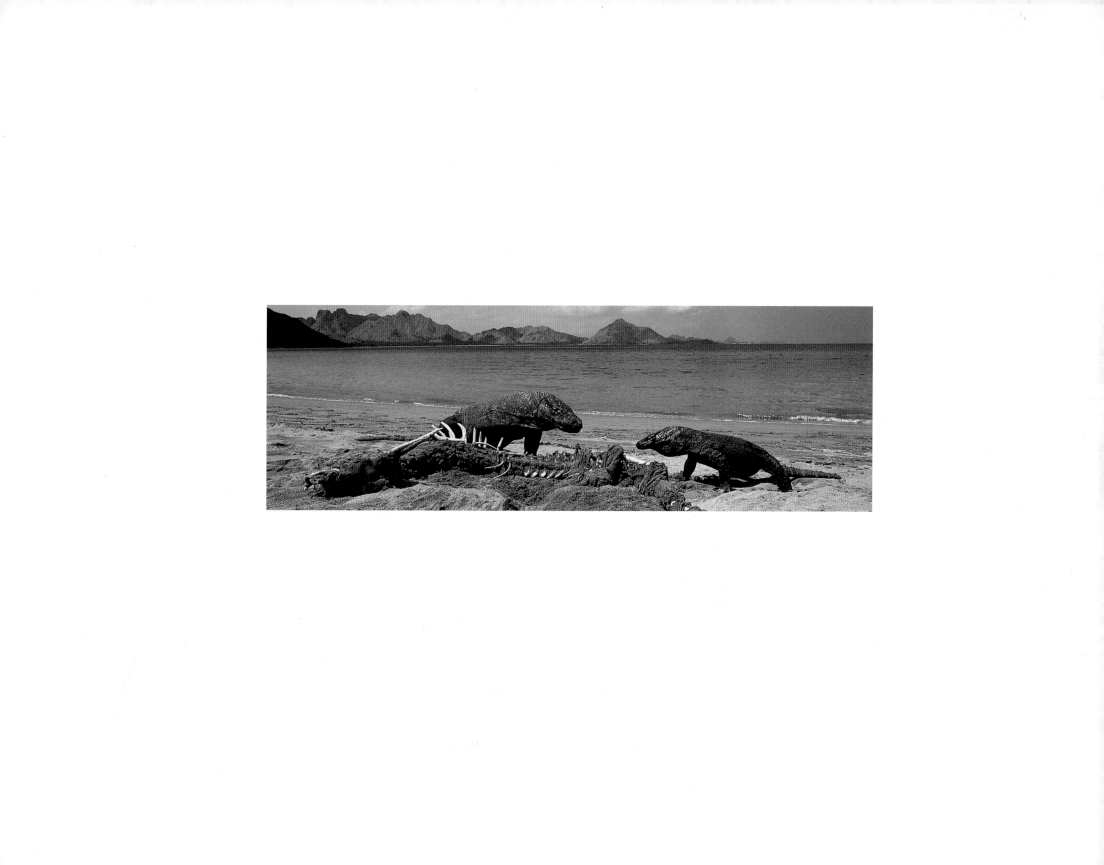

Spirit of a Continent

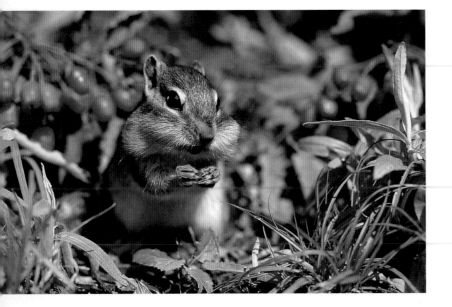

Above: The tiny chipmunk inhabits the taiga forests of Siberia.

Opposite: Rongbuk Glacier and the North Face of Mt Everest from Tibet. The Himalayas are a reminder of the geological forces that have shaped Asia.

A the dawn of the third millennium, the light of the rising sun swept westwards across the Pacific Ocean and the Bering Sea to strike the rim of the Earth's largest continent. Its light then spread inland. From the frozen Arctic expanses of the north-east to the humid tropics in the south, it swept a broad path across the most diverse tracts of earth, sky and water on the planet: Asia.

Light is the power source for almost all life. Whether on land or in the sea, light – captured, harnessed and converted – powers an awe-inspiring tapestry of biodiversity. And nowhere more so than in Asia, a continent whose enormity and physical range support a truly vast array of life that inhabits many of the most wonderful and richest of Earth's wild places.

Asia and superlatives go hand in hand, for this is the largest and most diverse region on Earth. The continental portion extends 6500 kilometres (4000 miles) south to north, from latitude 1° N to 78° N, and 9700 kilometres (6000 miles) west to east, from 26° E to 170° W, while the islands of Malaysia and Indonesia push the region well south of the Equator. Not surprisingly, therefore, Asia experiences the widest climatic extremes on Earth, and hence supports the planet's most varied flora and fauna. Greater in size than the Americas (North, South and Central combined), more expansive than Europe and Africa together, Asia represents almost a third of the Earth's land area, more than 43 million square kilometres (16 million square miles).

Geologically speaking, Asia is the youngest of the continents, consisting of several large fragments which have, over immense periods of time, accumulated in a series of collisions. The most dramatic of these is the convergence of the Indian platform and the southern edge of the continent which gave rise to the

MARK BRAZIL

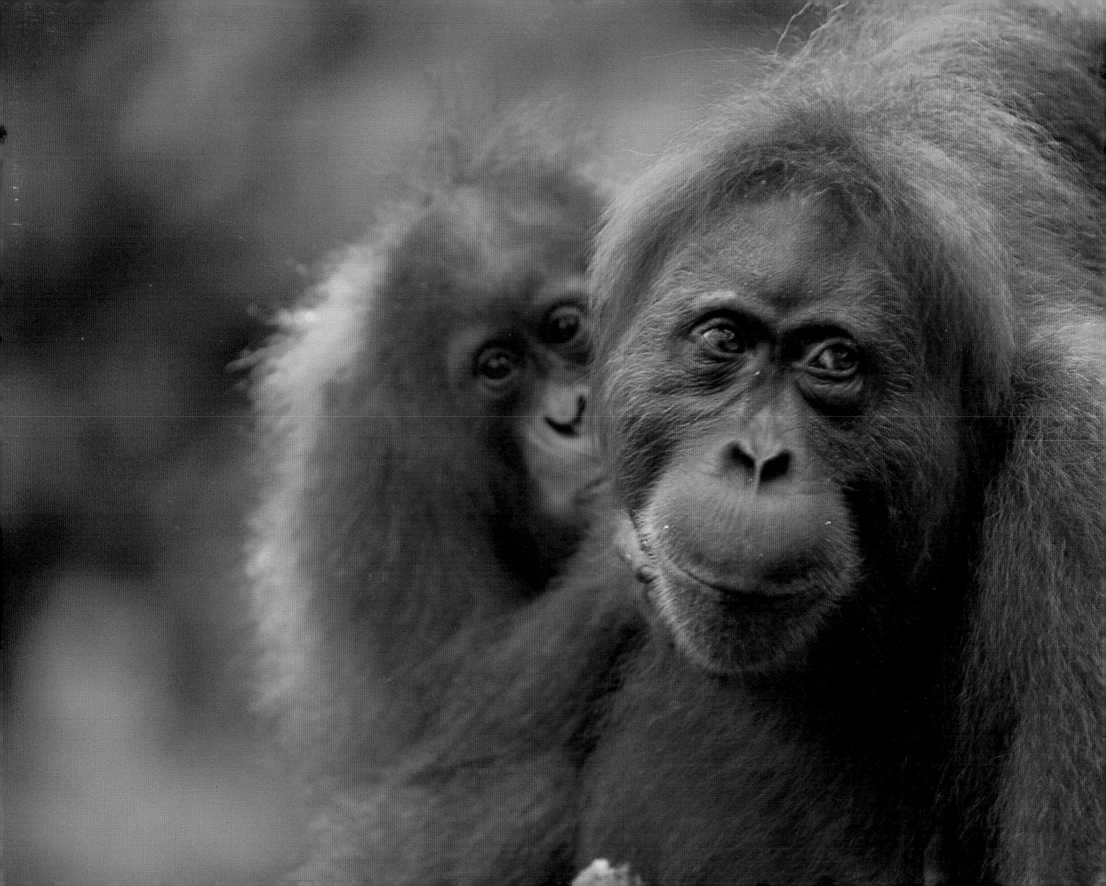

WILD ASIA

spirit of a continent

PELICAN PUBLISHING COMPANY

Gretna 2000

Page 3: orang-utan, mother and child; opposite: toque macaques feed on offerings at
an ancient temple; contents page, clockwise from left: man-faced beetle, Gobi desert,
Mt Bromo off the coast of Java, daisy coral, baby Indian elephant, pandanus tree;
page 10: cherry blossom in Japan; page 11: Komodo dragons

Published simultaneously in August 2000 by
 Pelican Publishing Company, Inc., in North America, and
 David Bateman Ltd., 30 Tarndale Grove, Albany,
 Auckland, in New Zealand

The word "Pelican" and the depiction of a pelican are
trademarks of Pelican Publishing Company, Inc.,
and are registered in the U.S. Patent and Trademark Office.

ISBN 1-56554-827-2

Book design by Shelley Watson, Sublime Design Ltd.

Printed and bound in Hong Kong

Published by Pelican Publishing Company, Inc.
1000 Burmaster Street, Gretna, Louisiana 70053

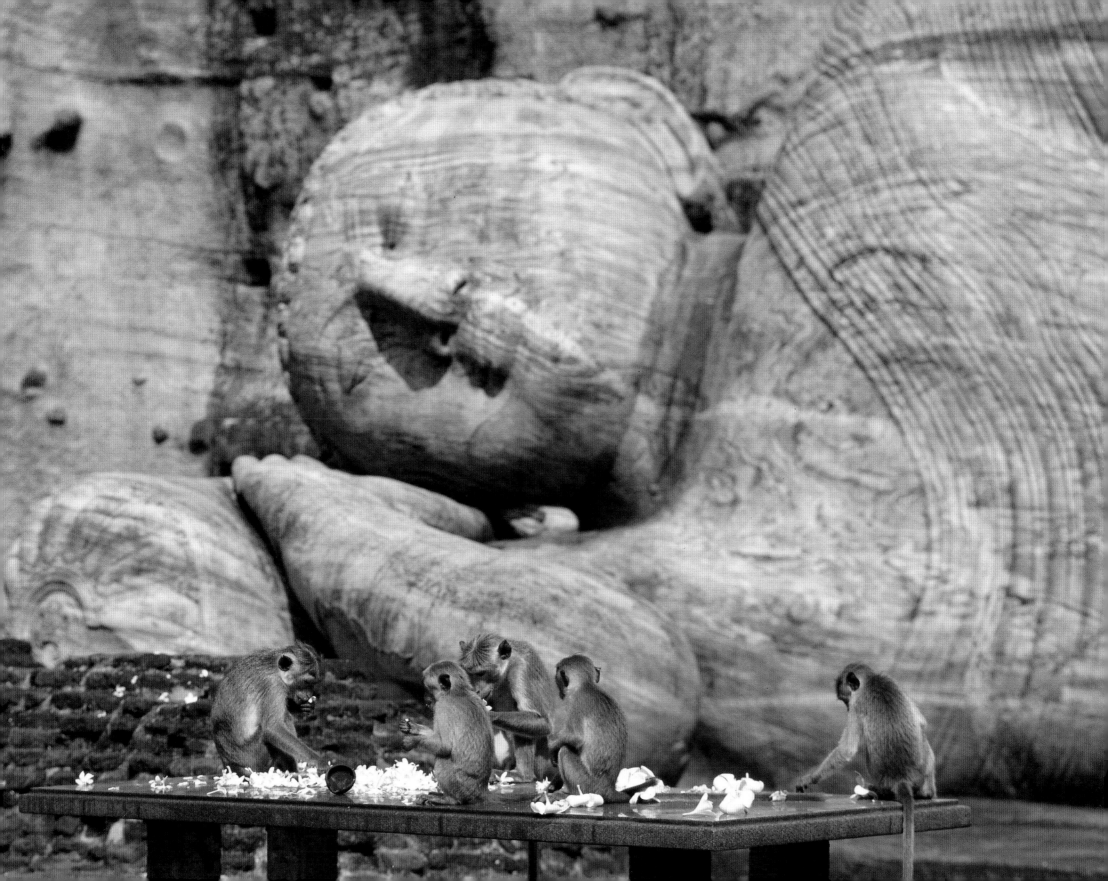

WILD ASIA
spirit of a continent

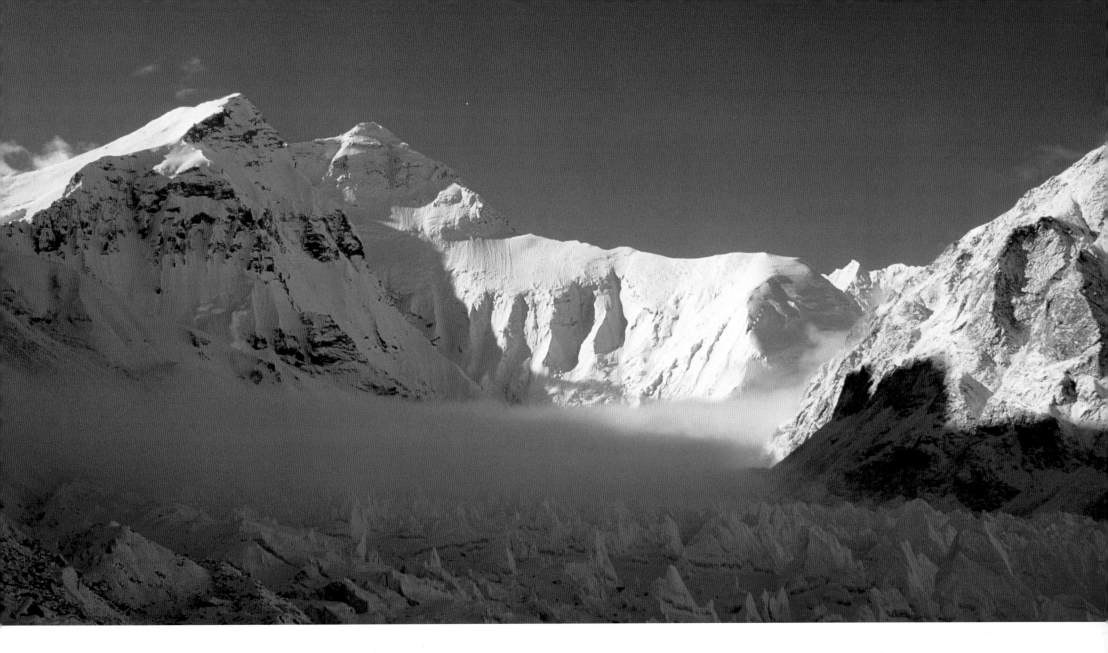

mighty Himalayas and, beyond them, the Tibetan Plateau.

Travelling westwards across the Pacific with the rising sun, modern Asia is clearly delineated on the horizon where Pacific waves lap the shores of Japan and the Bering Sea crashes against Russia's coastline. The arrival is abrupt, in a region vastly different from the Americas.

Viewed from the west, Asia appears less distinct. There, the mountainous wall of the Urals and the deep channel of the Bosphorus, though distinct physical borders themselves, are not clearly linked to form an obvious border to what lies beyond. Travel east into Asia from Europe and cultural and natural history

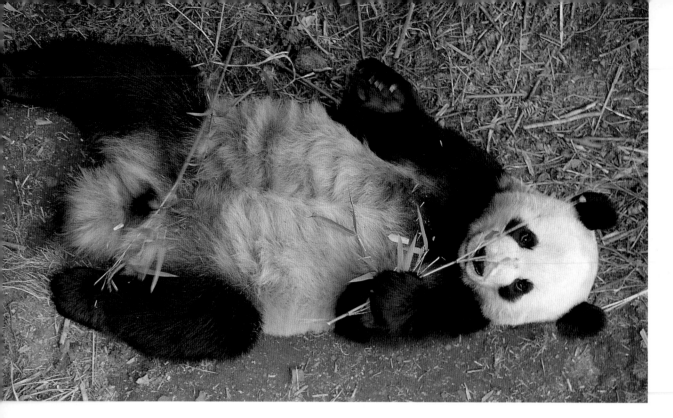

Above: Like many other animals unique to Asia, the rare giant panda is endangered.

Right: The desolate, stony Gobi desert is home to the only true wild camel left in the world – the Bactrian camel.

features blur and blend in a steady transition towards the less and less familiar.

Thus Asia's extent resists definition and its identity, seen from the different perspectives of east and west, is confusingly intangible.

Even within Asia the differences from one region to the next are so great as to render generalisations almost meaningless. In a volume such as this, we can only hint at the phenomenal diversity of wild Asia.

Definitions of Asia vary – some include even the Arabian peninsula – yet however it is defined, its breathtaking range of natural geographical features and phenomenal biodiversity elude description. As a result, superlatives applied to Asia lean towards clichés: if you are excited by the tallest, oldest, highest, deepest, then look no further, for Asia has them all. If it is natural diversity that interests you, then visit Asia. From Arctic tundra and taiga to tropical rainforests; humid evergreen and temperate forest regions; deserts and deciduous forests; steppes, montane and alpine regions, you will find them in Asia. And, stretching continuously from beyond the Arctic Circle to south of the Equator, there is a rich coastal and marine environment – the longest coastline of any continent.

Wildlife abounds in Asia: from multi-coloured butterflies fleeting through fields of Siberian wildflowers to rainbow-coloured reef fish playing hide and seek with predators amongst the coral forests off Indonesia's islands; from the monotones of camouflaged Arctic foxes in Chukotka to the bizarre colours and shapes of camouflaged insects in Malaysia's tropical rainforests; from the high-flying Demoiselle cranes that migrate each year over the Himalayas to the ocean-going salmon that return annually to the river of their birth; from common and widespread species of the north, such as the red fox and Asiatic chipmunk, to the rare and unique species endemic to the isolated islands of the south-east, such as the proboscis monkeys of Borneo and the gibbons of Java. Each region of Asia supports its own special fauna and flora. They are fascinating worlds.

The many distinctive features of Asia amount to so long a catalogue that just listing all of them would require a book, not just an introduction. Just consider that all of the peaks in the world

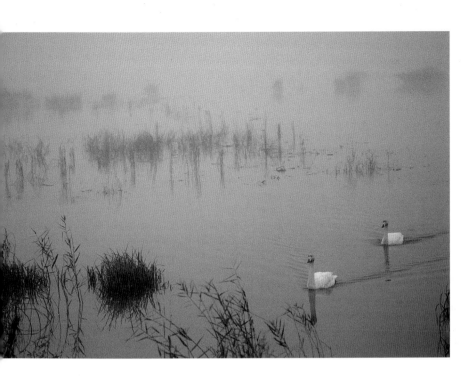

over 7000 metres (23,000 feet) in height are in Asia. Sagarmatha, Chomolungma, or Mt Everest – whichever alias it is known by – stands tallest of all. Elevated slowly over millions of years by tectonic forces, it reigns supreme over an Asia that not only towers to the planet's highest peak, but also plunges to some of its greatest depths, reaching more than 10,000 metres (32,800 feet) into the Ramapo Deep off the coast of Japan.

Seven of the world's longest rivers, all of them more than 4400 kilometres (2700 miles) long, flow across Asia. The longest, the Chang Jiang or Yangtze, stretches some 6390 kilometres (3970 miles) through China. It keeps distinguished company with other monster rivers such as the Lena, Amur, Mekong, Yellow and Ob'-Irtysh. Length, however, is not everything. Asia's largest river is the Yenisey-Angara River, flowing into the Arctic Ocean, with a drainage area covering 2.7 million square kilometres (1 million square miles) – an area almost the size of Argentina.

Seen from far out in space, the great continent of Asia is punctuated by a massive spine that stretches for thousands of kilometres across its centre: the Himalayas.

Above: The misty lakes of Honshu and Hokkaido in Japan are the wintering ground of the whooper swan.

Right: As graceful as it is ferocious, the Bengal tiger is at the top of the food chain.

About 50 million years ago the tectonic plate on which the Indian sub-continent rides rammed into the southern edge of Asia, pushing ancient sea beds high into the jet-stream.

The geological forces that shaped – and continue to shape – the continent drive its climate too. The ever-growing mountains of the Himalaya act as an immense barrier to the annual monsoon winds that sweep a curtain of torrential rain across southern Asia. As a result they are a massive weather machine, creating a vast rain-shadow to the north and feeding nineteen great rivers that carry life-giving water across a third of the continent. As if the greatest mountain range on Earth were not monument enough to the scale of Asia, other ranges, such as the Tien Shan and the Altai, join ranks with the Himalayas, making central Asia the 'roof of the world'.

Uplifted peaks are not all that Asia offers by way of mountains, for this is also one of the most volcanically active areas on Earth. Asia's eastern skirt drapes across the Pacific 'rim of fire', so that from Indonesia to Kamchatka

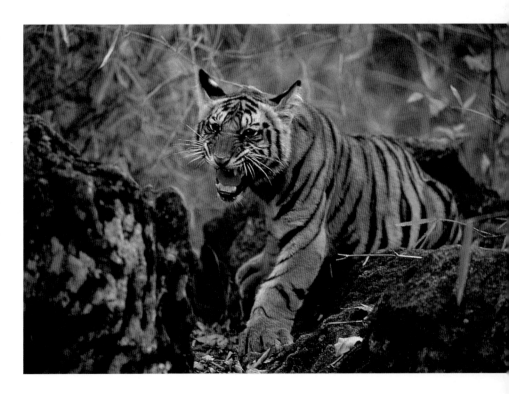

In spring, the taiga forests of northern Asia are carpeted with wild flowers.

dozens of ancient and modern peaks stand primed to vent gases, ash or lava at a moment's notice.

From a natural history perspective, Asia's great natural environmental regions, or biomes, support a phenomenally rich panoply of diversity. Each biome differs fundamentally from the next, not least in size, and it is this aspect of Asia that is so often misconceived.

In the north, Asia's landmass is greatest, thus its tundra and taiga zones are enormous. Asia becomes far more attenuated in the south. Yet despite this disparity, the image of Asia most readily brought to mind is more likely to be one of dripping tropical greenery, gaudily fluttering butterflies and slow-moving orang-utans rather than one of endless coniferous forests or ice-coated tundra where the wolf and polar bear hunt.

Size, in relation to geographic situation and climate, has interesting implications for Asia's biodiversity. Regardless of popular images, Asia's Arctic and sub-Arctic regions – the tundra and taiga – are truly enormous, literally dwarfing the tropics. Although vast, however, Asia's northern region supports the fewest species, and even among the species that live there, few are uniquely Asian. After all, Europe and Asia are contiguous, joined at the Urals by the last remnant of ancient scar tissue where two even older

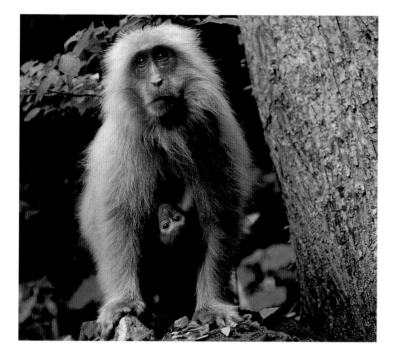

continents became welded together. And until about 10,000 years ago, Asia and North America were also connected by the Bering land bridge. This link was more than a physical connection; it was a biological bridge, allowing the dispersal and migration of genes and species from one continent to the next.

In the largest of the great continent's biomes, then, species are relatively few. Those that can survive are generally successful enough to populate vast areas. At these high latitudes, where winter dominates the year and summer is over in a blink, the plants and animals of Asia share many similarities with those of Europe and North America. Across the Asian tundra the summer growing season is so short that the few tree species struggle to reach ankle height. Here one may walk giant-like across the forest canopy itself.

Slightly further south, where the influence of winter is weaker, one enters the taiga zone, a region of swamps, pools and shady conifer forests, that is even more enormous than the tundra. The ground is free of ice for much longer each summer and many more species survive.

Above: As the northernmost monkey, the Japanese macaque experiences four distinct seasons.

Top right: During the brief northern summer months, the alpine meadows are knee-deep in wild flowers.

Right: The archetypal survivor: an Arctic fox.

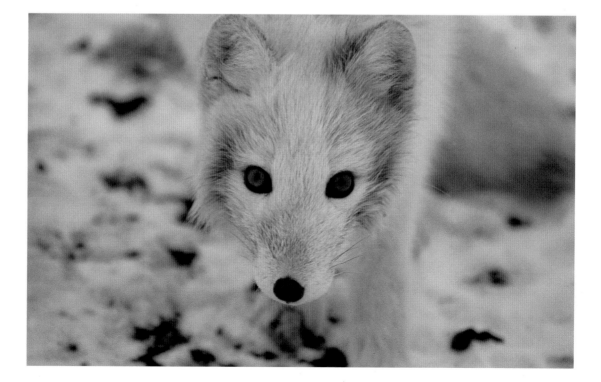

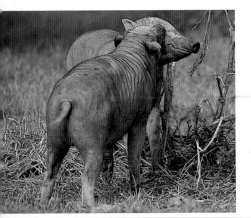

At its southern limit, the Asian taiga blends almost imperceptibly into the temperate zone. As it does, biodiversity continues to rise and the number of uniquely Asian species increases. The temperate region is also immense, stretching from Japan, across China to the flanks of the Himalayas. After the relative monotony of the coniferous taiga forests, the intensely seasonal forests of the east are a riot of autumn colours, a paint-box palette to rival any on Earth, and they are home to a 'messenger of the gods', the Japanese macaque. Further west, towering temperate bamboos hide the most recognisable icon of Asia, the giant panda, in its dwindling mountainous forest home.

Further west, the taiga zone blends into a different habitat, for the heart of Asia is unforested and throbs with heat. Straddling the continent in an immense band of aridity is a desert corridor as broad as the continental United States. At its western extreme, beside the Caspian Sea, lies the Karakum, in the centre the Taklamakan, while at the eastern extreme is the Gobi. Together they span a staggering 60 degrees of longitude.

The harsh desert environment in the heart of Asia is surprisingly akin to that in alpine regions and in the Arctic. Plants in all three habitats face the desiccating and abrasive effects of the wind and suffer debilitating extremes of temperature. They are forced into special growth patterns to resist the wind, the extreme heat and cold, and must be efficient at collecting or trapping moisture.

The desert corridor is not only a challenge to life itself, but also a significant barrier to the movement of species across Asia. Although there is specialised life here in the deserts, it is scarce, and biodiversity is low compared with elsewhere.

As we travel south across Asia, we move along two

Top left: Siberia's Lake Baikal is so massive the local people refer to it as a 'sea'.

Left: The wildest of pigs, the babirusa of Sulawesi, has evolved in isolation.

Below: Much of the beauty of Asia lies underneath the water: feather star crinoids clinging to the lip of a large sponge, Manado, north Sulawesi.

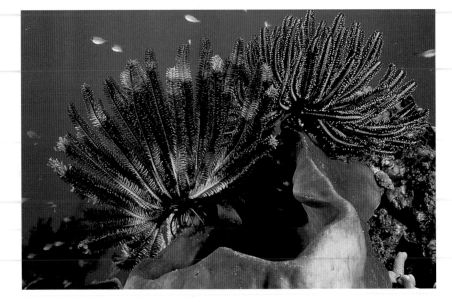

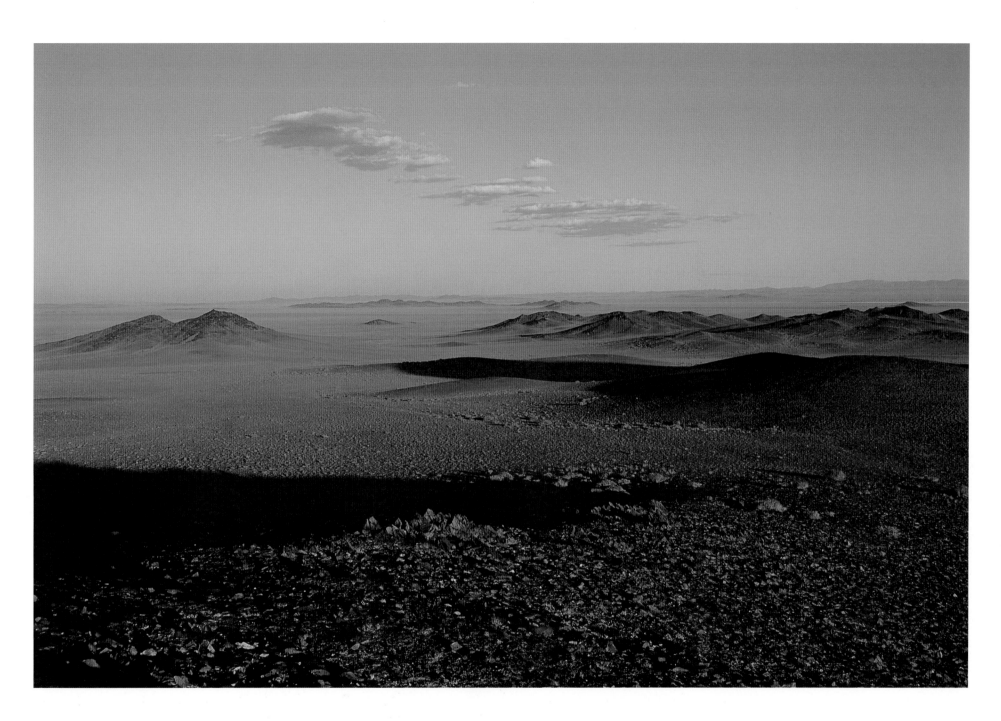

Above: The Gobi desert is a forbidding home and few animal species survive there.

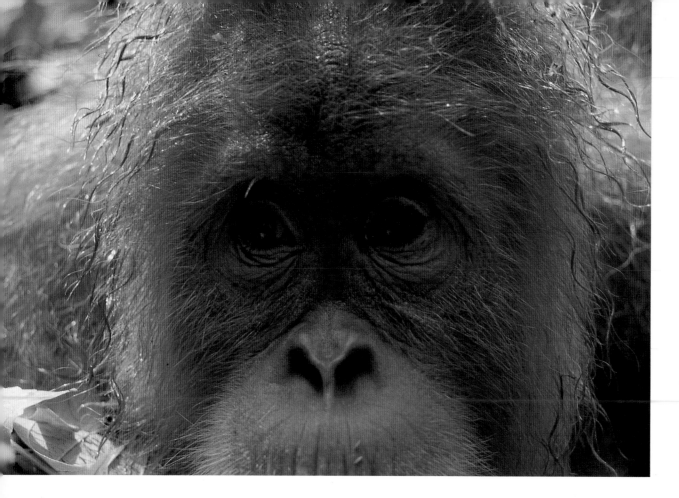

contrasting gradients. First, land area declines as we approach the tropics. Secondly, and in direct contrast, species diversity increases enormously, and along with this comes a proliferation in the plants and animals that are uniquely Asian.

Key elements in defining the habitats that occur in Asia are the continent's enormously varied topography and climate. While geography leaves the immense desert heart of Asia one of the driest places on earth, south-east of the great Himalayan barrier the reverse applies. In contrast to the searing summer heat and frigid winters of central Asia's high deserts, where only the hardiest species survive, astride the Equator, in South-East Asia, intense seasonal rainfall drenches Asia's sub-tropics and tropics. In some regions of the world the transition is a gentle one, from temperate to sub-tropical and then to tropical, but in Asia we are faced with a dramatic reduction in land area towards the Equator. The great continent narrows and ultimately breaks into a scattering of islands, and so gentle transitions on the continent itself may be disjointed and abrupt across the islands. Here, at another Asian extreme, we find majestic forests, tropical and lush, dripping with water all year round and teeming with life. Among one of the oldest ecosystems on the planet, we find the richest terrestrial biodiversity, the greatest concentration of truly Asian plants and animals.

Whereas one may walk across the forest canopy in the far north, in the tropics one walks far beneath the crowns of immense trees that tower skywards. A gibbon rushing through the foliage may be thirty metres (100 feet) above one's head. Cathedral-like, these shadowy forests harbour a diversity of life so enormous that it becomes difficult to grasp. Bizarre flying snakes and flying frogs defy natural conventions, while gem-like sunbirds, fuelled by nectar, are Asia's answer to the hummingbirds of the Americas.

Whereas the Arctic was home to few species, ecological niches in the tropics are so diverse that species are abundant. More icons of Asia dwell in these forests – the tiger, the orang-utan. In every direction are species upon species, some literally piggy-backing on others, creating a three-dimensional maze of life, from the microscopic to the elephantine. In Asia's deserts one must search for life. In its tropical forests, bewilderingly rich

Above: The king of the tropical forest, the orang-utan. Its name means 'people of the forest'.

Right: The rainforest attracts a rich diversity of exotic birds, such as this celebes hornbill.

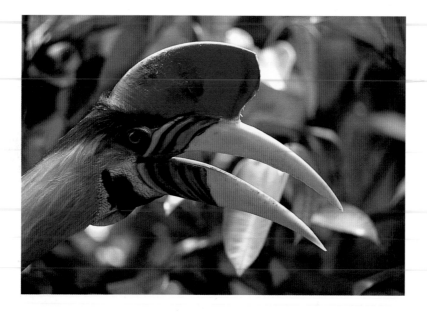

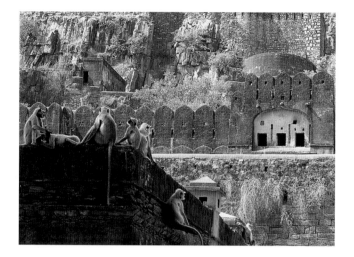

in species, life is likely to come looking for you.

The diversity of the forests is still only partly known. Even as recently as the 1990s, new large mammals and birds were still being discovered in Laos and Vietnam. We may never experience such exuberance of life again as exists now in these rich tropical forests.

Asia may be vast, and the enormous scale of its biodiversity may seem inexhaustible, but Asia also supports the highest concentration of humans in the world. As the first light of the new millennium spread across Asia, it spread across a region most obviously burgeoning with human life, for more than a third of the Earth's rapidly increasing 6000 million human population live here. In parts of India, China, Japan and Indonesia there are already on average more than 200 people crammed into just one square kilometre.

Above: The sacred Hanuman langur is at home in the ruins of a temple.

Right: The Indonesian rainforest.

Bottom right: Breeding dance of red-crowned cranes at sunset.

Whereas in the past Asia supported an amazing diversity of life, Asia now faces the greatest human and biodiversity crisis on earth. We humans are, like a blazing forest fire out of control, consuming and converting biodiversity as we spread. If we look forward another century – let alone another millennium – we will in all probability look out across an Asia without tigers, without orang-utans, lacking many of its other primates, and missing thousands of other species of plants and animals. We will witness a wave of extinctions resulting from massive habitat loss and environmental degradation. For some species conservation efforts are probably already too late, but for others perhaps not so. The people of Asia hold the choice in their hands. The future of wild Asia is theirs.

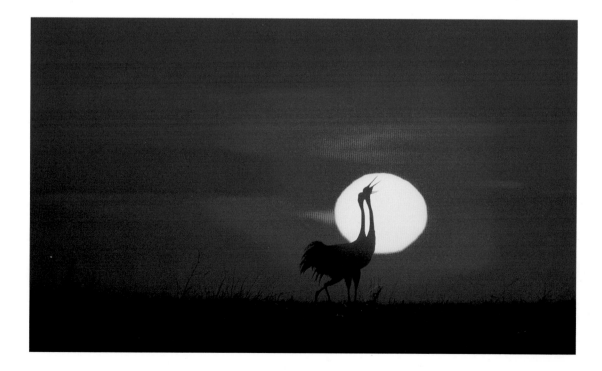

At the Edge

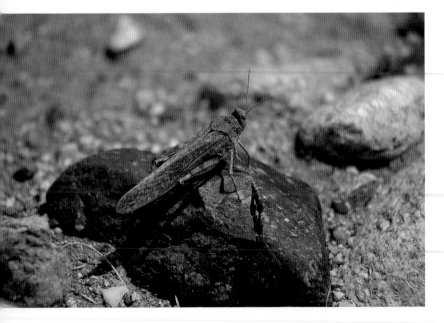

Like this grasshopper, many of the insects that live at high altitude are darkly coloured, which makes them more effective at absorbing warmth during the brief periods when the sun is visible.

At first sight, the Rumbak Valley in the northern extremes of India looks dead. For all but a few weeks of the year the whole valley is brown. Lying under the greatest rain shadow on Earth, Rumbak has sparse snowfalls that quickly blow or melt away, depending on the season. This is a land of extremes: a harsh high place over six kilometres (nearly three miles) above sea level. When the sun is not shining, the temperature drops far below freezing, no matter what the season. Out of the shade, the sun burns terribly through less than half the amount of atmosphere than at sea level. The thin air makes even walking on flat land exhausting – and nowhere around Rumbak is flat. The cliffs are enormous, crumbling and rugged. From high up the valley you can see the massive Himalaya mountains rise and fall west towards Pakistan, eastwards towards China, Nepal and south to unimaginably hot, wet and crowded India. The great mountains make a landscape in which people, animals and plants are all but swallowed up.

The size and majesty of the Himalayas are awesome almost beyond human comprehension. They cover close to 600,000 square kilometres or 230,000 square miles (an area greater than France), extending in an arc of almost 2500 kilometres (1500 miles) from the Indus River in Pakistan, eastwards into northern India, then across Tibet and Nepal, through the Indian state of Sikkim and into the Kingdom of Bhutan, and on towards China. These massive mountains soar into the sky – more than thirty peaks are over 7500 metres (24,500 feet) high. Fly, walk, drive

ALAN ERSON

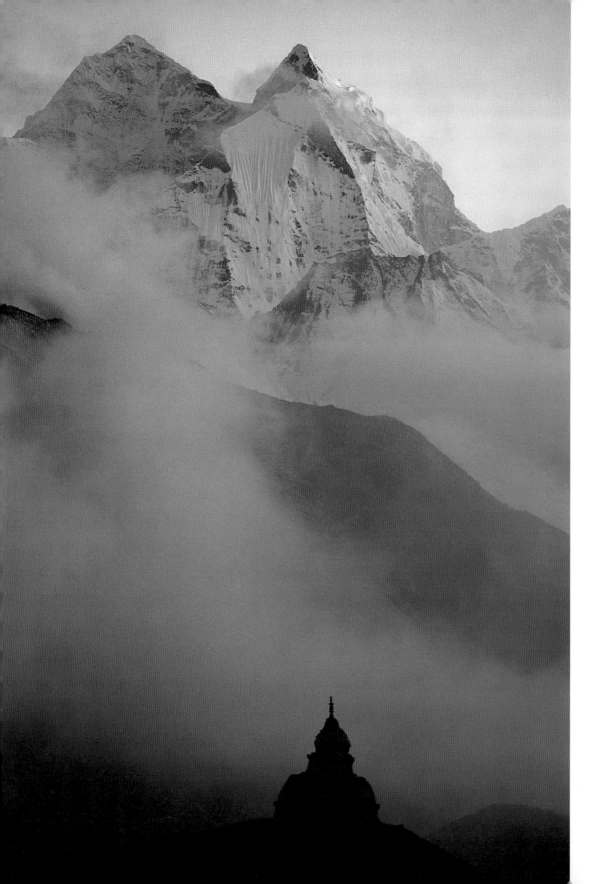

or ride a horse anywhere in the mountains and the scale of the place quickly destroys all your senses of distance, time and self-importance.

The great barrier that divides northern and southern Asia, the Himalayas control much of the weather experienced in the south. Here, in the altitudinal limits of terrestrial life, animals and plants live on the edge of existence. The huge drama and biological complexity of the Himalayas range from the rhinoceros of the Nepali terai, through the beautiful rhododendron forests of Kedarnath in India, the wooded valleys and bare peaks of Kashmir (the home of the black bear), then over the divide into snow leopard country in the high dry trans-Himalaya of Ladakh.

The snow leopard is the most elusive animal of the Himalayas – and also the best known. The cat lives hidden from view. Its perfect camouflage, the steep and open terrain it inhabits and its largely nocturnal habits have made human encounters extremely rare, and quests to glimpse it in its natural environment have been turned into legend.

The daunting cliffs of the high Himalayas are the mountain sheep and goat capital of the world. Bharal are half-sheep, half-goat. They are as brown as the country they inhabit. Like other ungulate species, such as the ibex, they thrive on the spiky, mostly buried alpine desert plants that grow in every crack in the rocks or in old streambeds. In turn, bharal are themselves food for the snow leopard, the predator of the cliffs, and Tibetan wolves, who hunt the less steep faces. Bharal infants can climb vertical cliffs within hours of birth – they must if they are to avoid sharp-eyed golden eagles and lammergeiers with young of their own to feed. They are among the hardiest of the many species of mountain sheep and goats indigenous to the Himalayas. Short-limbed, mostly silent and relentless in pursuit of scarce food and breeding opportunities, bharal are perfectly adapted to survival in the high mountains.

But almost every animal species in this harsh, beautiful region is under threat from human expansion. The great mountains will always remain grand and picturesque. But if people wipe out the indigenous species the heart will have been ripped out of the Himalayas.

Few species can survive in the rarefied atmosphere of the high Himalayas. Alpine plants adapted to freezing night-time and winter temperatures, searing ultra-violet light during the day and a very limited water supply, are joined by just a few insects, birds and a handful of mammal species.

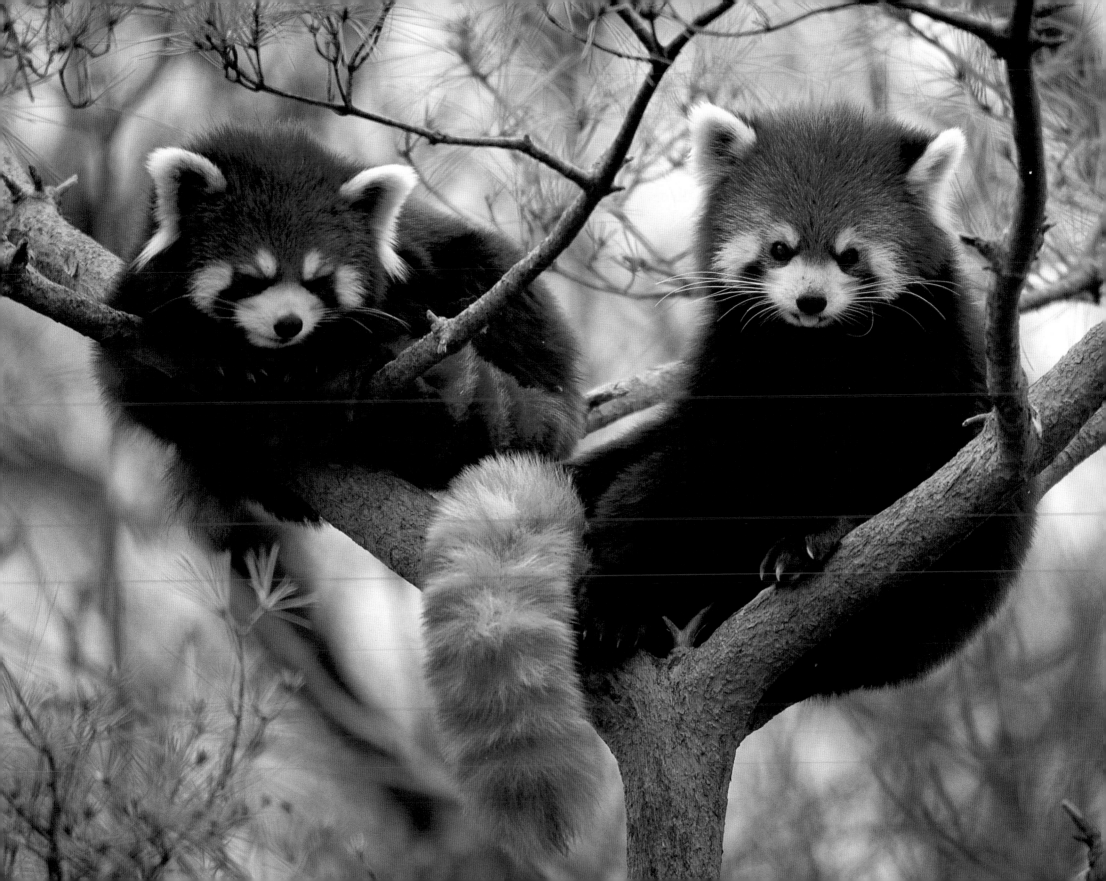

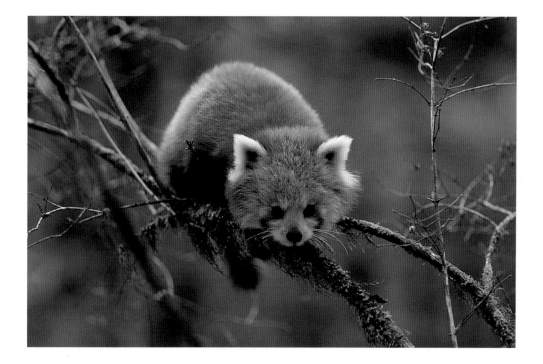

Until quite recently, red pandas were thought to be related to the black-and-white giant panda of China – possibly because both feed on bamboo. But now this long-tailed mammal, which is about the size of a large cat and lives in the forests of the Himalayas, is classified as a raccoon.

Opposite: The female monal pheasant, who has to provide camouflage for her eggs and chicks, is dull in comparison with her mate – one of the Himalayas most brilliantly coloured birds, with a plump blue body, pink neck and orange tail. Living high up in open mixed forests or rocky slopes, they dig through the snow with their strong beaks in search of insects and roots.

Top right: Altitude, exposure to sunlight and the ferocious winds that sweep across the Himalayas define the flora and fauna of the region. The temperate forests of conifers and broad-leaves stretch from an altitude of around 1400 metres (4500 feet) to where the alpine zone begins, about 3200 to 3700 metres (10,500 to 12,000 feet) above sea level.

Bottom right: Another bird with a penchant for remote, high-altitude places is the blood pheasant. A gregarious creature, it usually travels in flocks of between ten and thirty birds and feeds on berries, mosses, bamboo shoots and juniper sprouts.

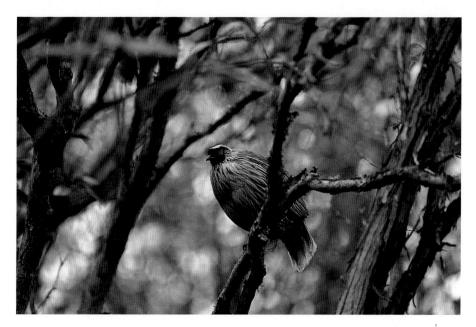

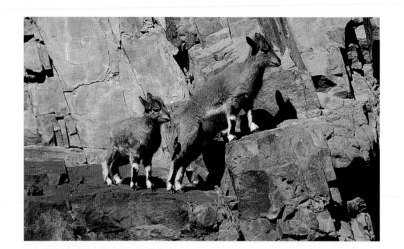

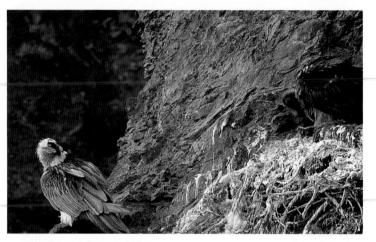

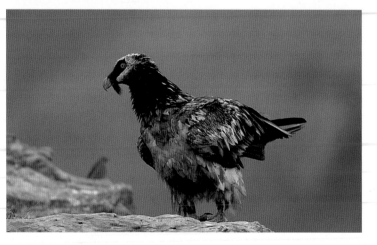

Opposite: The Himalayas are home to the greatest number of mountain sheep and goat species in the world. Bharal live in the high dry valleys and ridges of Ladakh, in India's Upper Indus on the border with Tibet – an extreme existence on and around near-vertical cliffs.

Top left: The English name for bharal is 'blue sheep', but the tough beautiful ungulate is at least half goat. With their short limbs and thick winter coats, they are well adapted to the harsh Himalayan environment, which is also home to their natural enemies: wolves and snow leopards.

Centre left: Ranging throughout the Himalayas, the lammergeier, or bearded vulture, is Asia's most specialised carrion feeder. Though they thrive on the remains of bharal and other animals, they are not interested in feeding on flesh. Lammergeiers eat bone. To break the bones into edible portions, the birds drop them from high up in the air on to the rocky ground below.

Bottom left: The lammergeiers' courting rituals, which take place in December, are no less wondrous than their bone-breaking habits. The male and female fall hundreds of metres through the air, spiralling around each other, in elegant aerial duets.

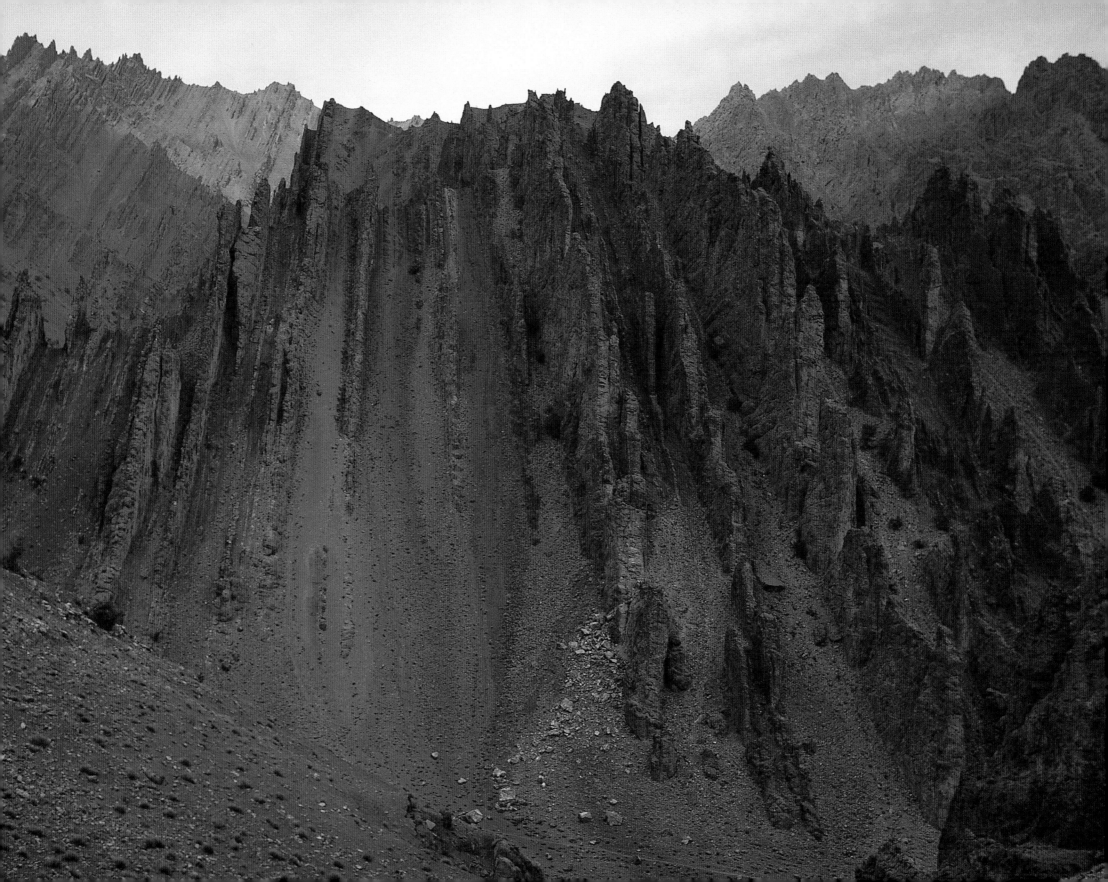

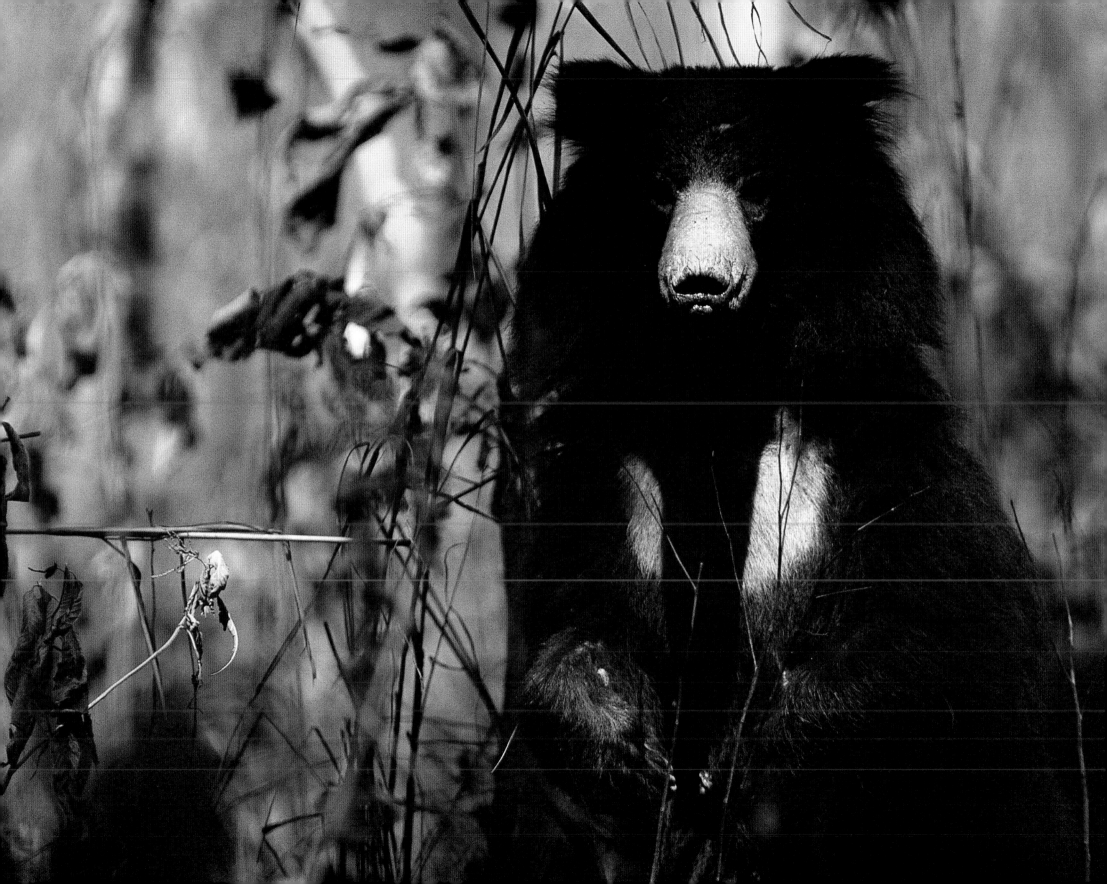

Above: In early spring, hungry Himalayan black bears emerge from their dens in Kashmir, on the wet side of the Himalayas, in search of food. They scan a landscape still white with snow for any scrap of green. As the forest warms, the bears – which are largely vegetarian – start on a feeding frenzy that will last almost eight months, foraging for leaf shoots, then fruit, berries, walnuts and finally acorns.

Opposite: The strange roars, howls, huffs, gurgles and squeals in the forests of Nepal are the sounds of sloth bears talking to each other – such friendships are unusual among other species of bear. These big mammals, which when fully grown weigh in at between 115 and 135 kilograms (250 and 300 pounds), use their muzzles to dig into the ground in search of food.

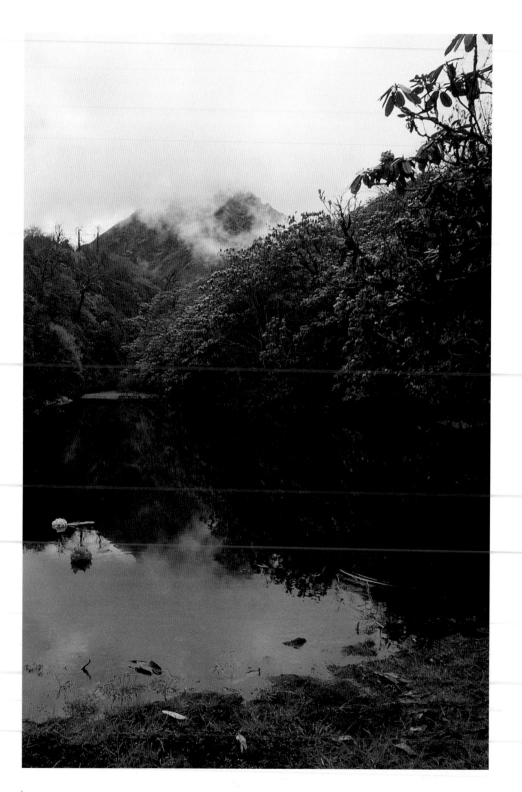

Left: For several months each spring the Himalayan region is swathed in colour as, one by one, the different rhododendrons produce their great flowers. Most of the world's 500-plus species of rhododendrons and azaleas come from here.

Opposite, left: Lichens and mosses thrive in the same moist soils and shady areas preferred by rhododendrons.

Opposite, right: The petals of the Himalayan blue poppy, or mecanopsis, have a texture that resembles paper and an intense blue-mauve colour. Drifts of these delicate-looking, early-summer flowers thrive on the lower reaches of the mountains.

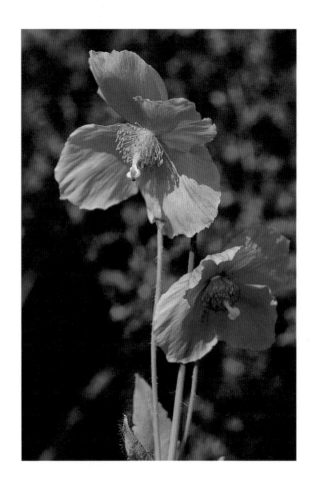

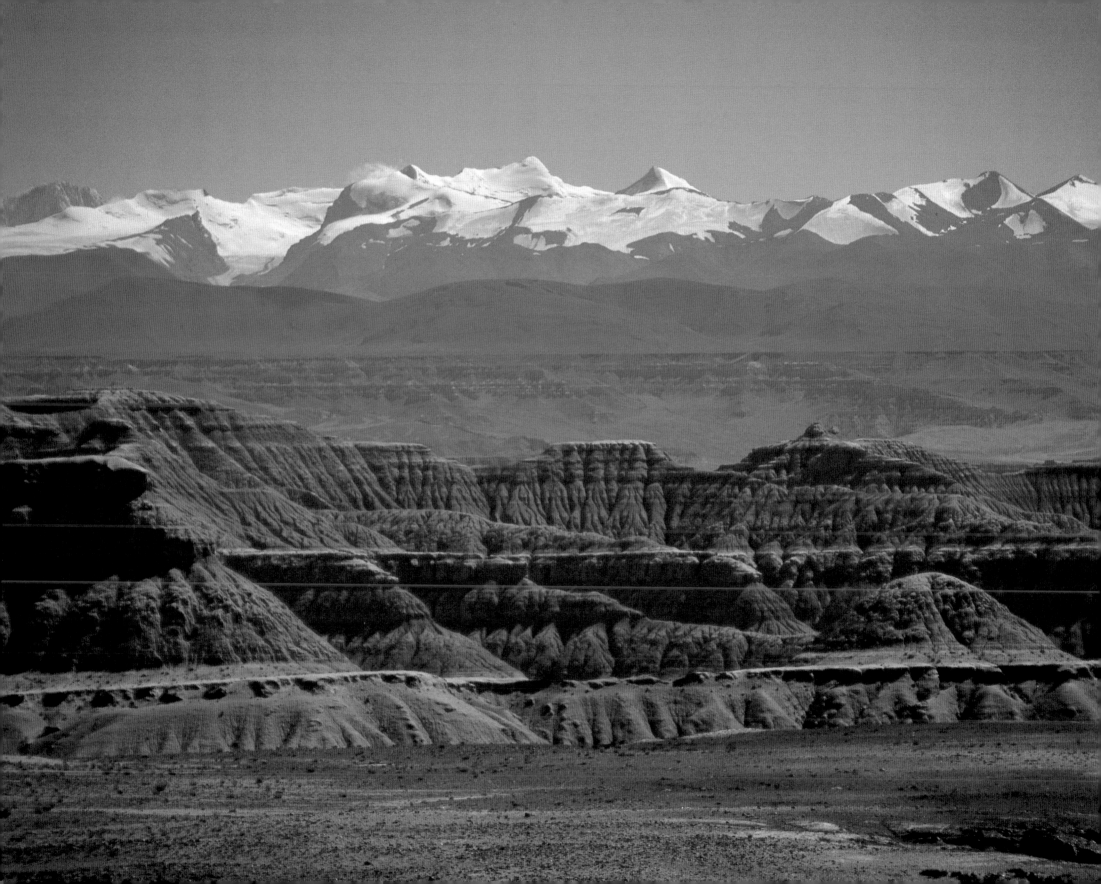

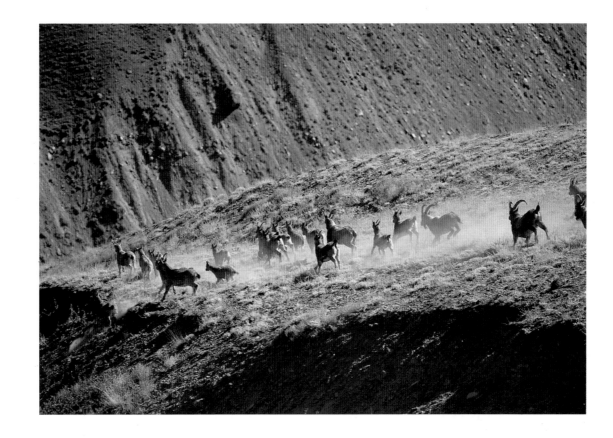

Above: Hard, even-toed hooves for grip, stamina to travel continuously and the ability to nibble vegetation down to the soil surface allow ibex to survive in these harsh environments where plant life is scarce.

Opposite: The tectonic forces that raised Asia's great wall, the Himalayas, pushed the Tibetan plateau high up – on to the 'roof of the world'. The immense rain shadow cast by the great mountains leaves the plateau desert-dry.

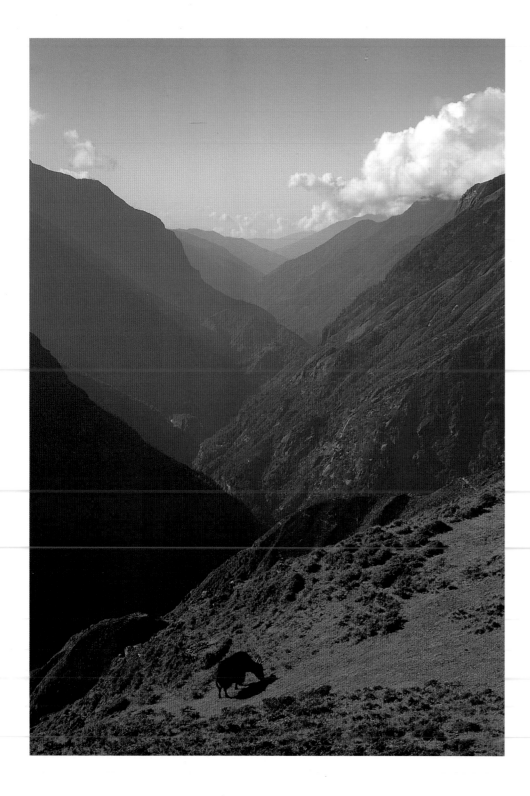

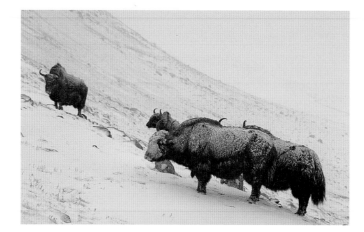

Top: It is widely believed that yaks eat snow in winter, for these huge grass-grazing animals require a great deal of water to survive. Few yaks survive in the wild now and they are listed as endangered.

Above: The yak has long been domesticated and, indeed, is the main resource of western Tibet. Raised mainly for their milk, beef and hides, a staple of the Tibetan diet is yak butter, which is made into tea and also eaten with roasted barley flour.

Left: The yak, a massively built species of ox, inhabits the high ground of the Tibetan plateau. Herds of female and young wild yak confine mature bulls to the sidelines, to be consorted with only during the winter mating season.

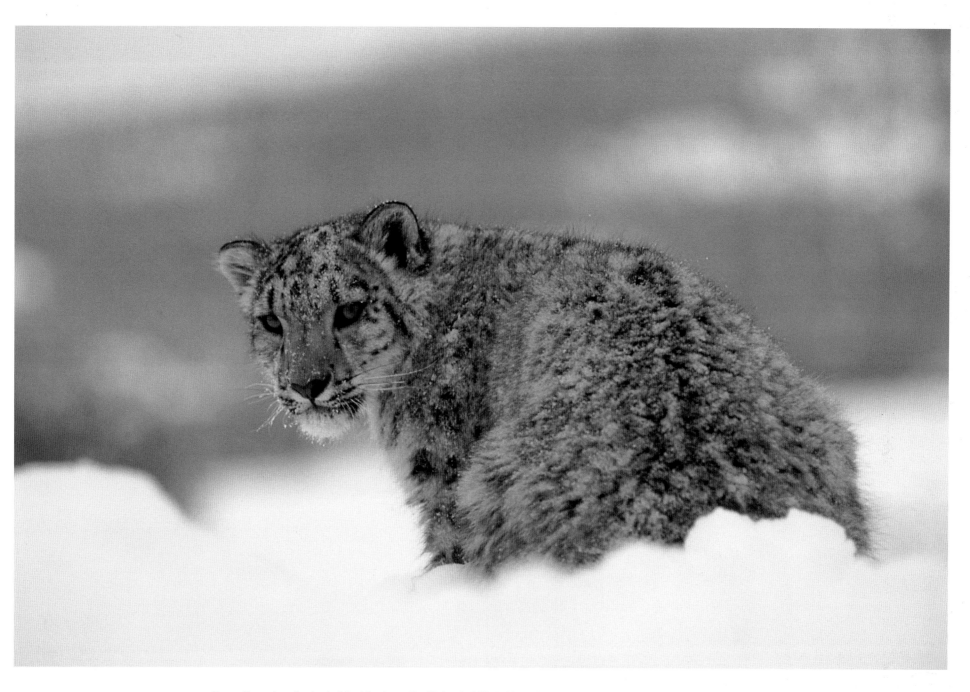

Above: The enigmatic ghost of the Himalayas, the Altai and of Hindu Kush, the snow leopard is the most difficult of all the large cats to observe. A superbly camouflaged 'lie-in-wait' hunter, it preys on the nervous bharal and other even-toed ungulates.

Winter's Kingdom

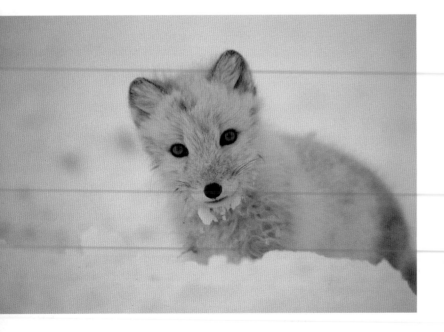

A lone hunter, the fox is a master of survival. Its small ears, short legs, and furred feet and nose are all adaptations for reducing heat loss in the Arctic environment.

Paradoxically, the largest part of Asia – the immense northern expanse of Russia – has the fewest species. Here winter rules a cruel kingdom where light leaves the land for months on end, where ground and sea freeze, where temperatures can reach as low as minus 50 degrees Celsius (minus 58 degrees Farenheit), and where only the very hardiest of species can survive beneath the shimmering half-light of the aurora borealis.

Come spring, the return of the sun's light turns this Arctic realm topsy-turvy. While the ground beneath remains frozen, snow, ice and finally the surface soil thaw. For the greater part of the year the land lies desert-like, with water locked away as ice, now, suddenly, there is too much. Low-lying ground turns to a peaty quagmire and the plants that once slept beneath ice and snow must now fight for life in a surfeit of water.

Light, previously absent, is now ceaselessly present. The once-dormant plant life rushes to a climax of growth. The few willows and birches that grow here reach outwards rather than up, stretching prostrate across the ground to maximise access to the fleeting

MARK BRAZIL

With the soles of its feet insulated with hair, the polar bear lumbers across the Arctic ice stalking seals and adding fish, carrion and whale meat when it can get it. This beautiful animal is strong and muscular, the true emperor of the ice.

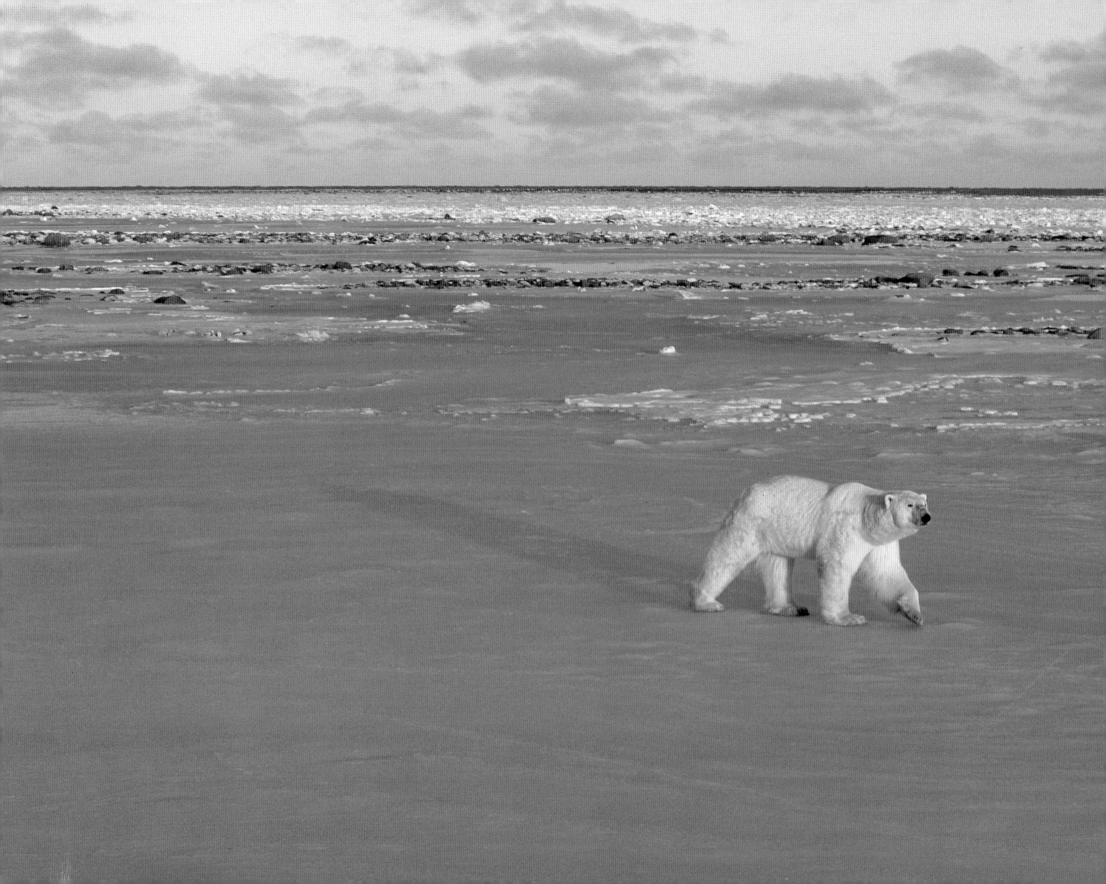

weeks of sunshine. Summer flowers rapidly outstrip them, rising knee-high on the lush tundra to present their blossoms to the bumble-bees, before seeding and collapsing into the soil as summer ends and winter returns once more.

The Arctic tundra and taiga – the largest of Asia's environmental regions – spread in an immense band across the northern portion of the continent from the island of Novaya Zemlya and the Ural Mountains in the west, to the Chukot Peninsula in the east. Though long, the tundra – a treeless zone with a frozen subsoil – is a relatively narrow strip of land, mostly stretched along the northern coastline of the continent and lying above the Arctic Circle, except where the Kamchatka Peninsula extends a long finger of tundra into the Sea of Okhotsk.

The tundra's coastal edge and adjacent sea ice are where the polar bear predominates, while on land the Arctic fox and musk ox roam. Their names are as familiar here as in North America or northernmost Europe, for all three regions are closely connected. The few animals that have solved the difficulties of life

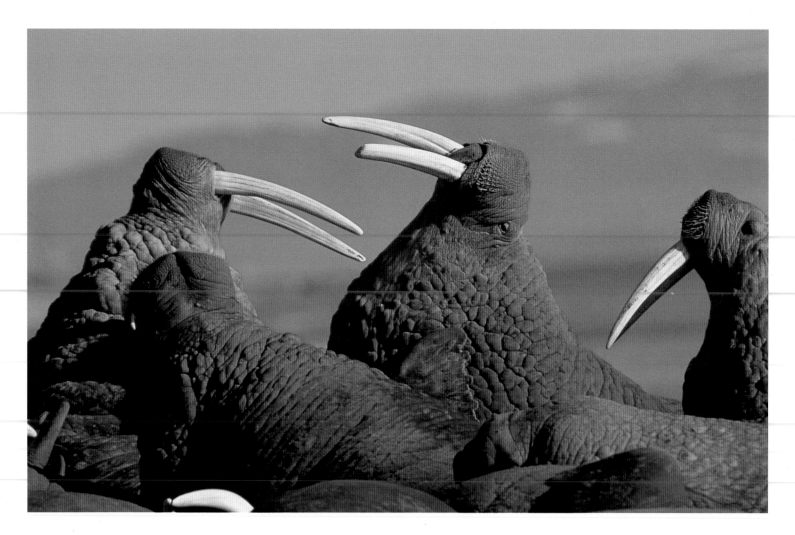

The cold but rich Arctic waters of the Laptev, Chukchi and Bering Seas support the impressive bulk of the docile Pacific walrus. Asia's largest seal is more than three metres (10 feet) long and weighs up to 1500 kilograms (3300 pounds). For the indigenous peoples of this region, the walrus has been a traditional source of food, ivory and skin for boats.

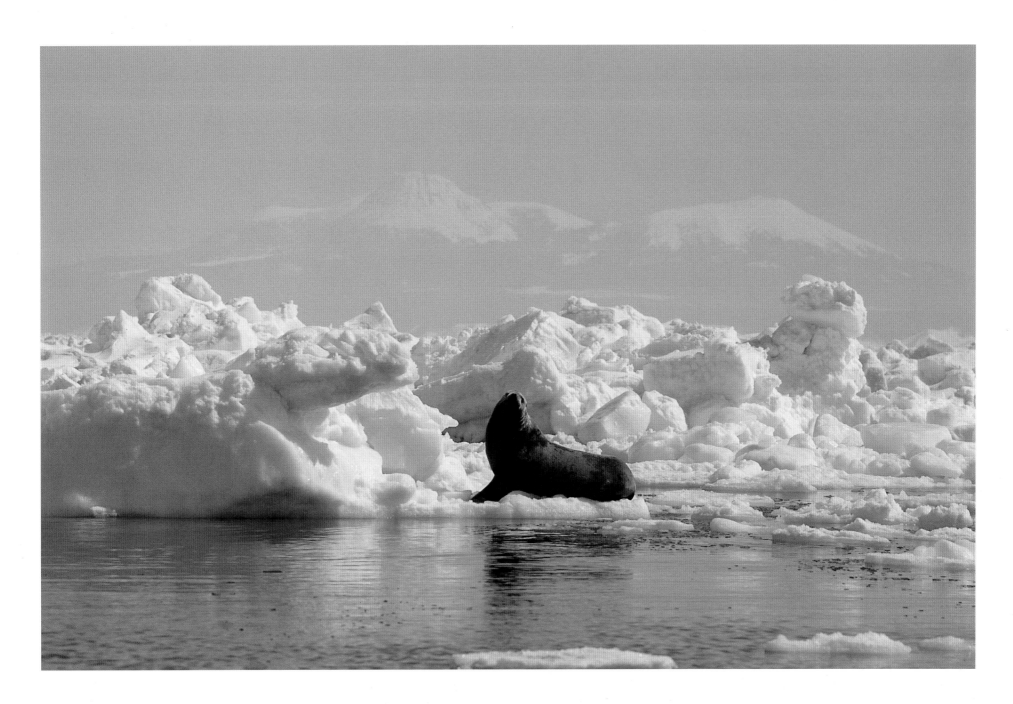

Steller's sea lions communicate with each other in low roaring calls, similar to those that lions make. They are classified as a threatened species, breed on rookeries on the Kuril Islands and Kamchatka and on islands in the Okhotsk Sea.

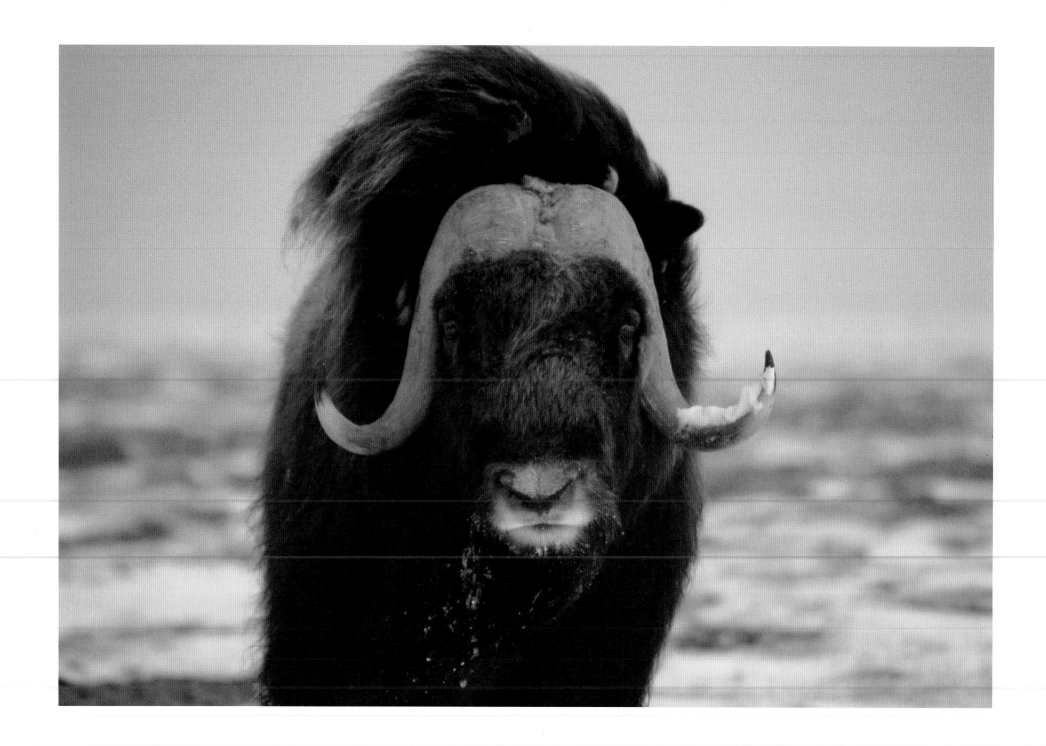

in these northern-most polar extremes are widespread.

Along its southern edge, the open tundra gradually gives way to the taiga, a boreal habitat that extends across Siberia from the Sea of Okhotsk to the West Siberian Plain. Richer in species and experiencing less harsh winters than the tundra, Asia's taiga consists of enormous conifer forests inter-mixed with swamps and pools.

Offshore, in the cold coastal waters of Northern Asia, the sun also drives a season of intense fertility. During long months of winter the seas have been frozen, but in the spring, rising temperatures and storms work together to break the sea ice, releasing the bounty of the coastal currents. First to arrive along the shores of the north-west Pacific are millions of seabirds, among them Steller's sea eagles, which have wintered on the coasts of northern Japan. The birds come here to breed, and they are soon followed by spectacular migrations of salmon, which will sustain their young. The salmon also feed other predators, such as brown bears, which emerge from hibernation inland and migrate to the coast and rivers to feed voraciously before the return of winter.

Summers in the Arctic are unpredictable and, at best, a short respite between the long periods of frozen darkness. The northern breeding birds may not produce surviving young every year, and when spring is late the young birds may not be able to fly by the time the first frosts arrive. Then, with or without their young, the birds must flee before winter's kingdom tightens its grip on life again.

As birds migrate away, the approach of winter forces plants into an early dormancy, or even death, while small mammals take another option – hibernation – so that they may sleep through the dark and deadly cold and awake to sunshine. Across a pristine land of ice and snow, northern Asia awaits the return of life-giving light to winter's kingdom.

Opposite: A living relic of the ice age, the musk ox's response to winter on the tundra is neither to migrate nor hibernate. Instead, it insulates itself against the cold. Beneath its shaggy guard hairs is an extremely light and astonishingly warm undercoat, known as 'quiviat'.

Right: Named after the German naturalist who sailed with Vitus Bering's second Pacific expedition in 1741, the Steller's sea eagle is Asia's largest bird of prey. It grows to around a metre (three feet) from bill to tail tip, and has a wing span two-and-a-half times its height. With its big, strong, high-arched beak, the Steller's sea eagle can rip carrion to pieces.

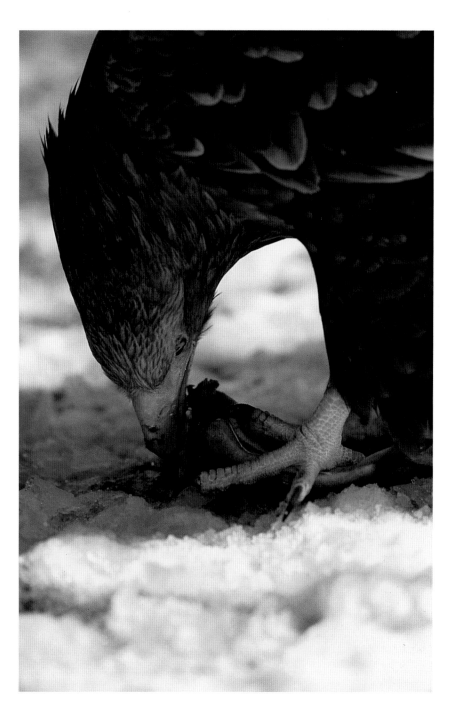

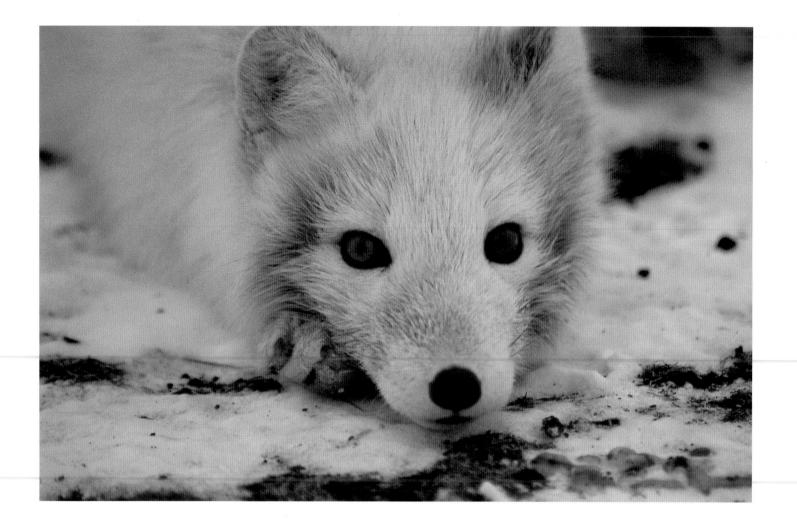

The sea ice of the Chukchi Sea blends imperceptibly into the land ice of the frozen tundra. The Arctic fox is at home on both, ranging inland for caribou carcasses and out on to the sea ice for the remains of seals killed by polar bears. Matching its coat colour to the season, it patrols the kingdom of winter, sneaking, hiding, pouncing, scavenging. Inquisitive, and fearless of humans, it is as at home raiding eggs from a summer bird colony as it is hanging around a polar bear's feast for the scraps that remain.

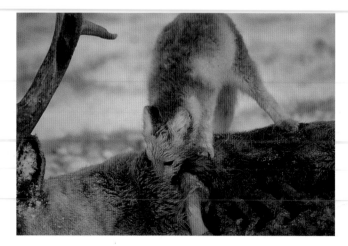

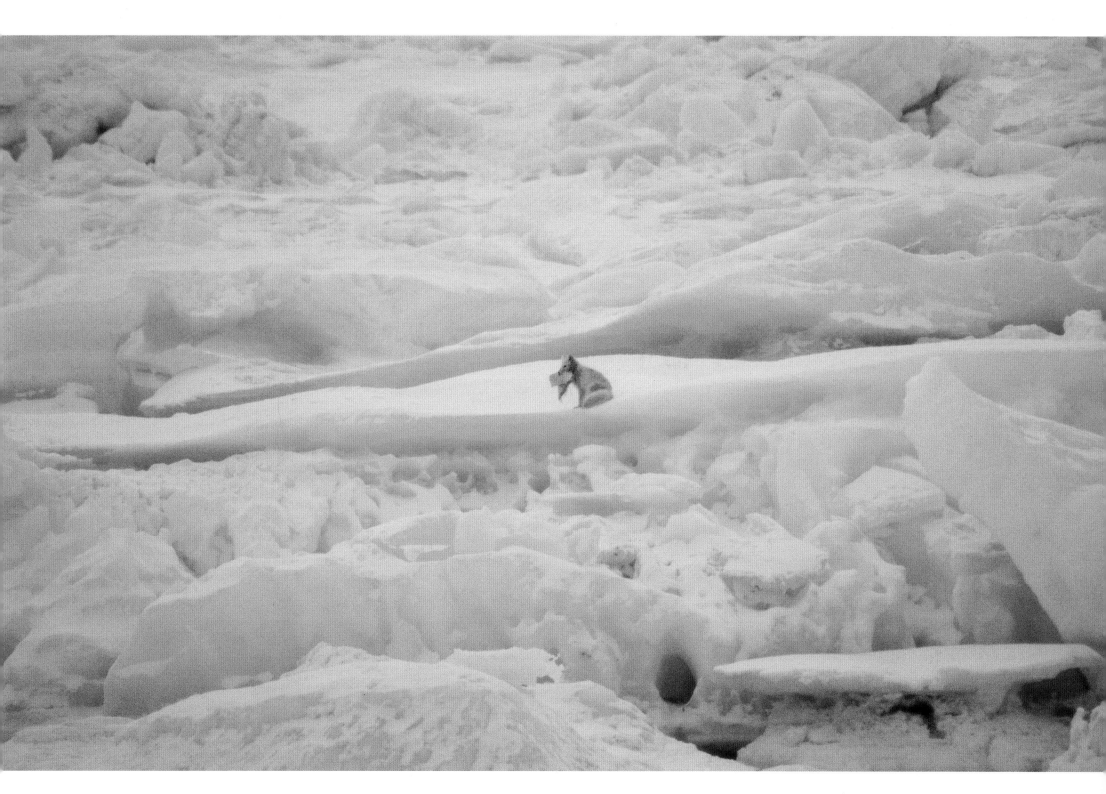

*Asia's enormous taiga zone –
consisting of fir and stone-pine,
larch and pine, and in some places
birch – stretches from the Pacific to
the Urals, from the shores of Lake
Baikal (left) in southern Siberia to
the tundra belt in the north. These
taiga forests represent the northern
limit of tree life on earth.*

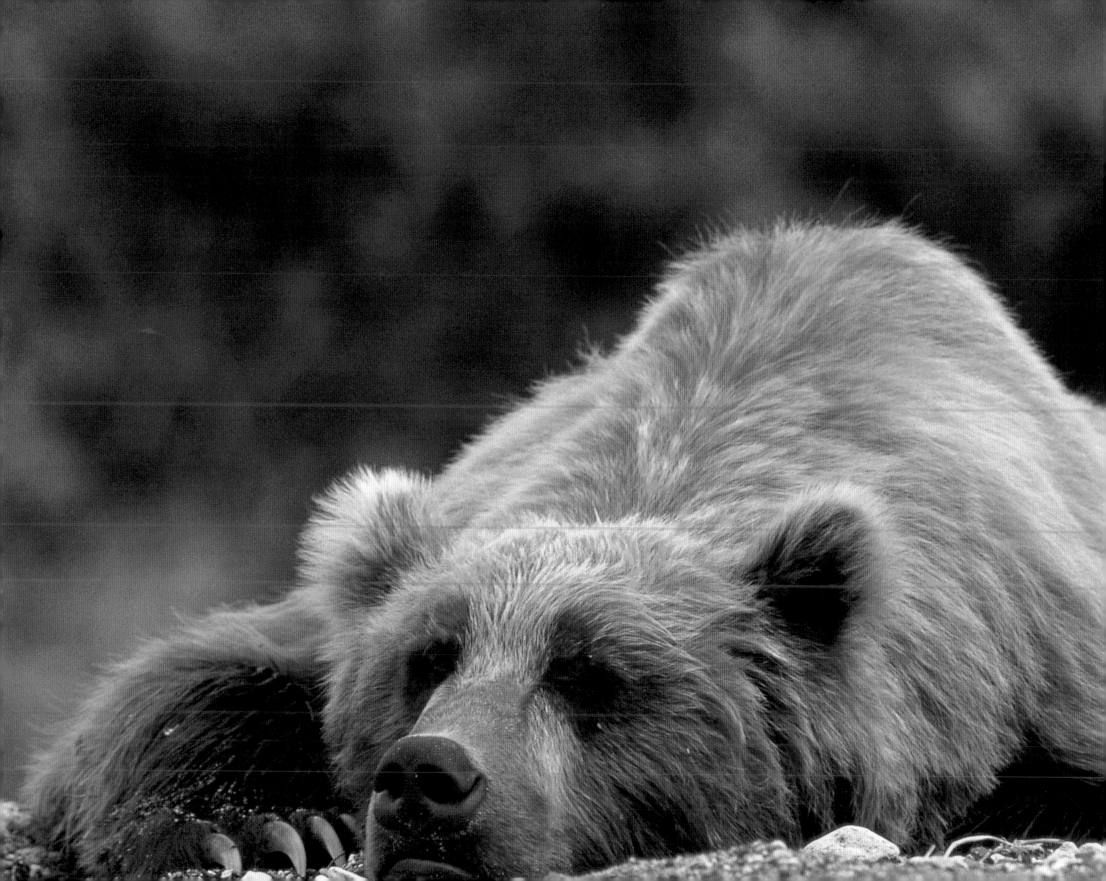

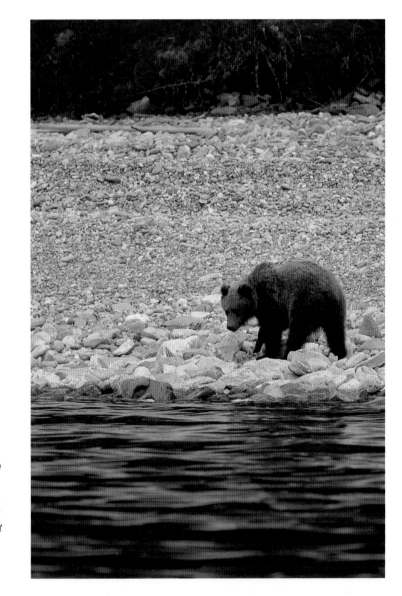

Left: Of all the taiga mammals, the brown bear is the most impressive. Standing on its hind legs, it is almost three metres (10 feet) tall. A solitary animal, it lives in dense taiga and wanders through open meadows and near water in search of food.

Right: Despite their fearsome reputation, brown bears are largely herbivorous, although they also search the coastal zone regularly for food, such as beached carrion or migrating salmon. This bear is pacing the banks of Siberia's Lake Baikal on the look-out for tiny caddis flies, a strangely delicate feast for such a large mammal.

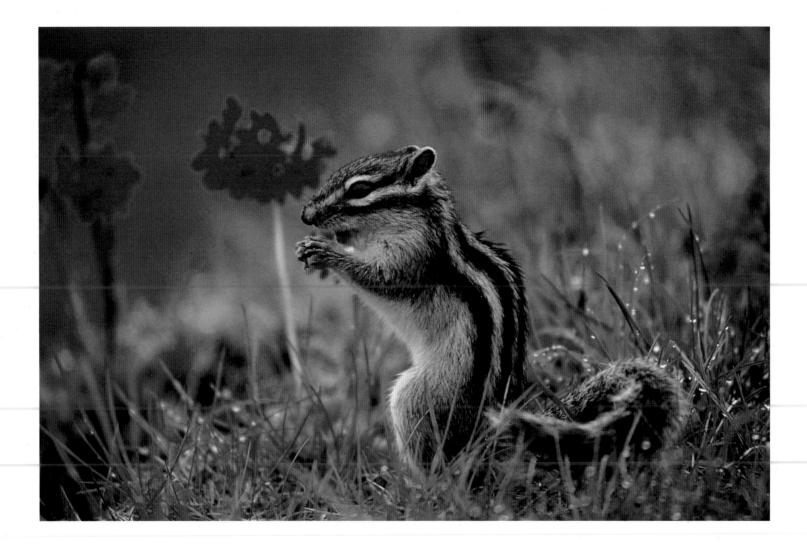

Weathering winter is difficult for small mammals. Bears and other large mammals are able to store body fat to last them through the cold months, but smaller species, such as this Siberian chipmunk, must feed well during summer, then gather and store seeds and nuts, stockpiling enough in their hibernation burrows to last for nearly six months.

Above: The souslik – or little ground squirrel – strips the succulent parts of grasses, seeds and bulbs, as well as young stems and leaves, and lives in a burrow. Pretty as they are, these little members of the rodent family are one of the most serious agricultural pests in Siberia.

Top: Fresh-leafed birches bring brightness to a springtime forest that has been dormant for months. Soon migrant warblers and thrushes will be singing here as the brief summer attracts a myriad of insects to the forest environs.

Left: Ever on the alert, the red fox waits patiently for suitable prey before darting in for the kill. Found all over the taiga, this is the common fox of Europe and North America.

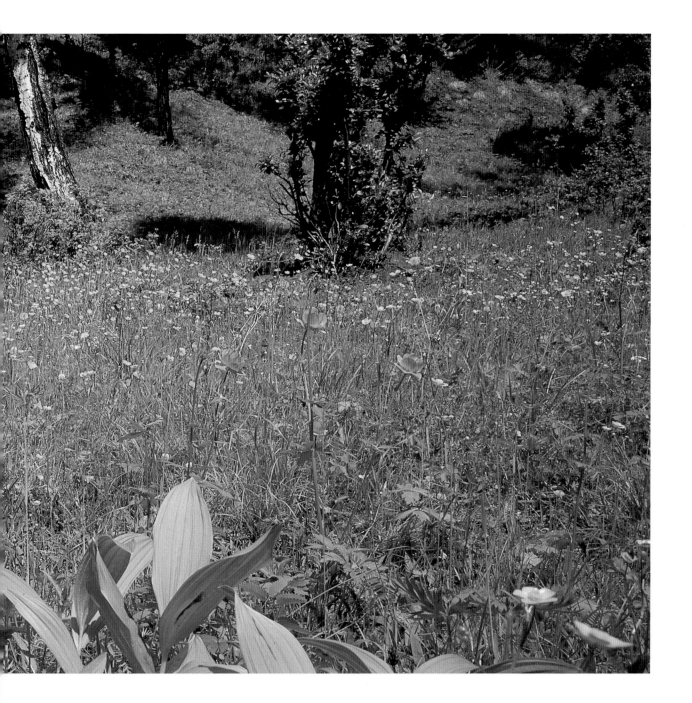

Light brings new life to the taiga forest. Once the summer flowers appear it becomes difficult to remember that for more than one-third of the year everything has been dormant beneath snow. Few insect species are present in this cold region, so many flowers are dependent on bumble-bees for pollination.

During the brief northern summer months, the alpine meadows are knee-deep in wild flowers. Larkspur, lilies, aquilegia, edelweiss and other alpine species appear, revealing the close interdependence between plants and insects. Their bright, showy flowers promise a supply of nectar to attract black-veined white butterflies, which cannot help but be dusted with pollen.

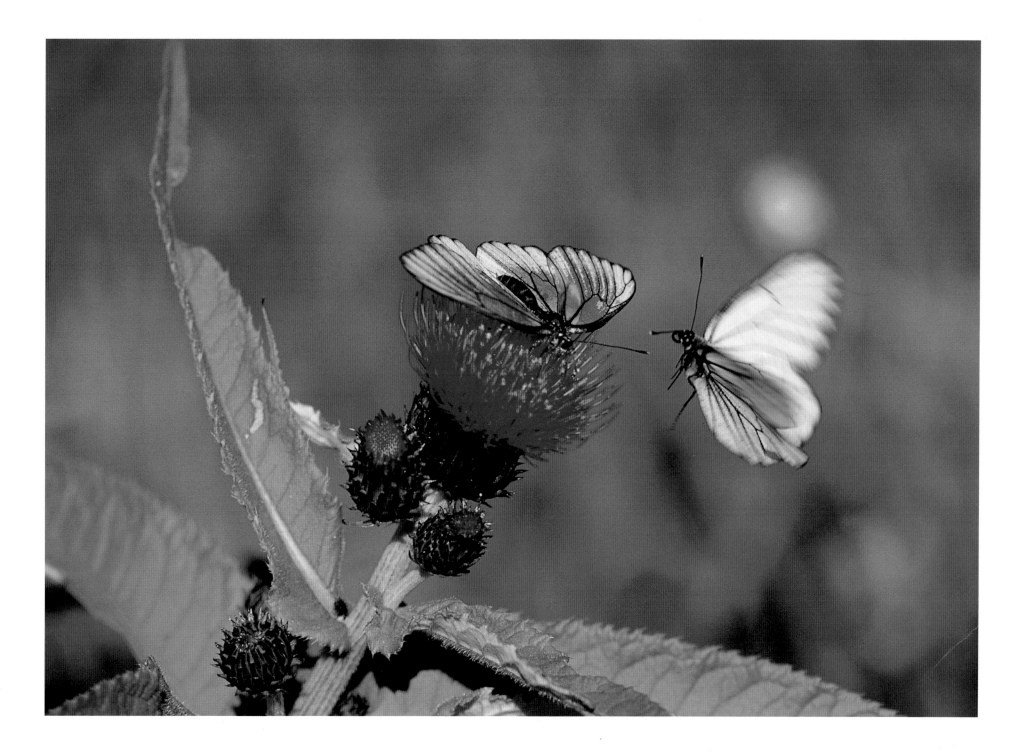

A Forest for all Seasons

L ooking at our planet from space the southern pole appears an ice continent surrounded by vast and turbulent oceans. The northern pole is also ice, but here the ice is surrounded by great continental land masses. As our Earth rotates around the tiny star we call the Sun, the poles of our planet tilt minutely toward the light and heat, then away again in a rhythm we count in years.

Quite recently – only a heartbeat in the eons of geological time – much of the northern world was covered by great sheets of ice. For millennia, they scoured the land. Then the ice retreated, leaving behind a new world to be colonised by plants and animals.

At the eastern rim of continental Asia lie the three main islands that are Japan: Kyushu in the south, then mountainous Honshu, and Hokkaido to the north. The great glaciers of the last ice age never reached Honshu, where there remains a greater diversity of plants than elsewhere in temperate Asia.

Here the forests move in a rhythm that is dictated by the Earth's

Unscoured by the last ice age, northern Japan's temperate forests have remained amazingly rich in plant species, making for extraordinary autumn colours. The lifespan of these forests is measured in millennia – they live to the rhythm of the changing seasons. The seasonal pattern of winter dormancy, spring flush, summer plenty and autumn nut and berry harvests drives the life-cycle of the Japanese macaques, the northernmost of all monkeys, and the other animals that live here.

JEREMY HOGARTH

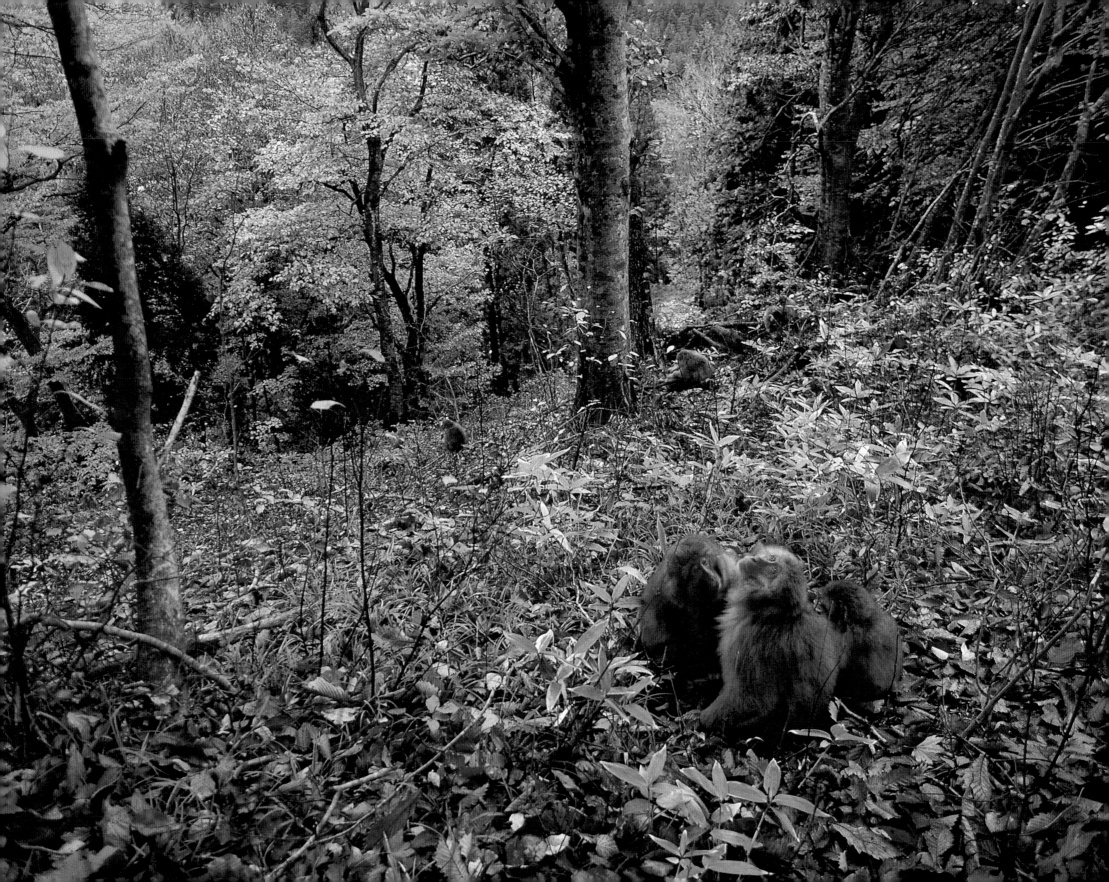

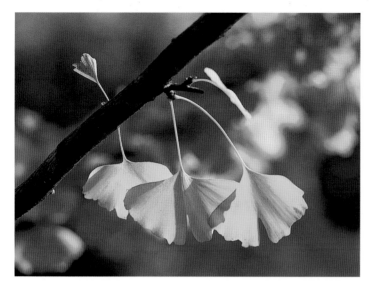

Above: One of the oldest plants on Earth, the gingko – or maidenhair – tree has a distinctive fan-shaped leaf, which changes from a pale lime-green, through deep green at the height of summer, to a bright gold in autumn.

Opposite: Autumn, more than any other season, defines the temperate region. This prolonged period is one of gathering. Plants retrieve nutrients from their leaves, which they then discard, and animals collect and store food, or they lay down fat to survive the coming winter.

rotation. As the North Pole tilts toward the Sun, the hours of daylight lengthen; trees and plants react by budding their spring leaves. Fresh and green, the leaves allow the trees to process the energy they need to grow and survive. Spring, then, is the sound of birdsong and insects; summer a time of green stability and the sound of cicadas. But already the trees are preparing for the colder, darker months as the north of the planet again tilts away from the distant star.

Autumn is a time of colour, and a time of continuous change and beauty as the forests prepare for the winter. Winter is the time to close down, a time of silence, except for the winds. Yet there is still colour in the forests.

Her thick winter coat covered with a mantle of snow, a female Japanese macaque huddles from the wind. Snuggling into her warmth is her baby, it too covered by a thick coat of fur. Around her in the bare trees sit more macaques, in all a group of thirty-nine. They sit in family groups, grandmothers with their daughters, the daughters with their infants. The few adult males are separate. These macaques are the northernmost wild primates on the face of the planet; it is only we humans who live further north than the Shimokita Peninsula.

Macaques have been in Japan for tens of thousands of years, yet they arrived at this northern limit perhaps only 20,000 years ago. It must have been a slow progression as, gradually, over the centuries, small groups moved into vacant territories further to the north. Now the present members of troop A2-85 are as far to the north as macaques can go. They are perhaps the ancestors of distant relatives that lost ancient territorial battles or went searching for a new world.

The macaques of the Shimokita Peninsula have adapted to their world of four distinct moods, and they move through their forest as the forest itself moves through the seasons.

It is easy to watch the macaques through their changing year. It is harder to see the individual struggles and strategies of the temperate forest; how it is the beech tree that is dominant, and how it tries to out-compete its neighbours, the oaks, the maples, the mountain ashes, and the many other species that make up the northern forests, to reach towards the precious sun.

Harder, too, to glimpse what is perhaps the most potent symbol of Asia's temperate forests, the giant panda. Nowhere else in the world does such a large, purely herbivorous bear occur. But with its habitat threatened by clearance of land for agriculture, this endearing black-and-white character is now largely confined to the parks and reserves in China dedicated to its preservation. One of the greatest symbols of the temperate forest's rich and distinctive productivity is today constrained not by the forces of nature but by the activities of people.

When the temperate forests of Japan prepare for winter by shedding their leaves, the Japanese macaques must put on weight for the winter that they know will soon be upon them.

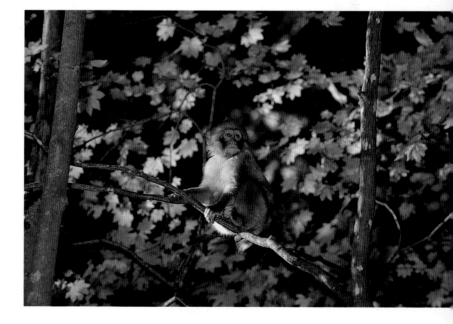

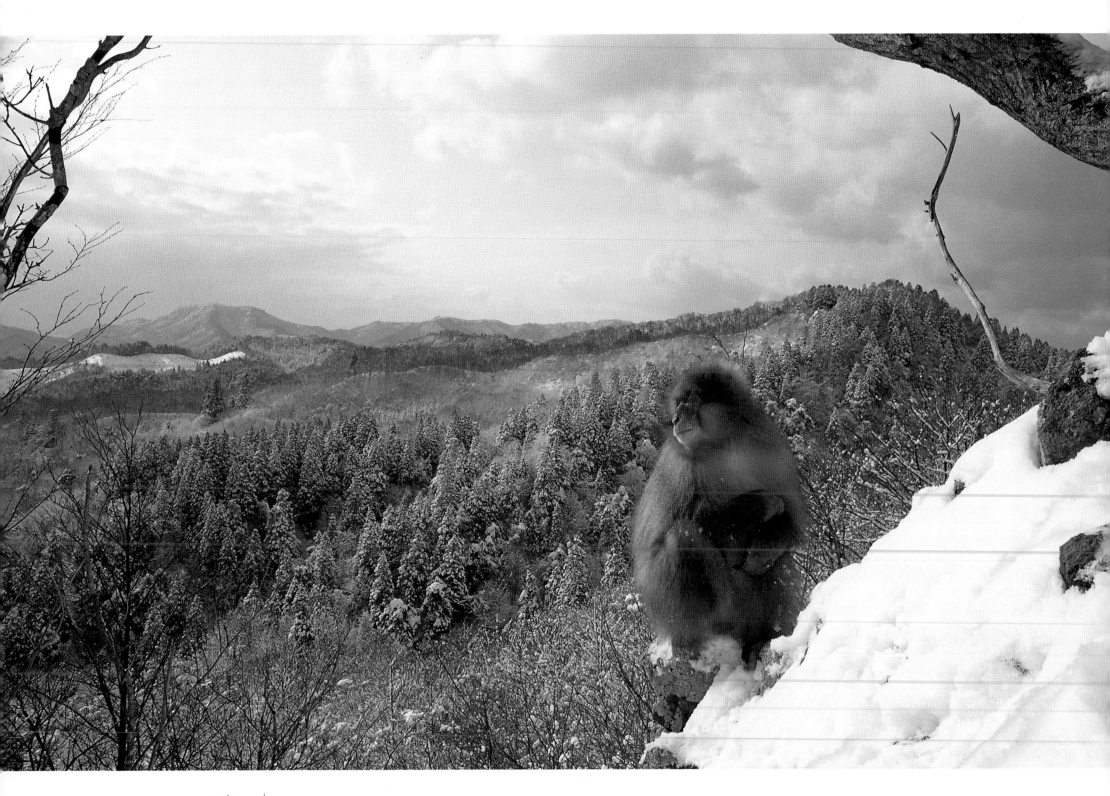

Opposite: At home on the ground and in the trees, Japanese macaques are hardy, long-lived creatures. They live in social groups and maintain a large territory, which they constantly move through in search of food.

Top right: Despite an appearance closer to that of its North American namesake than to a canine, the Japanese raccoon dog does indeed belong to the dog family. An omnivore that usually forages nocturnally, it eats anything from nuts and fruit such as persimmons to mice, birds and other small animals.

Bottom right: During the long winters, the macaques must resort to the lean diet of tree bark. In more plentiful seasons, they eat a wide range of plants, including fruit, seeds and leaves, as well as fungi, birds' eggs and invertebrates.

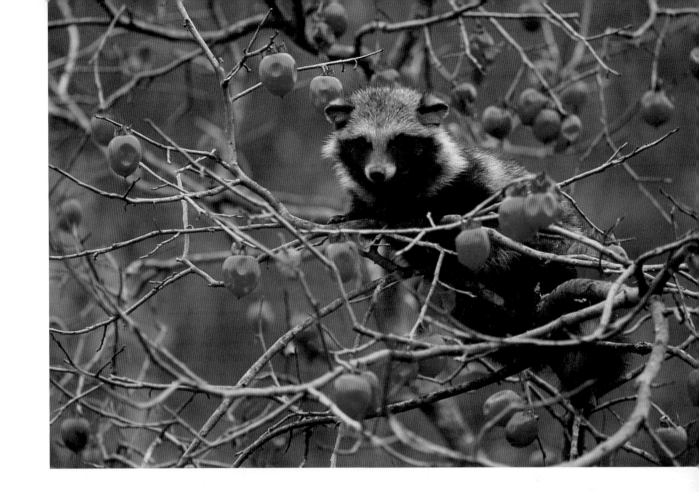

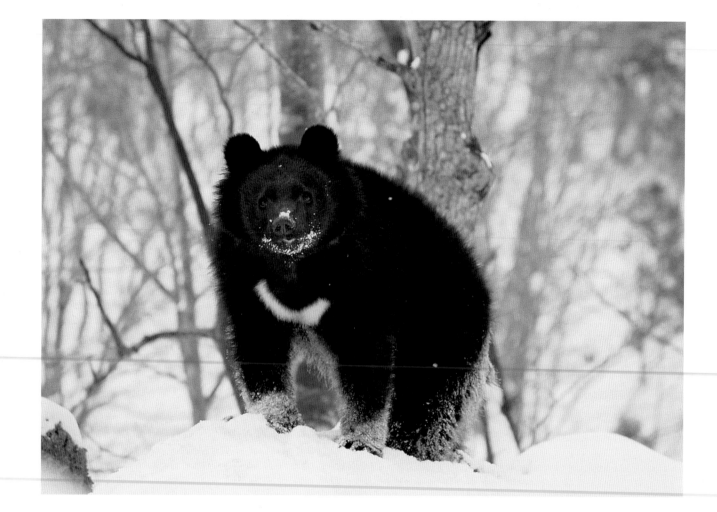

Opposite: Bamboos are found all over Asia, and beyond, and vary from small grass-like dwarf forms – the major ground cover in Asia – to enormous stemmed plants. They all share the unusual characteristic of flowering rarely, and then doing so synchronously across large areas.

Top left: The Asiatic black bear does not sleep deeply in winter. It has a large body and if its body temperature were too low, it would require a huge amount of energy to wake up. So its sleep is shallow, and it can wake at any time if disturbed.

Bottom left: China's Qinling Mountains still support a population of Asia's most distinctive 'bear', the herbivorous giant panda. Rare and endangered, pandas have come to symbolise conservation. They are also a wonderful example of the degree of specialisation found in nature. This huge animal is largely dependent on bamboos and has even evolved a special digit to help it hold their stems.

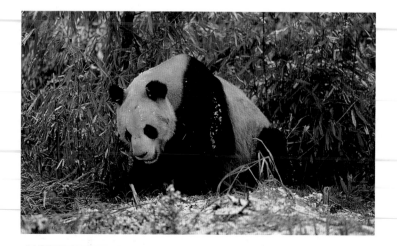

63

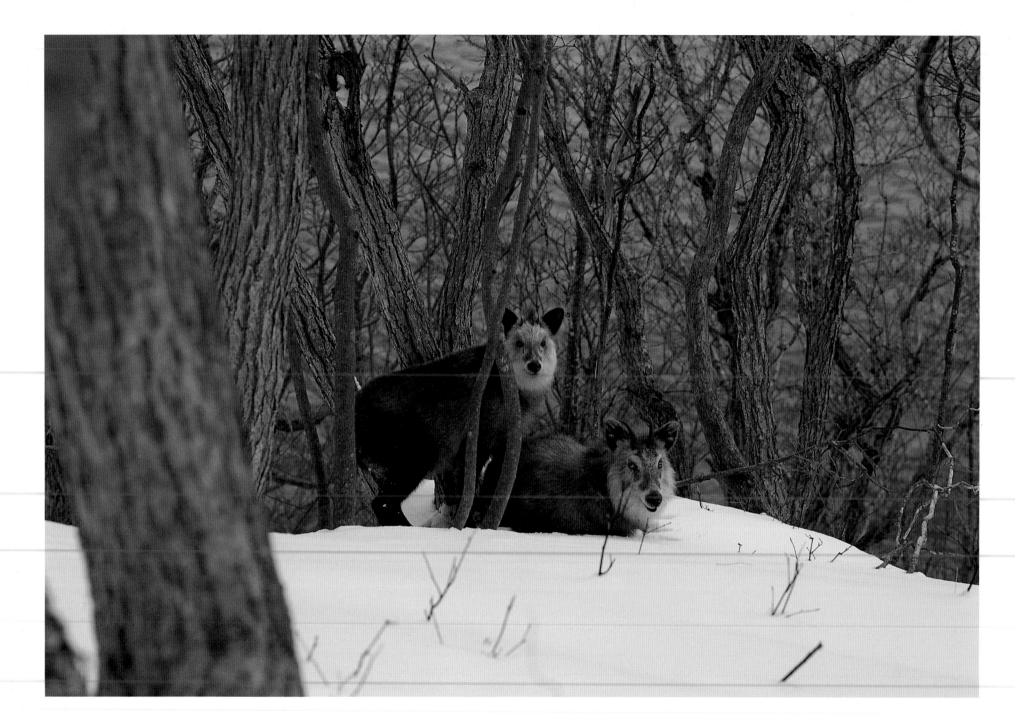

Serows, closely related to the goat family, gorge themselves on shrubs and low plants, which in the summer are lush and green. During winter they push through deep snow to forage on bark and whatever else they can find.

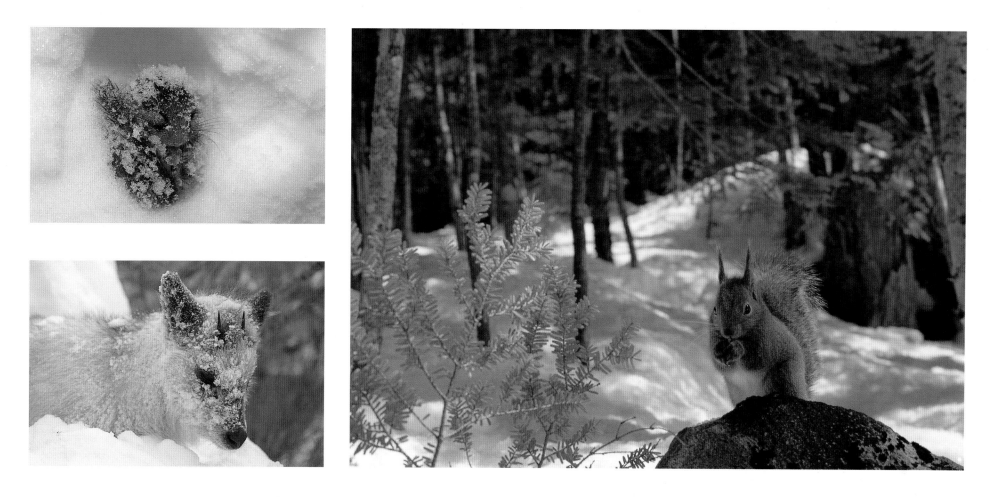

Top left: To hibernate, yamane, the tiny Japanese dormouse, lowers its body temperature to near-zero degrees Celsius (32 degrees Fahrenheit). Its heart beats only fifty times a minute, one-tenth of its active heart beat. Even with this lowered metabolism, it is still expending energy. If it failed to store enough fat in autumn, this is a sleep from which it would never wake.

Above left: A young Japanese serow.

Above right: As the snow begins to melt away, a Japanese squirrel savours a morsel that it buried last year in the autumn. In roaming its woodland territories, the squirrel is a major browser of tree flowers, seeds and berries.

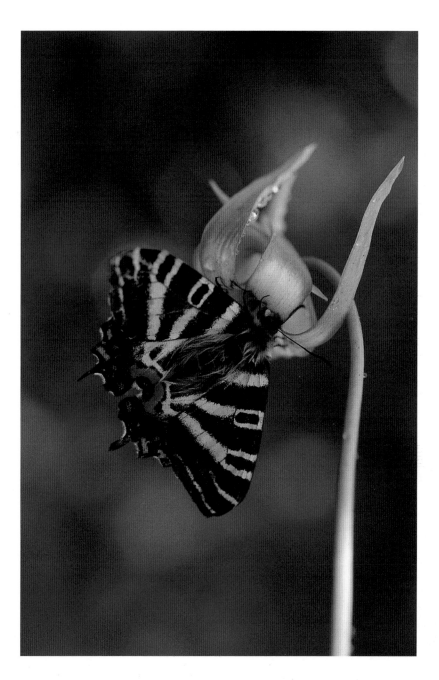

Right: Swallowtail butterflies are important pollinators of flowers in the broad belt of temperate forest that occurs in east Asia. Their long mouth parts, including a pumping tube for nectar, enable them to reach into the deepest of flowers.

Opposite: Known as sakura in Japan, the cherry blossom is revered as a symbol of transient beauty – that blows away in the wind. In springtime, Japanese news broadcasts include daily updates of where the cherries are blossoming.

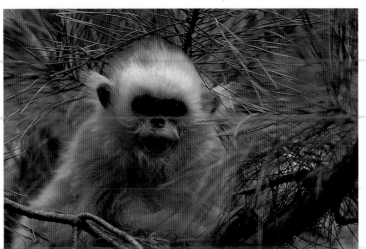

Top right: Originating in temperate Asia, the magnolia is one of the world's most spectacular flowers. Usually cream or pink, some of the blooms on these hardy trees and shrubs are as large as saucers and have powerful fragrances.

Bottom right: The golden snub-nosed monkey inhabits some of the same forests as giant pandas, and is almost equally as endangered. Adapted to life in mixed forests of bamboo, conifer and deciduous trees, it ranges up to 3150 metres (10,000 feet) during summer, descending to survive the harsh winters with prolonged snow and sub-zero temperatures.

Opposite: When living in groups with a refined social hierarchy, grooming one's relatives involves more than just maintaining a fine fur coat, it is an important ritual, a way of maintaining the status quo.

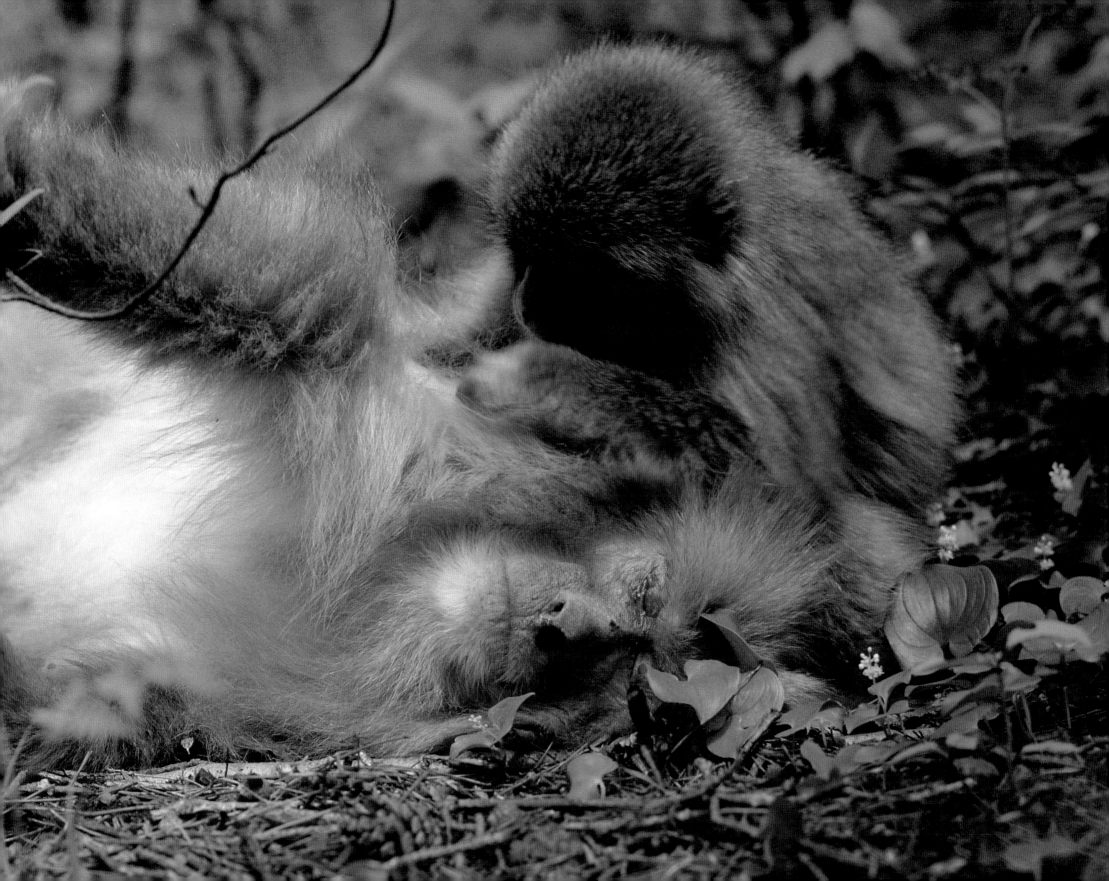

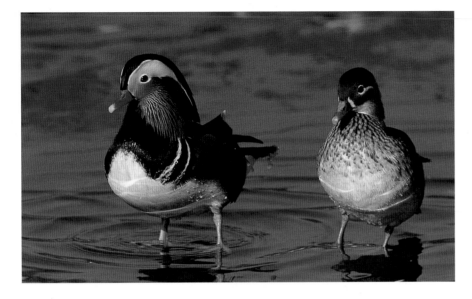

Left: During winter, mandarin ducks gather in flocks, spending months feeding at shady pools and lakes, and eating acorns in the adjacent forests. Then in late winter and early spring, male mandarins engage in aerial display flights to woo a mate. The male is perhaps the gaudiest of all the ducks, with its Chinese-junk-like tail and neck-ruff plumes. Its mate is subtler, more subdued. They nest in holes and typically breed in old deciduous forest alongside rivers in the temperate zone.

Bottom left: Roaming their woodland territories in groups, sika deer are major consumers of plants, seeds and berries. Plants of the temperate forest respond to such pressure by swamping mammals and birds with more food than they can consume.

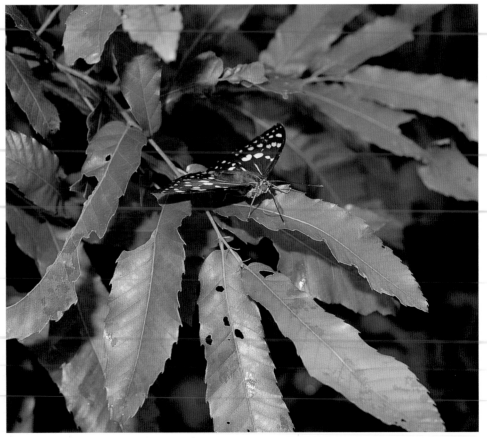

Right: In Japan, the giant purple butterfly is called gifu-cho or 'spring goddess'. Attracted by the sugary sap from a tree, the male is on the look-out for potential mates. He can be quite aggressive to intruders, even chasing out small birds. The female looks quite different from the male, having no purple colouring on her wings.

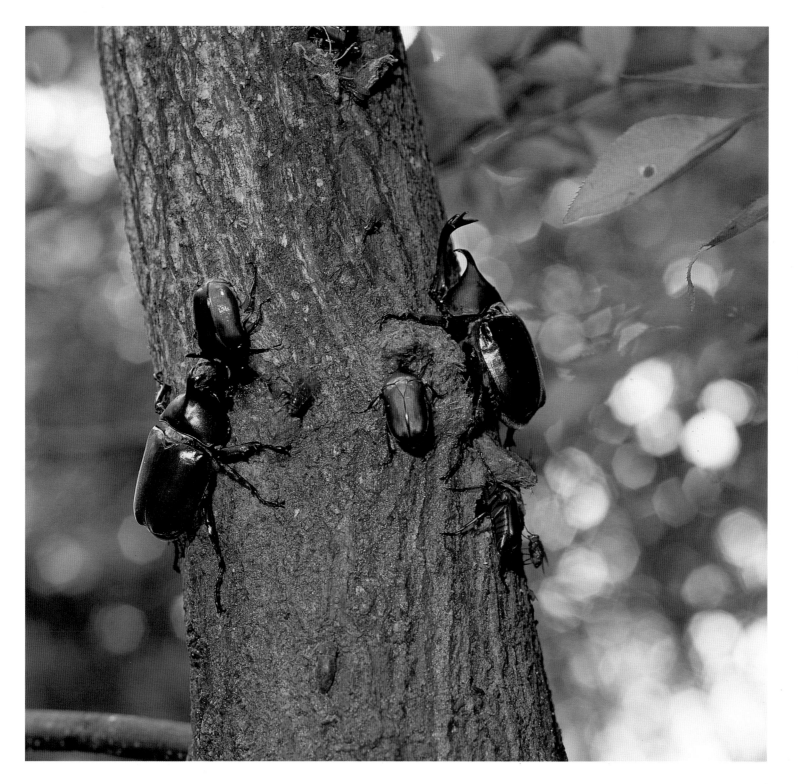

Their heads shaped like the helmets of ancient samurai, beetles crawl up a tree to get its sap. At any moment, a fight may break out among the males, each hoping to attract females.

The Realm of the Red Ape

T he rainforests of tropical Asia extend in patches from the Western Ghats of India to where the edges of Asia blur into Australasia along the myriad islands of the Indonesian archipelago. They are, perhaps, the oldest living things on earth, and their age can be measured in light years.

Rainforests are cradles for evolution. The flora of just Malaysia, Indonesia, the Philippines and New Guinea could comprise as many as 30,000 plant species, but in reality the number is possibly beyond counting. The numbers of insects, birds, reptiles, mammals and other life forms that live within these forests are beyond our imagination.

To be in a lowland rainforest of South-East Asia is to be within a living organism. It is a breathing thing, just as alive as the numberless creatures within it. In these forests there is an interwoven depth of complexity that we do not fully understand, for we are still intruders.

The rainforest seems to live without seasons. The flowering and seeding of the countless species of trees and plants is erratic; there is no rhythm of spring and summer, autumn and winter. And no flowering and fruiting season is ever the same. Sometimes there may be one or two years between flowering, on other occasions almost a decade. Despite this, each member of every species, although widely dispersed throughout the forests, will flower and fruit at the same time, almost as if they were communicating with each other. This synchronised flowering allows each species to pollinate and reproduce. It also swamps the forest's many fruit eaters with a surfeit of food, ensuring the survival of each species of tree, which in turn ensures the survival of the animals that live in the forest.

Asia has the greatest diversity of primates

JEREMY HOGARTH

The close genetic relationship of humans and primates is nowhere more obvious than in the shape and movement of the hands.

Orang-utans live for many decades and, like humans, their childhood is prolonged and vital to their survival. For the first several years of their lives, youngsters remain within touching distance of their mothers, and although sons eventually leave, daughters stay near even after the arrival of a sibling.

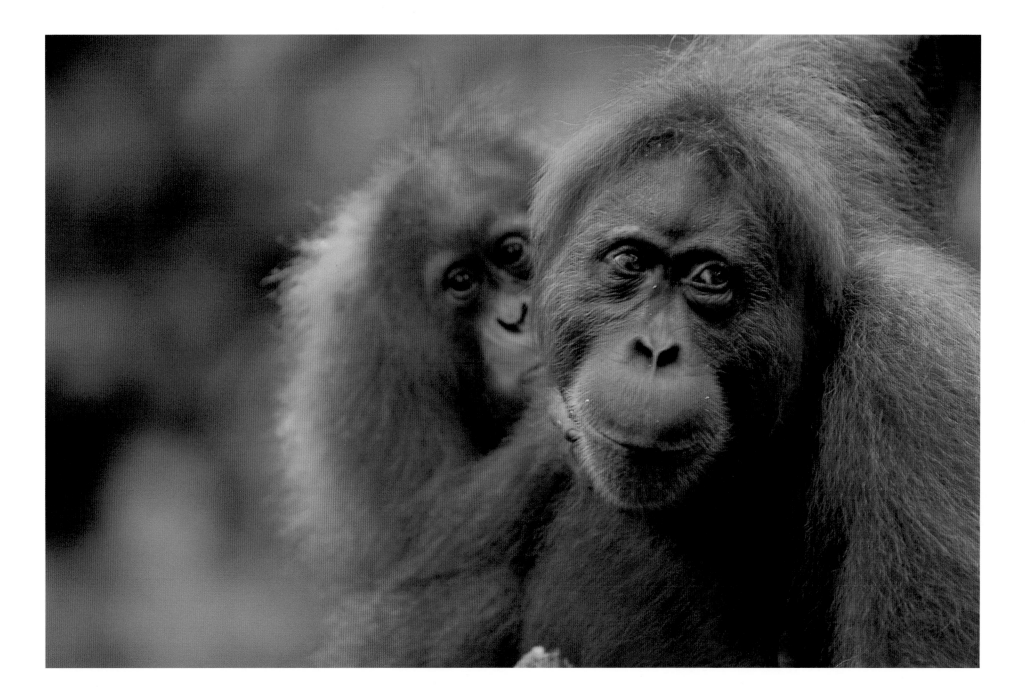

anywhere in the world, and the dawn chorus in the tropical forests of Sumatra is unique. Sometimes before the light of dawn a leaf monkey makes a single call to announce its presence to others of its species. As the light creeps over the canopy, the first to welcome the new day are the white-handed gibbons. Later in the early morning, the siamangs join in, with whooping calls that can be heard for over a kilometre.

Just now and again there is a deeper call from the forest, the solitary call of a male orang-utan. His call is a series of deep and muffled bellows which finally fade in their intensity, lost in the background singing of the insects. Of all the rainforest animals, perhaps none understand the forest like the orang-utans, literally 'the people of the forest'.

We still know very little about the orang-utan, the only great ape to live in the trees. Once widely distributed throughout much of Asia, now there are perhaps fewer than 20,000 remaining on only two islands – Borneo and Sumatra.

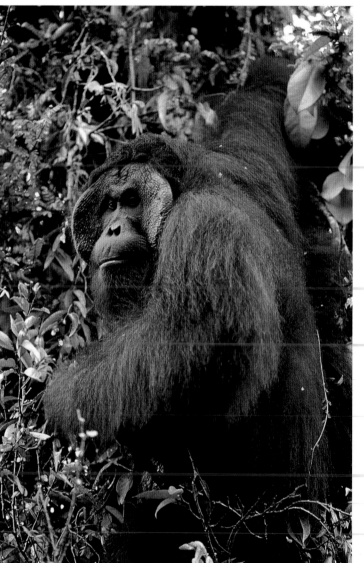

Orang-utans have always been thought to be solitary, but in one patch of lowland forest in the far north of Sumatra we are glimpsing a different way of life. Here, as everywhere, the orang-utans move in and out with the seasonal fruitings of the forest, but in this one patch of forest they tolerate each other. Males are still solitary, but females seem to have preferred companions. In our world we would call them friends.

In this one area of the forest a few of these wild orang-utans have learnt to use tools. Simple tools indeed – just a twig which is broken to length and used to fish out honey from the nests of native bees, and to fish ants and termites from tree hollows. They also use broken and shaped twigs to carefully remove seeds from a forest fruit which protects itself with small and very painful fibres, like shreds of fractured glass. As far as we know, these are the only wild orang-utans which have learnt to use tools. This one group in North Sumatra is perhaps showing us the start of a culture. Or the end of one, for the forest is going.

At night, in the extreme humidity, while malaria-carrying mosquitoes whine in the darkness, another sound breaks through the singing of the insects – the distant sound of a chainsaw. Sometimes, as the crash of another tree falling rolls through the forest, an orang-utan makes his long call. It is a primordial call that proclaims his existence in his universe. But now it is also a lament that yet another particle of the oldest living entity on Earth has gone, for each tree that falls is yet another break in the web of complexity that makes up the Asian rainforest.

Opposite: Asia's largest primates are its two species of orang-utan, found in Borneo and Sumatra. Feeding on the fruits, fresh leaves and shoots of ancient tropical rainforests, they send a steady rain of seeds and detritus to the forest floor, performing an important role in the forest's great life cycle.

Left: The enormous cheek pads distinguish the fully adult male orang-utan. His life is a solitary one in a large territory that will overlap those of several females and their offspring. Though often within sight or sound of each other, males and females normally only consort when mating.

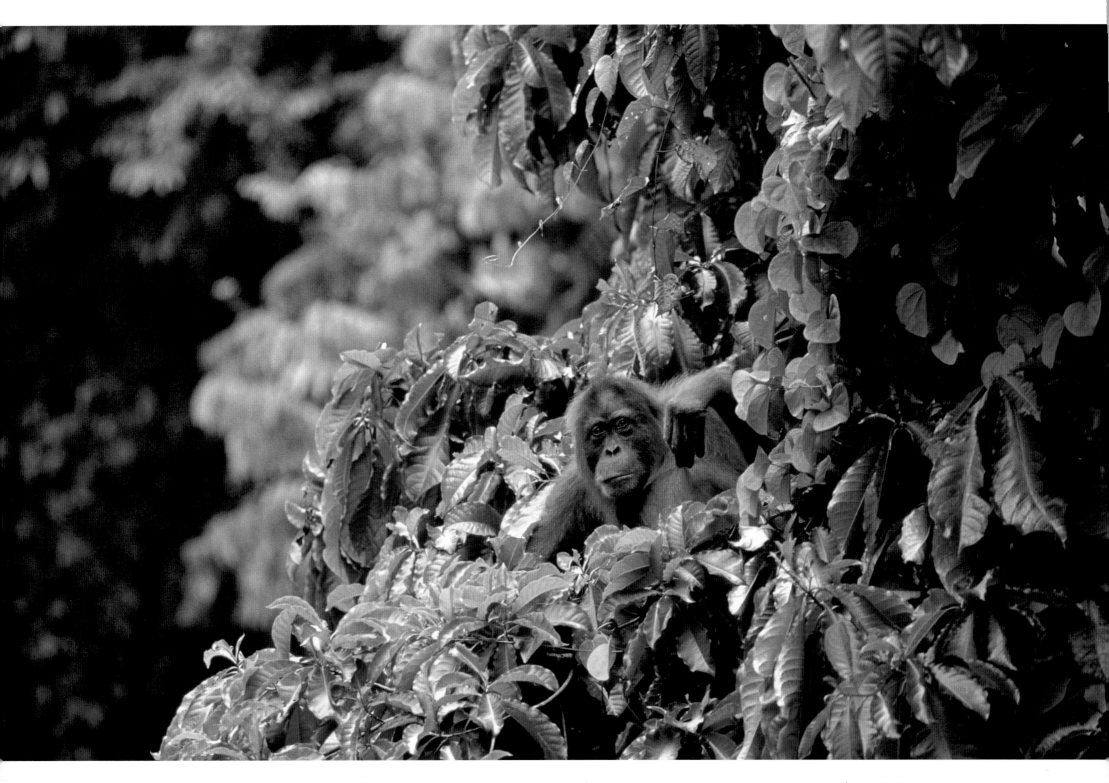

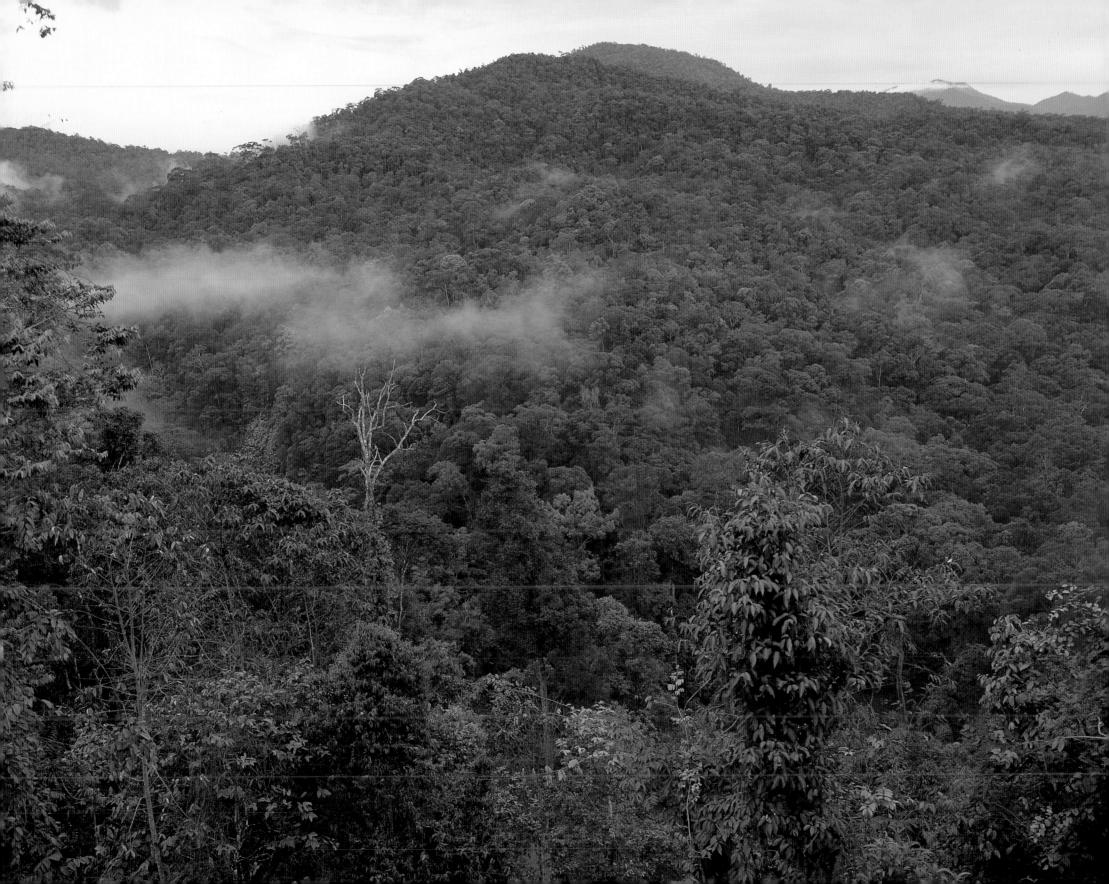

Opposite: Season after season, century on century, the rainforest has been shaping the destiny of the creatures it shelters, as they in turn have shaped their forest. In all its complexity, the rainforest can be seen as a single, living organism. It consumes rain and warmth and exhales oxygen. Its canopy is like the outer skin – it receives the most sunlight, it is the most exposed to wind and rain, and it protects the forest beneath.

Top right: Ranging over enormous tracts of forest, the wreathed hornbill seeks out fruiting trees. Its heavily beating wings are so loud that it can be tracked by sound alone. In spite of its size, the hornbill's beak is relatively light, having a hollow casque.

Bottom right: A member of the starling family, the white-naped myna is also renowned for the sounds it produces. But, unlike the mechanical noises of the hornbill, it varies its calls in uncanny imitations of many of the different bird species it encounters.

Left: Cork-screwing up to the sky, lianas are woody climbers that are rooted in the soil and force their way up from the forest floor through all the zones of the rainforest to the canopy.

Opposite: Adept brachiators – moving arm over arm – siamangs cover great distances at remarkable speed. Canopy-dwellers, they are famously monogamous, and both parents take part in caring for their young.

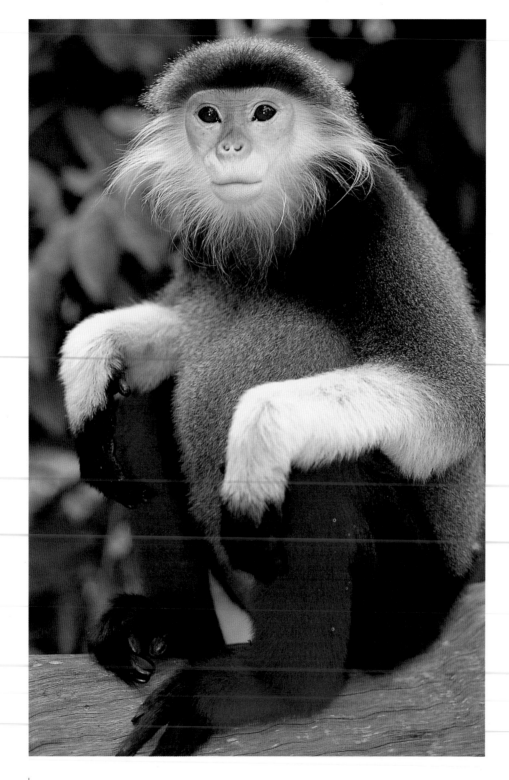

Above: Adding its long hooting notes to the dawn chorus of the South-East Asian tropical forest is the dark-handed, or common, gibbon. Gibbons are canopy specialists – supreme brachiators, they hurtle through the tree tops at breakneck speeds.

Left: Confined to primary and secondary tropical rainforest in a narrow region of Vietnam, Laos and Cambodia, the beautiful and rare red-shanked douc langur is endangered by both hunters and habitat loss. Little is known about these leaf-loving monkeys, including why they are so strangely coloured. Endangered, partly because their unusual colouring makes them so attractive to poachers, few douc langurs survive captivity.

Opposite: Primarily a herbivore, the silvery Javan gibbon chooses its salads from over 120 varieties of plants, devouring fruit, leaves, flowers and buds. For extra variety it adds some insects as well as honey. Unlike many other rainforest primates, this gibbon does not duet with its mate, but restricts its calls to mating, alarms and threats.

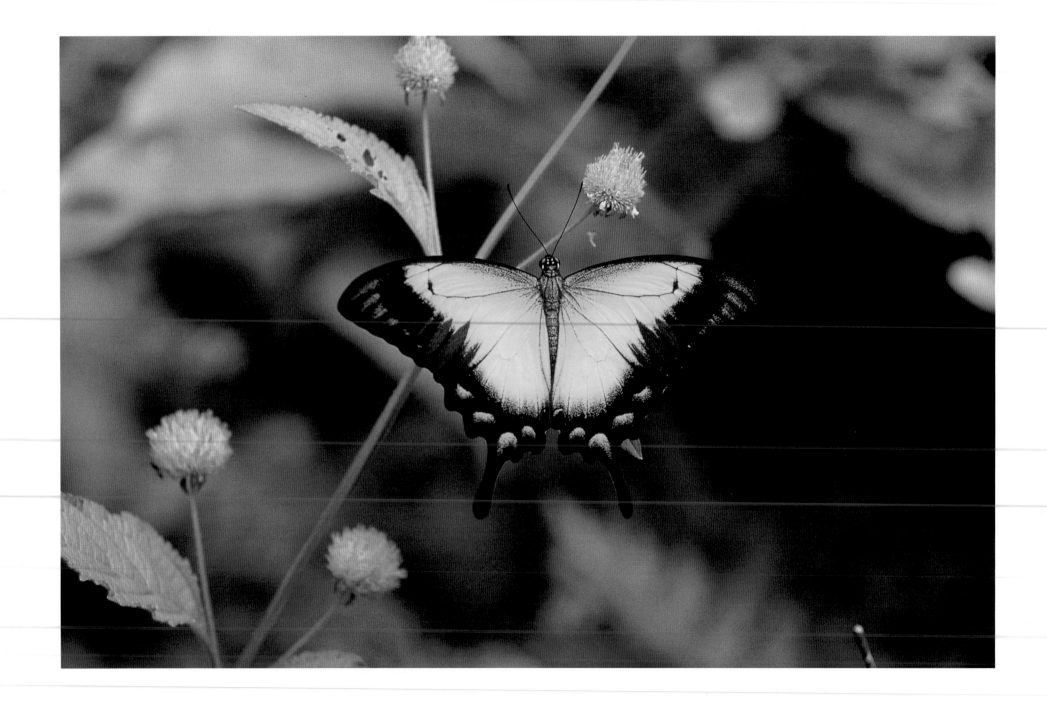

Opposite: Tropical habitats in Asia are especially rich in butterfly species, many of which are endemic to small areas. Of the thirty-eight species of swallowtail known from Sulawesi, for example, eleven of them are found nowhere else.

Top right: The degree of specialisation in tropical forests is phenomenal. Among the largest butterflies are the Rajah Brooke's birdwings. Some of the birdwing species have wing-spans of up to thirty-three centimetres (thirteen inches), and most of them are confined just to the tropical forest canopy.

Bottom right: Predatory plants are rare, except in South-East Asia's tropical rainforests. These clustered, liquid-filled pitcher plants lure flying insects to their deaths with their scent. Likewise, their slippery in-curling rims make it difficult for any forest-floor invertebrate crossing the area to avoid being consumed – once footing is lost, insects are unable to climb out and are digested by the fluid inside these highly specialised plants.

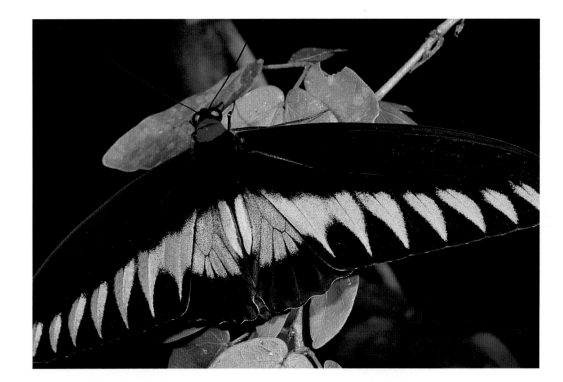

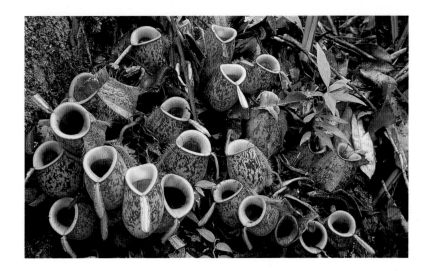

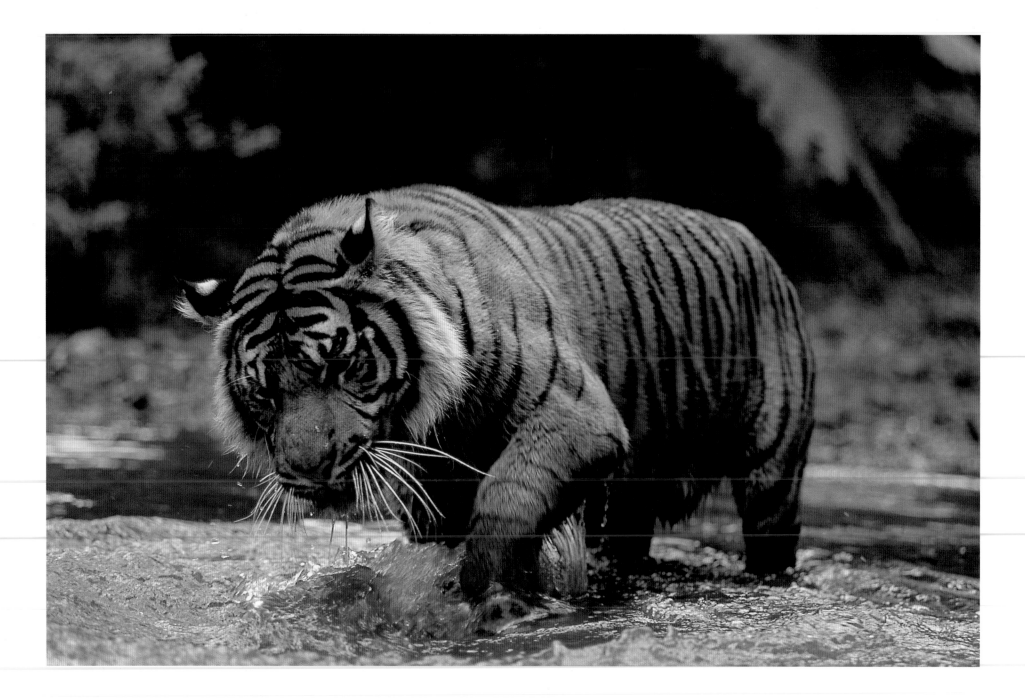

The smallest of the tigers, the Sumatran tiger is almost extinct: only about four to five hundred are known to exist, and these are mainly in the national parks of Sumatra. It inhabits lowland rainforest and preys on rusa deer, muntjac and wild pig.

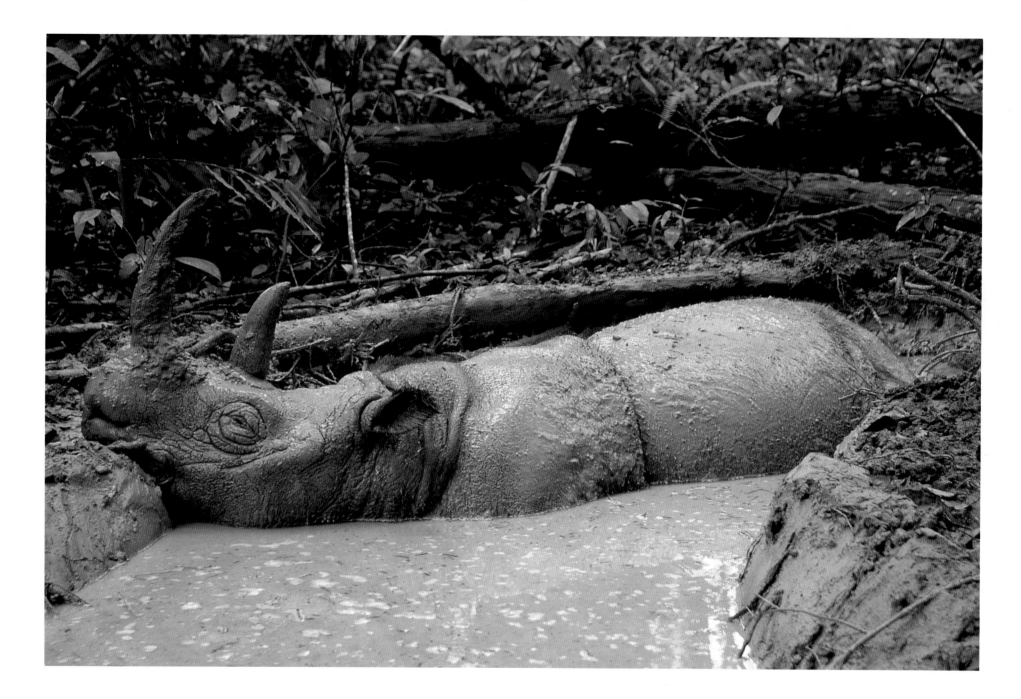

The two-horned Sumatran rhinoceros is the only rhino with hair – and it is long
and shaggy reddish-brown hair. Another oddity is its fringed ears. Despite several
decades of conservation effort, the rhino population is continuing to decline.

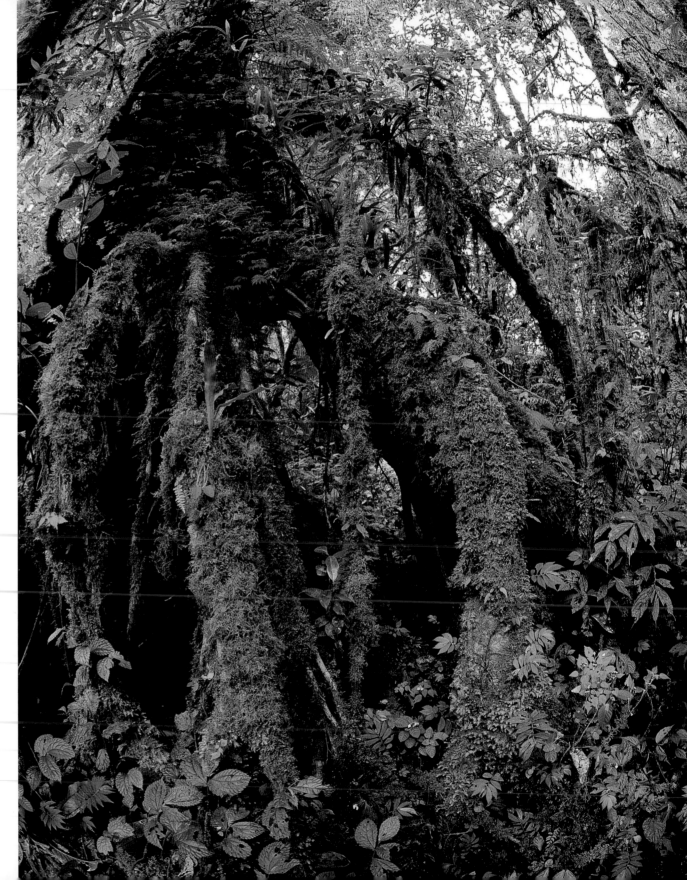

In Borneo, just one hectare (two and a half acres) of lowland forest may have as many as 240 species of trees; the neighbouring hectare may add half as many again. Tropical rainforests contain the greatest three-dimensional biodiversity on Earth, but they are not just wildlife habitat. They are key players in the cycling of oxygen and carbon dioxide in the atmosphere and are crucial sponges, regulating the movement and supply of water all year round.

The most singular species of the rainforest, and one of the rarest flowers in the world, the rafflesia has no leaves or stem and draws its sustenance from the vine on which it lives. The rafflesia takes four or five years to flower and is pollinated mainly by flies, which it attracts by producing a scent resembling the stench of rotting meat.

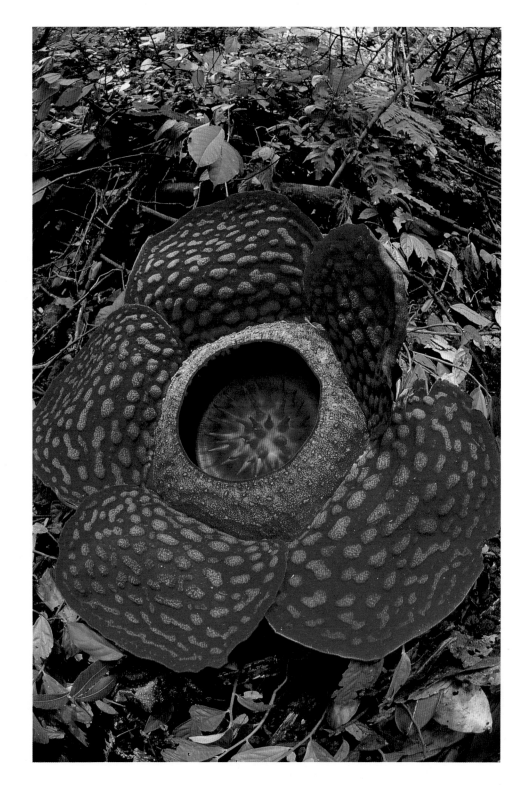

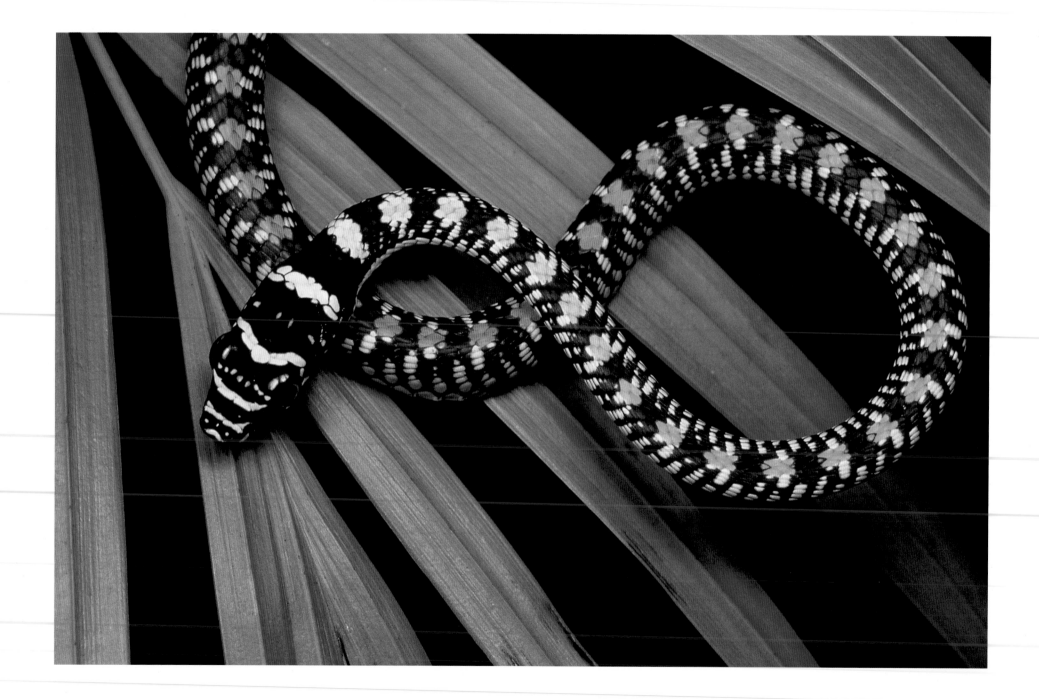

Above: Tropical forest plants are under attack from all quarters, from leaf-eating monkeys, squirrels, rodents and insects. However, the rain of droppings from arboreal caterpillars and other leaf predators merely speeds the recycling of forest leaf into forest soil.

Top right: The blood pythons, though reaching nearly two metres (six and a half feet) in length, are most notable for their great girth. These forest snakes are constrictors, relying on their strength to crush and suffocate their prey.

Bottom right: Biodiversity in Asia's tropical forests is astounding. In the complex three-dimensional world of these humid forests, tree-trunk lizards belong to one of a great many ecological niches.

Opposite: So rich are Asia's rainforests that their species are still poorly catalogued. New species such as this flying paradise tree snake are still being found in hotspots of biodiversity such as Vietnam.

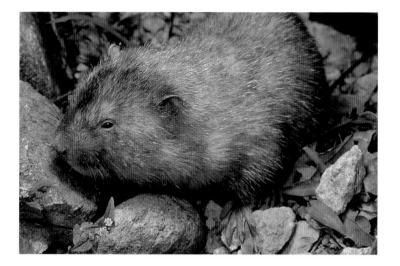

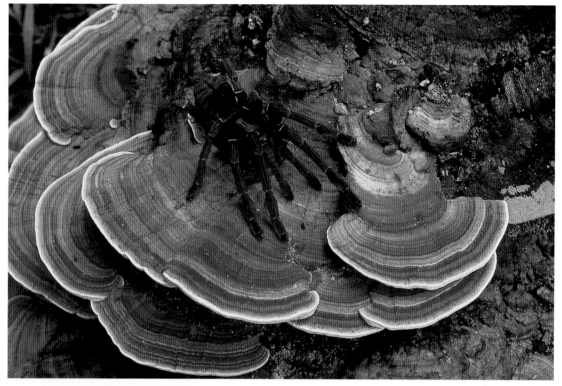

Above: A distinct family of rodents, the bamboo rats are adapted to a subterranean life-style. Almost neck-less and with small eyes, they are more like a giant mole, living in burrows they dig with their teeth and claws.

Top right: Predators in the rainforest range from the mighty tiger to the lowly spider, though this large tarantula is perhaps not so lowly. Preying on large insects and small mammals it is a stealth hunter, chasing down or jumping on its prey.

Bottom right: In a web of life that has had millions of years to evolve in isolation there are bizarre coincidences and supremely refined similarities: caterpillars that resemble twigs, spiders that mimic flowers – camouflage hides both the hunted and the hunter. The leaf-mimicking colouring of this frog presumably gives it a selective advantage.

Opposite: In the breadth of diversity found in the tropical region, it seems that almost any pattern or colour combination that one can imagine has already evolved. This oddly patterned creature is known as the man-faced beetle.

Monsoon, God of Life

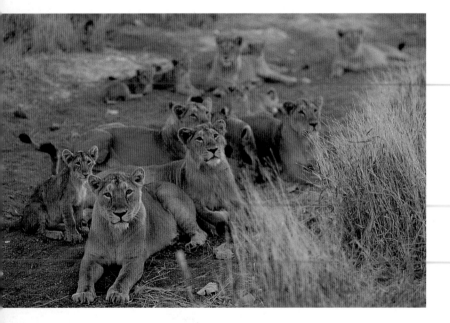

Seasonal forests, merging into savannah, are tinder dry for much of the year. Until recent times, the top predator in this Asian savannah habitat was the lion. Now it is reduced to a tiny remnant population in the Gir forest of Gujarat in southern India. Asia's lions have thicker coats and more pronounced tail tufts than their African cousins. Living in a limited habitat surrounded by cattle-grazing lands, they regularly take domestic stock, which is easier to hunt than wild game.

It is May and summer is at its peak in India. For weeks the temperature has been rising. The heat is now stifling. High in the sky vultures circle on the thermals, their sharp eyes searching the ground below for signs of the dead or dying. Their view is of a parched land. Great rivers have been reduced to trickles and ponds turned into slimy mud puddles. Forests are leafless and the sun beats down through bare branches. Tinder dry leaves carpet the ground, waiting to catch the first spark. The land yearns for rain, but the only clouds in the sky are the haze of smoke from distant forest fires. It is the most testing time of the year for the creatures of the land. The old and the weak often do not survive.

The crippling heat must be endured for, paradoxically, it will usher in a season of rain that will rejuvenate the land. As the landmass heats up, hot air rises in great turbulent shafts, drawing in cool winds from over the ocean. As they sweep in towards the land the winds absorb enormous quantities of moisture from the sea's surface. Ominous thunderheads mass like a dark army at the western tip of southern India, blotting out the sun. The temperature drops dramatically and forked lightning electrifies the sky. And

Monsoon clouds near the Indian coast promise an end to eight months of dryness. Although it may be many days yet before the storm actually breaks, the pending rains somehow exert their influence on plants and animals, which begin preparations for the breeding season.

S H E K A R D A T T A T R I

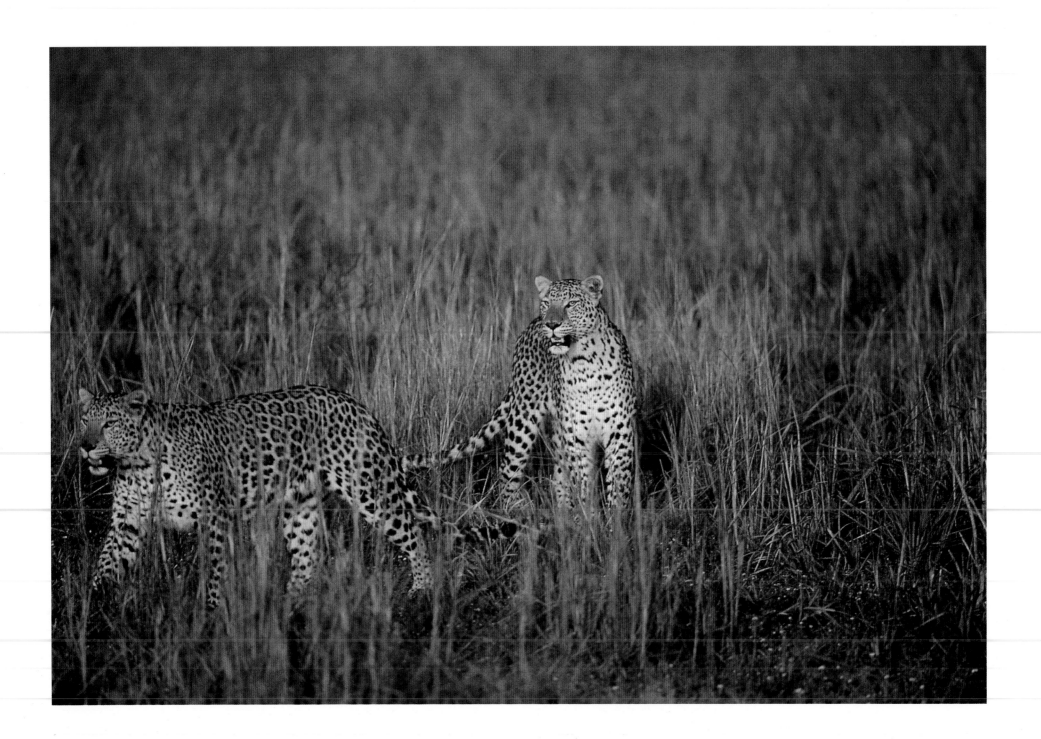

then, at long last, the first swollen drops of rain hit the dust. The drops become a deluge and, within minutes, the land and every creature living on it is drenched. The monsoon has arrived.

The monsoon is an annual phenomenon, but one that can never be taken for granted. It can arrive with surprising punctuality for several years in a row and fail one year without warning. Even when it arrives on time, it can leave vast areas untouched and still gripped by drought, while overwhelming others with its abundance, unleashing floods that cause death and destruction. No one can say how it will behave from year to year. It is a mysterious and capricious god.

The summer monsoon arrives in India as two arms. A western arm comes in from the Arabian Sea and makes its first landfall at the tip of southern India around the first week of June. The waves of clouds are prevented from reaching the interior by a chain of mountains called the Western Ghats that stretch along the coast of India. Instead, channelled by the mountains, the monsoon travels slowly north while continuing to douse southern India.

An eastern arm of the monsoon rushes in from the Bay of Bengal a week later and drenches north-east India before radiating west towards central and north India. Eventually, both flanks of the monsoon will come up against the towering barrier of the mighty Himalayas. Here they can go no further.

For all wildlife in India the monsoon is of great significance, for in its timely arrival lies their salvation. As the first sharp drops pelt down, elephants trumpet in excitement. Travancore tortoises emerge from under the leaf litter and brightly coloured giant centipedes patrol the forest floor in search of food. Up in the canopy lion-tailed macaques enjoy the special fruits of the monsoon. It is a season of plenty.

While the monsoon rains lash south-west India, the north continues to reel under a heat wave. The temperature soars every day, reaching a blistering 49 degrees Celsius (120 degrees Fahrenheit). Dust devils swirl in the air and heat haze creates mirages. In the forest, the furnace-like heat drives animals to the shrinking water holes. Rhesus macaques dive headlong into the water and tigers soak themselves in forest pools, loath to move until dusk.

When the monsoon finally arrives in north India in early July, the effect is dramatic. Almost overnight parched brown turns to verdant green. Dry streams begin to flow again and marshes fill to brimming. Fish populations explode and thousands of water birds arrive at the marshes to breed. Thanks to the bounty of the monsoon a new crop of nestlings will be raised.

Towards the end of September the monsoon begins to retreat, but sometimes its last burst can be its most vigorous. Swollen rivers rise further and breach their banks. In India's north-east, the rising waters of the mighty Brahmaputra engulf the grasslands of the Kaziranga floodplain. Thousands of animals flee the rising waters and seek safety in the hills. Although many others die during these deluges, the floods are essential for the well-being of the grasslands, for the silt they carry will further enrich the soil, ensuring that Kaziranga remains fertile enough to support its myriad creatures.

By the time the monsoon finally abates, winter is setting in. Now, hundreds of thousands of ducks, geese and other waterfowl arrive from as far away as Siberia, Mongolia, China and Europe. Year after year, these birds escape the approaching icy winters in their homelands to feast on the legacy of the Indian monsoon.

Then, as winter turns to spring and the temperature begins to rise, the travellers leave. The lushness of the monsoon begins to fade and, as spring gives way to summer, the land starts to dry. Forests wilt. And as the last puddles of water evaporate, the very life is sucked from the ground. Once again the long wait begins for the monsoon, India's god of life.

The leopard is light and lithe and, with its long legs, it is the best tree climber of all the big cats. Preying on all manner of smaller mammals and living in a variety of different habitats, the Asian leopard is an extremely adaptable animal.

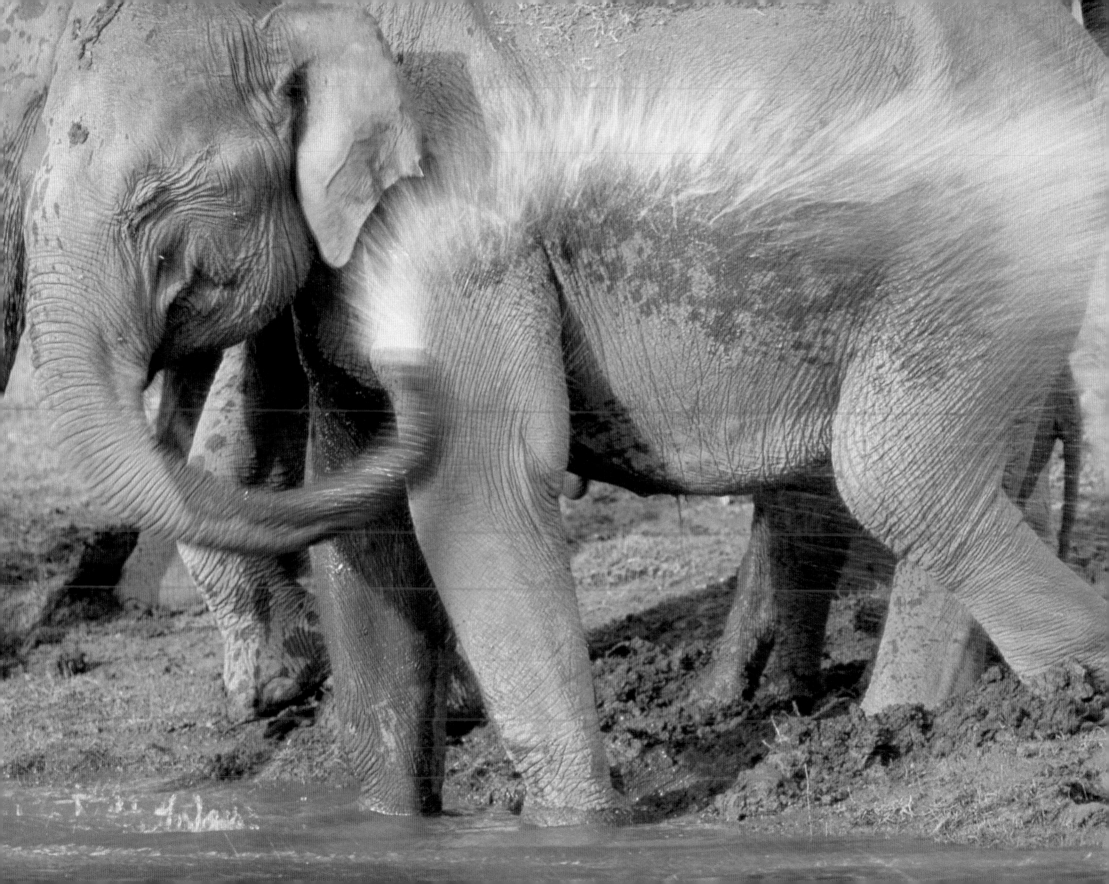

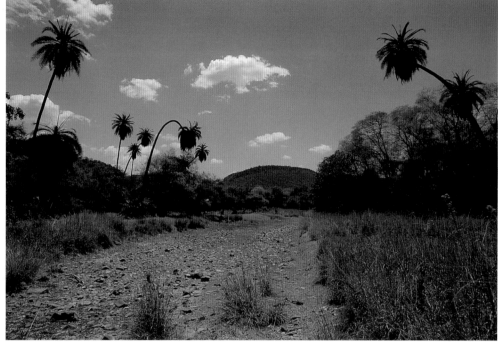

Above, and opposite: By the end of the dry season, grazing and browsing animals must spend longer and longer in search of food. For elephants, which require an average of 180 kilograms (400 pounds) of food each day, this is the most difficult time of the year. But once the spell of the dry season is broken, the elephant herds are able to relish the plentiful water supply – they seem to love bathing as much as drinking.

Right (top and bottom): The annual dry season leaves the Ranthambore river-bed baked hard. The parched land is slow to absorb the deluge carried on the monsoon. Only gradually does it seep in to the soil as rivers swell, once-dry pools reappear and every hollow fills with water. Plants must catch and hold as much as they can now, so that they can survive another long dry interlude.

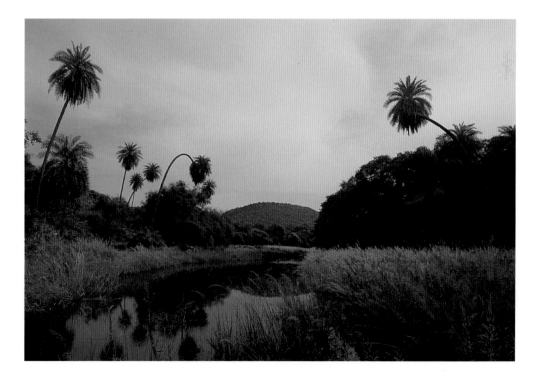

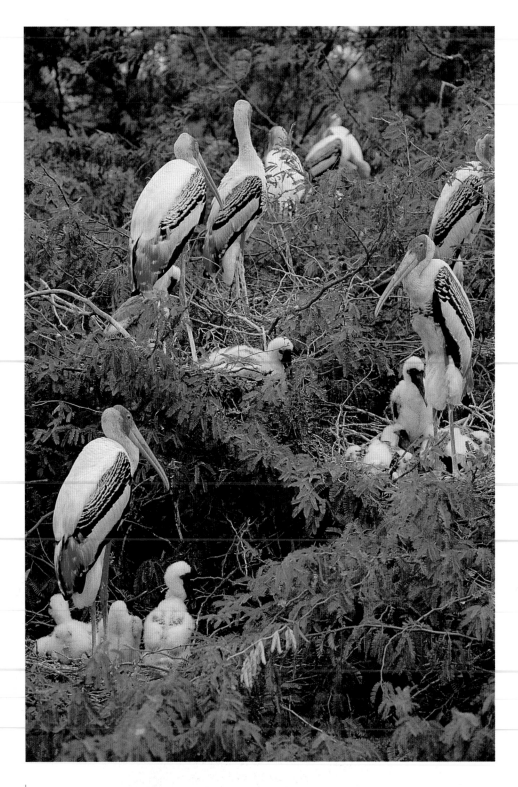

Left: The most spectacular annual monsoon visitors to Bharatpur in north-west India are painted storks. Males and females both sport beautiful breeding colours, and constant preening keeps them looking their best. During a good monsoon, almost every nest will have two or three chicks, protected from the sun by their parents' wings.

Opposite: Later in the season, the marshes of northern India overflow with the arrival of tens of thousands of egret, cormorant and other waterfowl from Siberia, Mongolia and China. The birds are escaping the approaching icy winter in their homelands, and year after year come to feast on the gifts of the Indian monsoon. After the winter, when temperatures begin to rise, the birds fly away.

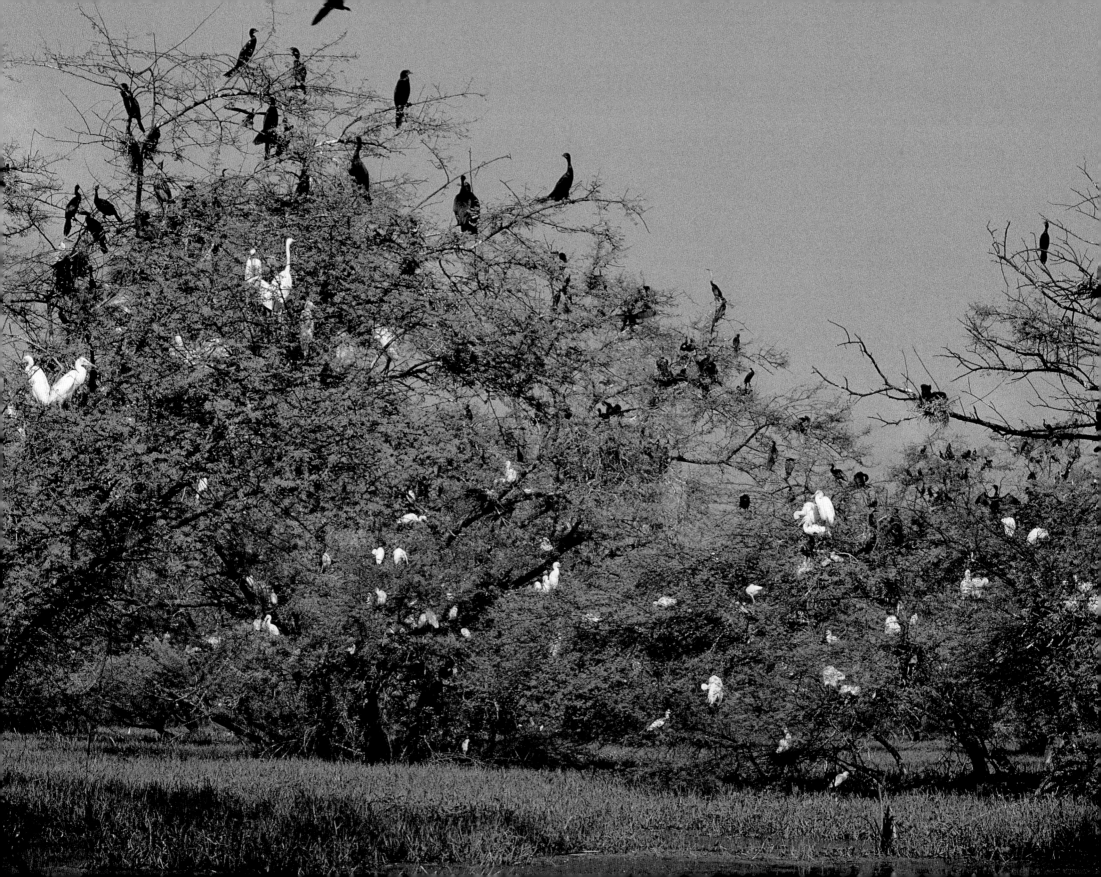

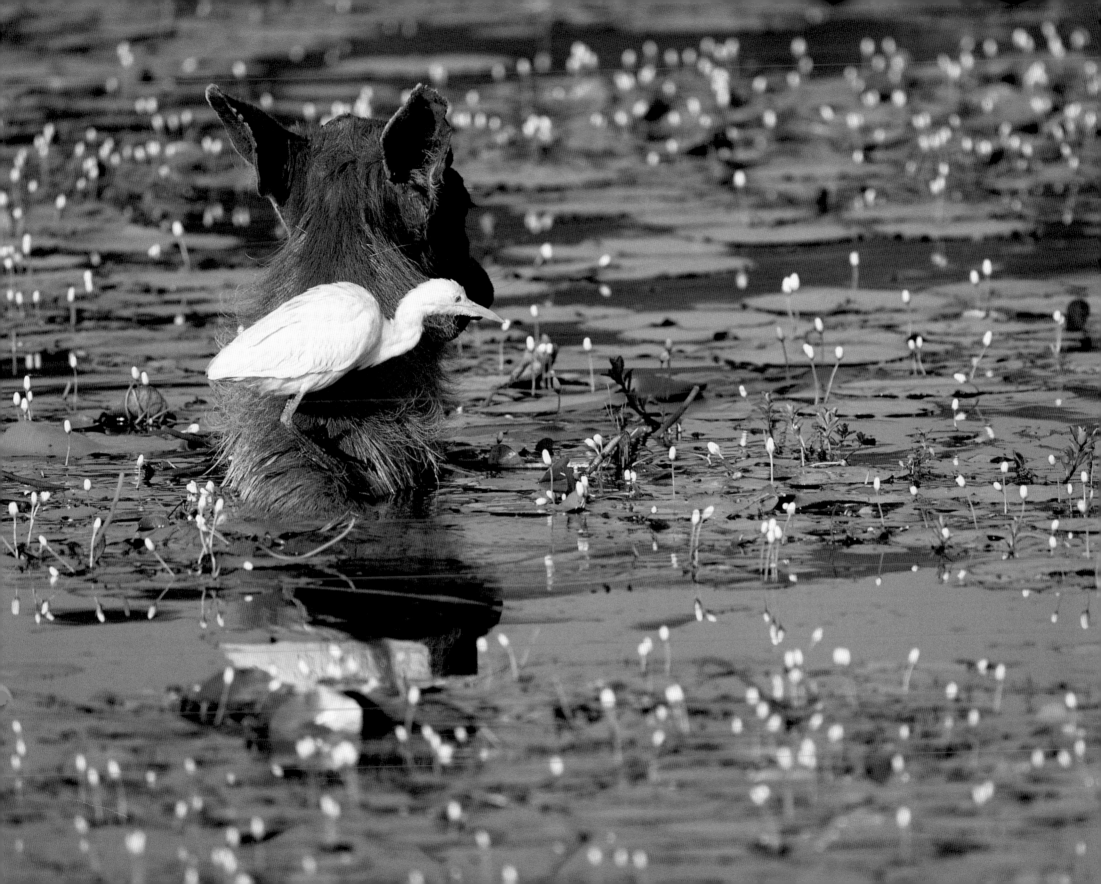

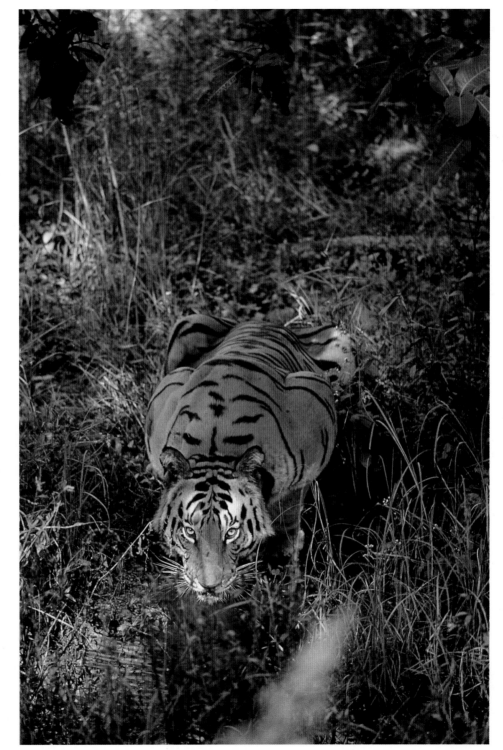

Right: The Bengal tiger is one of the world's great predators. An ambush hunter, it relies on stealth and surprise to make a kill – one wrong move and a potential feast could vanish. Despite its ferocity, its habitat and population are under threat: the tiger can only survive in a territory that is safe from poachers and has plentiful prey of deer and wild boar.

Opposite: As the marsh-loving sambar feeds on water weed revived by the seasonal rains, it provides the ideal perch from which a cattle egret can hunt. The egrets snatch fish, frogs and aquatic insects that have been disturbed by the movements of the deer.

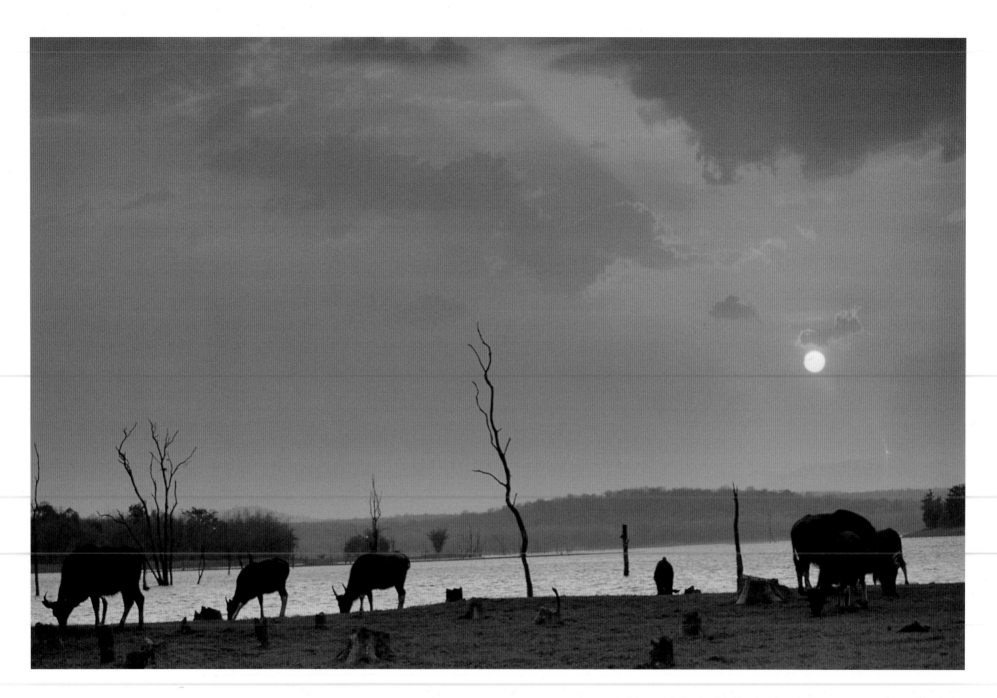

Retiring residents of upland tropical forests, the gaur emerge in small herds to graze on grasses during the morning and then in the cool of the late afternoon. They require huge ranges and, where their habitat has been disturbed, they have adapted to nocturnal feeding.

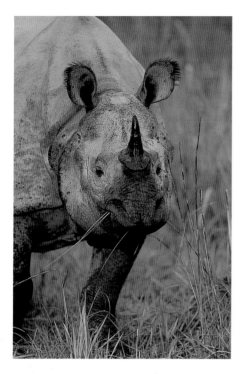

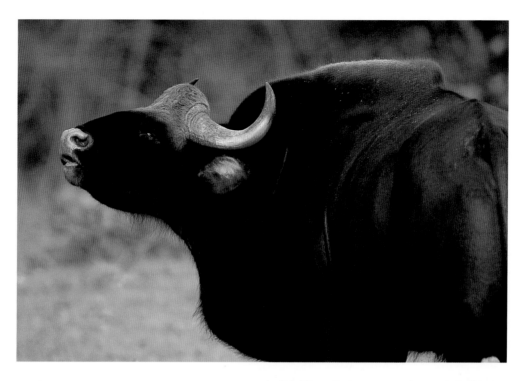

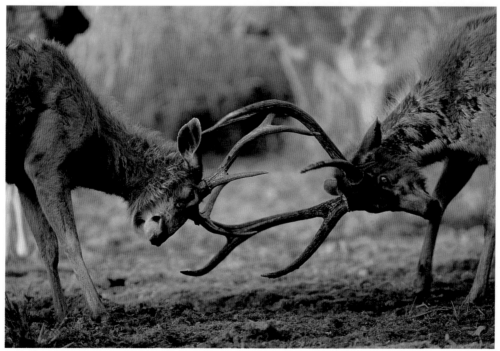

Above: The terai is the stronghold of the short-sighted and nervously aggressive Indian one-horned rhinoceros. It is a unique habitat of elephant grass-land, woodland and marsh on the fertile southern flanks of the Himalayas.

Top right: The return of the rains in June encourages a flush of grassland growth. On the fresh vegetation the immense wild cattle, the gaur, are able to sustain their enormous bulk. They travel great distances to find a good supply of water to drink – unlike other big mammals, they do not seem to enjoy bathing.

Bottom right: The hard clattering sounds of sambar stags indicate that the annual rut is underway. Injuries are surprisingly few, considering the weaponry involved in these ritualised battles, as the deer vie for mating rights. The winner's prize is the opportunity to pass his genes on to another generation.

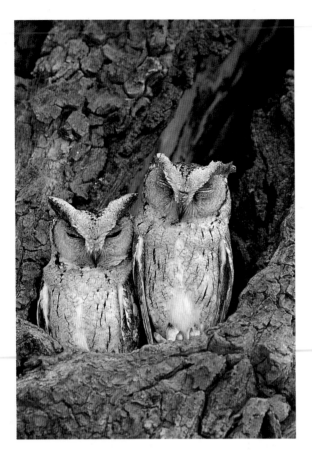

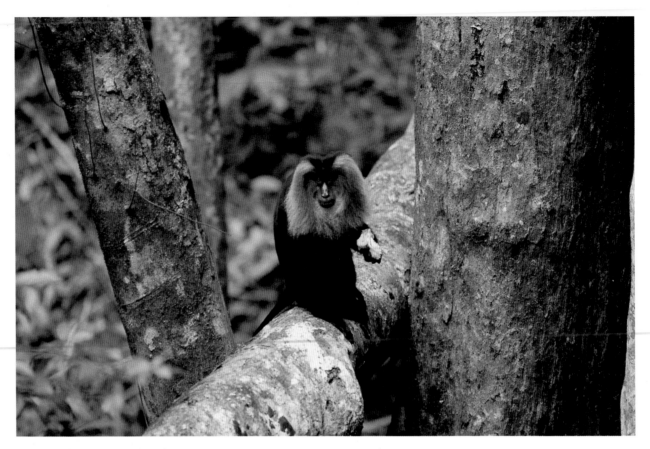

Above left: The diminutive Indian scops owl hunts for the large insects and small reptiles it favours during the cool of night. By day it roosts in a tree cavity, or tree fork, occasionally emerging into the warming sunlight.

Above right: A great grey mane, glossy black coat, long tail with tufted tip and short limbs immediately distinguish the lion-tailed macaque. This shy, reclusive – and highly endangered – monkey of India's Western Ghats is a herbivore, gleaning seasonal fruit from the tropical forest.

Opposite: There is an old belief in India that when the peacock begins to dance, the rain must be on its way. But the peacock often dances in vain and temperatures soar ever higher. Once there is a smell of rain in the air, the elaborate courtship display becomes more urgent.

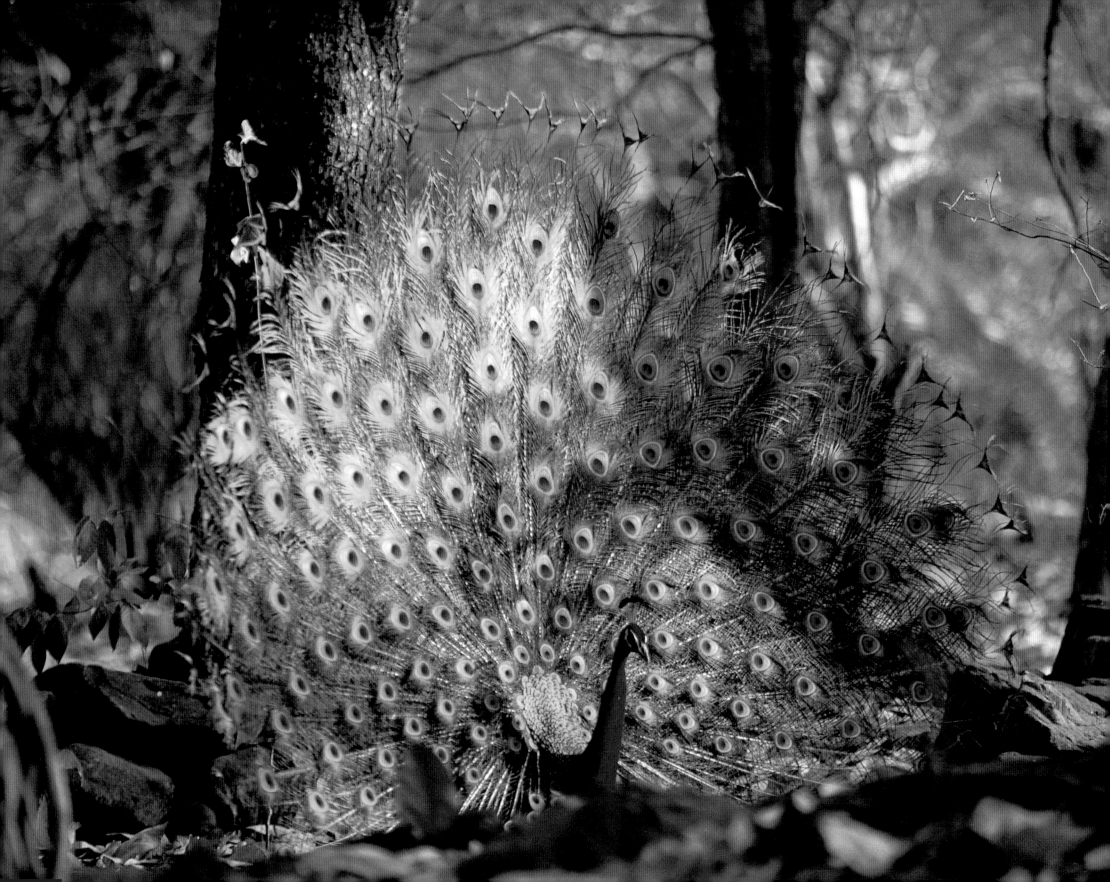

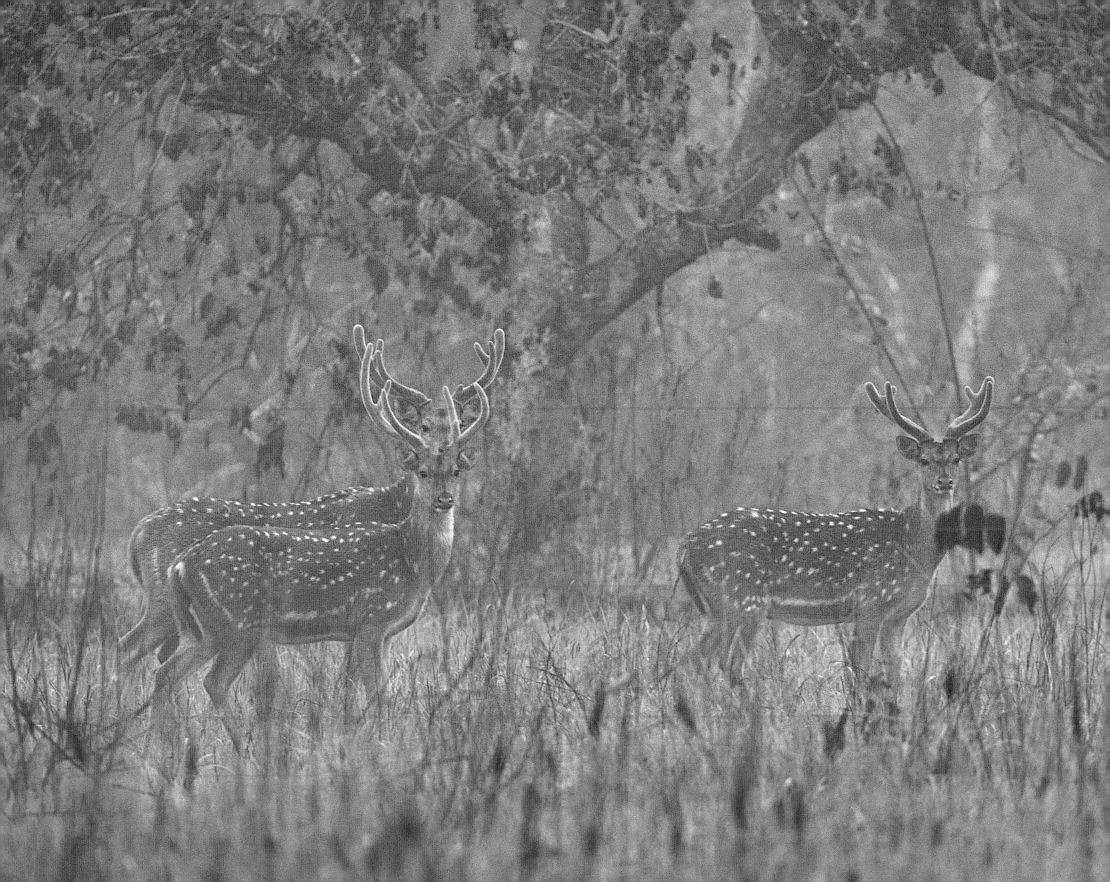

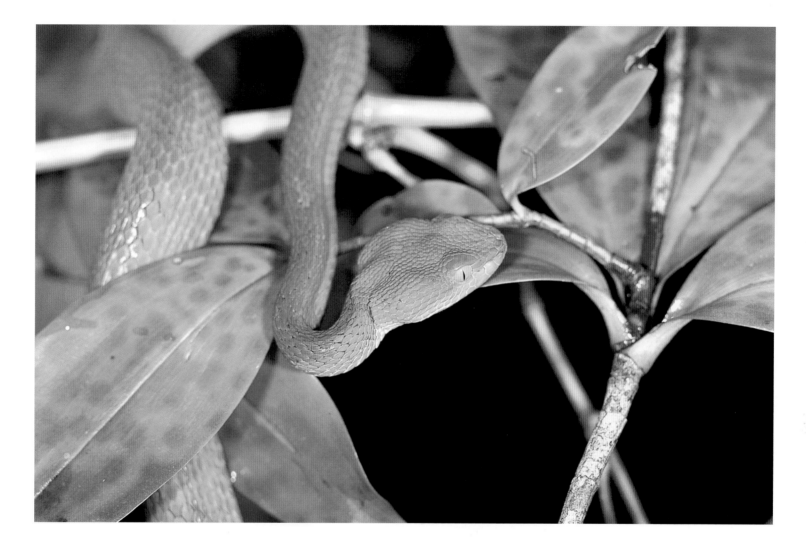

Above: Time is meaningless for a Pope's pit viper lying in wait among the foliage for passing prey. Brilliantly camouflaged, this tree-dwelling viper has only to flick its tongue at a victim to release a 'hit' of the venom that is stored in pits on each side of its face.

Opposite: Its white-spotted coat providing superb camouflage, the chital is the sentinel of India's monsoon forests. Its barking call and foot-stamping alarm send urgent signals to others in the herd, and to other species, that a predator, perhaps a tiger, is out on the hunt.

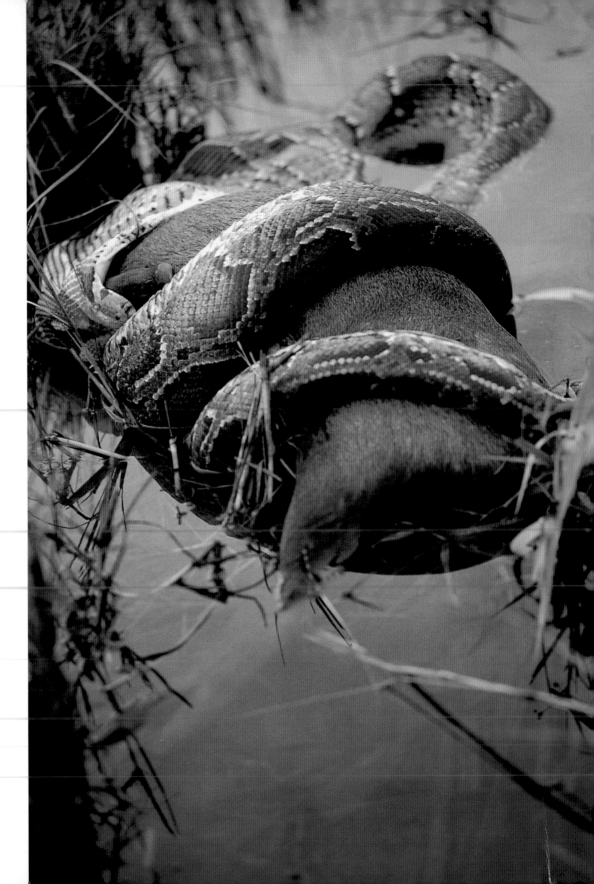

Right: A young python is almost sixty centimetres (two feet) long when it hatches, big enough to crush a large mouse or a frog. At full size, it has no trouble fending for itself, squeezing the life out of its prey with its constricting, coiling body.

Opposite: The demand for crocodile skins brought the gavial to the brink of extinction. In the 1970s, it was estimated that no more than sixty adults survived in Indian waters. Extensive conservation programmes based in sanctuaries have been reasonably successful, although few released gavials have yet reached breeding age.

The Arid Heart

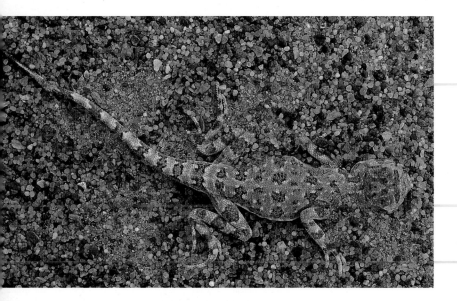

Above: A desert lizard relies on camouflage and stealth. Sometimes this is not enough. It needs all the luck it can get, as buzzards are a constant presence in the sky, scouring the desert floor hunting for their growing families.

Opposite: The very names given to the parched lands of Central Asia conjure up images of desolation and emptiness. The Gobi, in Mongolian, means 'waterless place'.

A sia's heart is a dry and lonely place. Sand dunes stretch to the horizon, their undulating forms slowly sculpted by rainless winds. High plateaux of dark purple stones, baked to a shiny polish by fiery summer temperatures, disappear beneath a dense shimmer of heat haze. Tough, thorny scrub lines dry river beds, hinting at occasional downpours which scour the land before the water evaporates and disappears, as if it had never fallen at all.

The great desert corridor of Central Asia lies further from the influence of the world's oceans than any other place on Earth. Here winter temperatures plummet to minus forty degrees Celsius (minus forty degrees Fahrenheit) then soar in summer to over forty-five degrees Celsius (113 degrees Fahrenheit). Arctic winds, blowing south across the tundra and taiga, have lost their moisture by the time they reach the interior, and the water-laden monsoon winds from the south are blocked by the high barrier of the Himalayas. Only creatures with specialised physiology and behaviour are able to survive.

To outsiders, deserts are hostile places. They are defined by what they lack: water, soil, vegetation, shade, life. Wind strips moisture from the air and buries plants beneath suffocating sands. Waterholes that sustained one year may be barren the next. Rains fail more than they fall.

Yet even here, where the basic life-giving properties of our planet seem all but absent, life survives in remarkable diversity. Every species has evolved its own strategy for survival. Nomadic wild asses and rare Bactrian camels range over vast areas in their constant search for water. Rodents, reptiles and insects live beneath the desert floor, venturing above only when the searing sun has set to quench their thirst on the

ALISON BALLANCE AND MICHELLE GILDERS

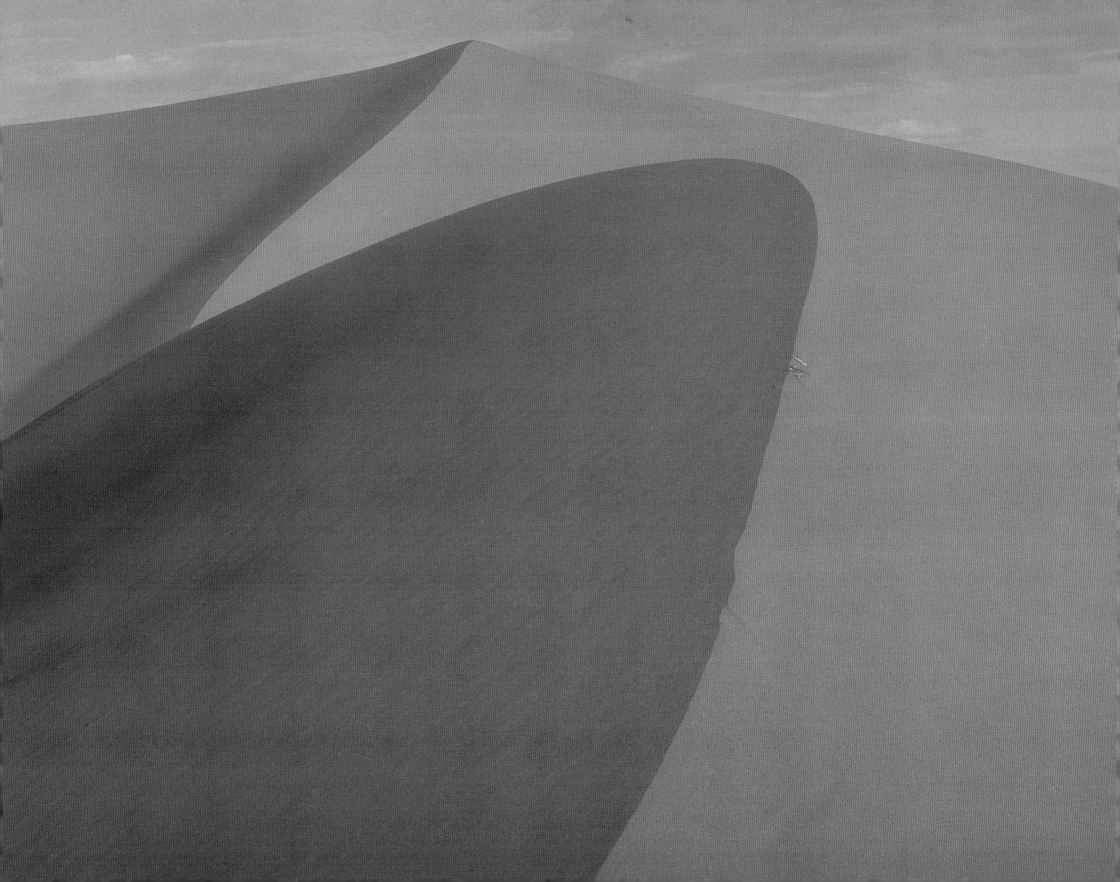

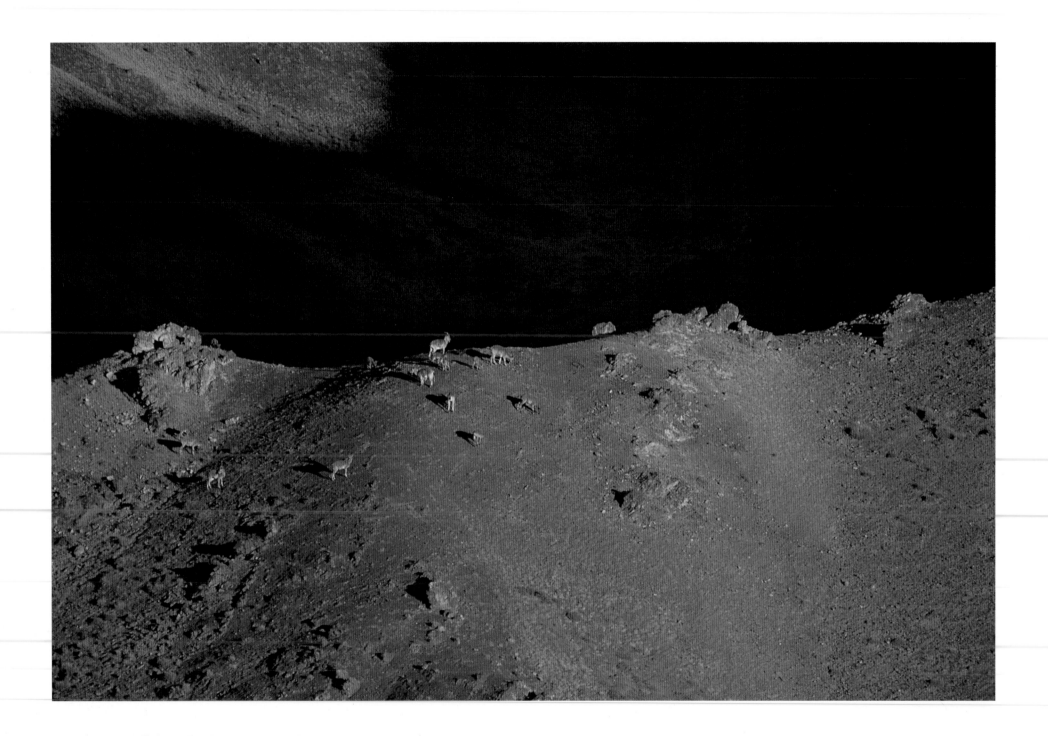

precious moisture locked in seeds and vegetation. Great gerbils are gardeners – turning the earth, fertilising it and living off the plants it nurtures.

Deserts demand tenacity from their inhabitants, and success is marked by generations not individuals. Desert gerbils have numerous litters in the hope that a few survive. The wild ass raises one foal at a time, putting all of its energies into a single life. Plants send forth seeds by the thousand so that a single one may shoot, even if it must lie dormant for years.

Asia's core is flanked to the north by another vast and evocative landscape – the dry grasslands of the steppe. In the thirteenth century, Genghis Khan and his Mongol warriors swept west across this 8000-kilometre (5000-mile) plain into Europe to form the largest empire the world has ever seen. Today, Mongolia is a sparsely populated land of nomadic herders who live alongside the wildlife of the steppe; animals such as Mongolian gazelles, whose restless mass migrations around the eastern steppe are one of Asia's greatest wildlife spectacles, and Przewalski's horses.

But the grasslands are not always benign – like the deserts they also suffer extremes. In spring, huge wind storms buffet the land, spinning off tons of dust. Every winter freezing winds sweep down from the Arctic and the huge Asiatic anticyclone settles over Central Asia, pushing temperatures down well below zero. Although it is too dry for much snow to fall, even the deserts freeze in winter's icy grip.

The driving imperative of all who live in Asia's deserts and dry grasslands is securing the future. It is this challenge which makes them unique and wondrous places. The arid heart of Asia beats strongly despite adversity.

Opposite: With sturdy legs and splendid horns up to a metre (three feet) in length, the ibex are classic wanderers of the central highlands, with dry grasses comprising sixty per cent of their diet.

Right: The shy chinkara, or Indian gazelle, is at home in the drier areas of the Indian sub-continent. In true desert country, they are able to get the water they require from their food and from dew, although they will of course drink water if it is available.

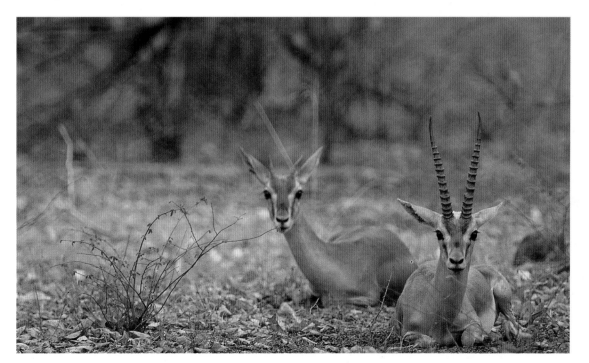

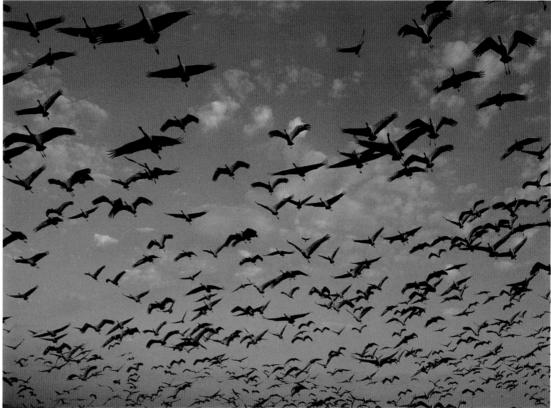

Right: Demoiselle cranes spend the summer months breeding on the grassland steppes and semi-deserts of Mongolia. Each year they migrate over the high Himalayan passes on their way to wintering grounds in the desert region of north-west India and Pakistan.

Bottom right, and opposite: The smallest and most elegant of the world's cranes, the Demoiselle rears its young on a diet of insects, beetles and lizards on the grasslands of the Mongolian steppes. Growing is a race against time, for the young cranes must be capable of flight in readiness to escape the frigid winters of their breeding grounds – temperatures in the steppe can plunge to minus fifty degrees Celsius (minus 122 degrees Fahrenheit).

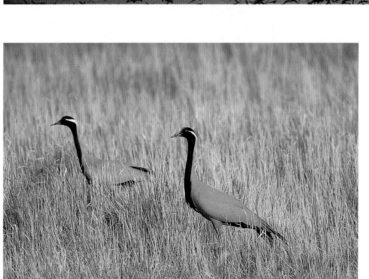

Opposite: At the eastern extent of the desert corridor that spans central Asia is the Gobi. This huge expanse of stone desert is home only to creatures that have found solutions to a multitude of problems; sub-zero winter temperatures, searing summer temperatures and the inevitable shortage of water.

Top left: Small desert animals are unable to wander far in search of food, but the great gerbil is an extremely efficient processor of seemingly dry vegetation. It can survive for prolonged periods on just the moisture obtained from its food and has thick fur as protection against cold windy winters. In summer, it stays underground during the day and only comes out at dawn and dusk.

Bottom left: Mongolian marmots, or tarvaga, are active for only half of each year, spending the remainder hibernating in the relatively stable environments of their burrows. The sharp whistle of their alarm call is a common sound on the steppe, since even the shadow of an eagle will send them bolting for safety.

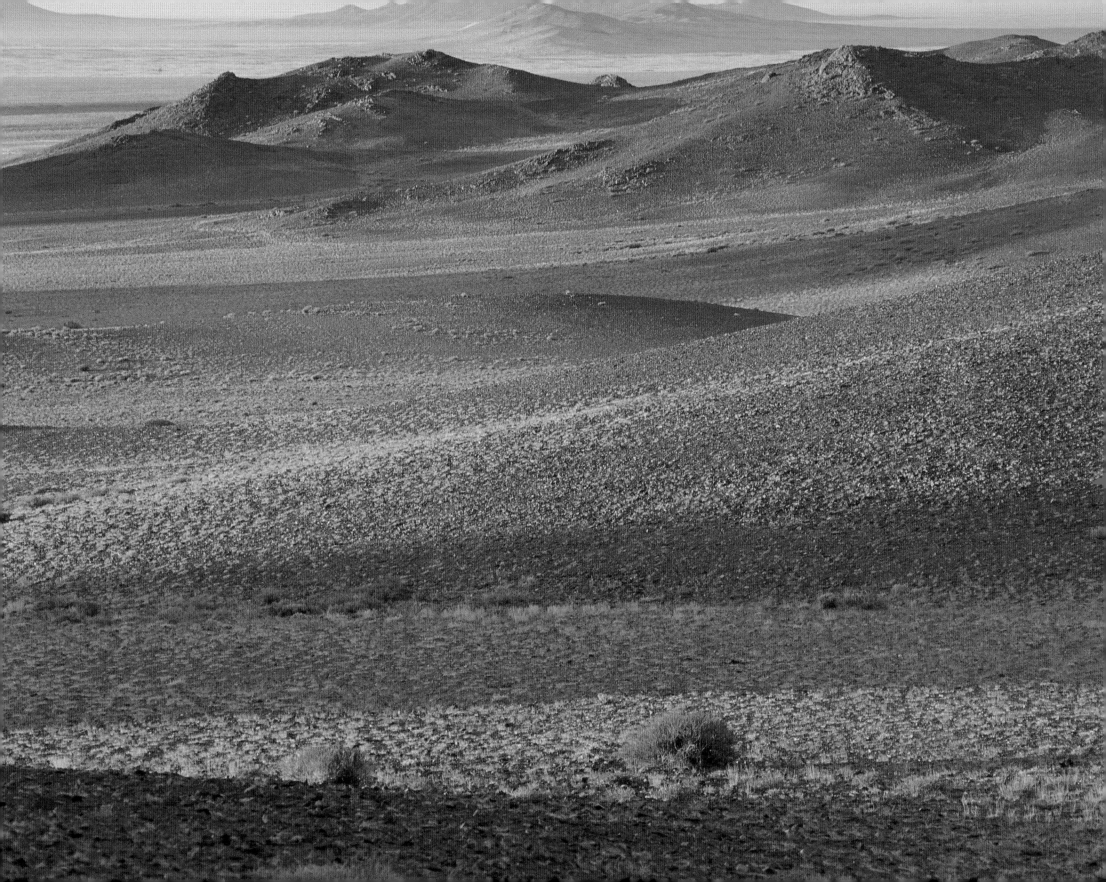

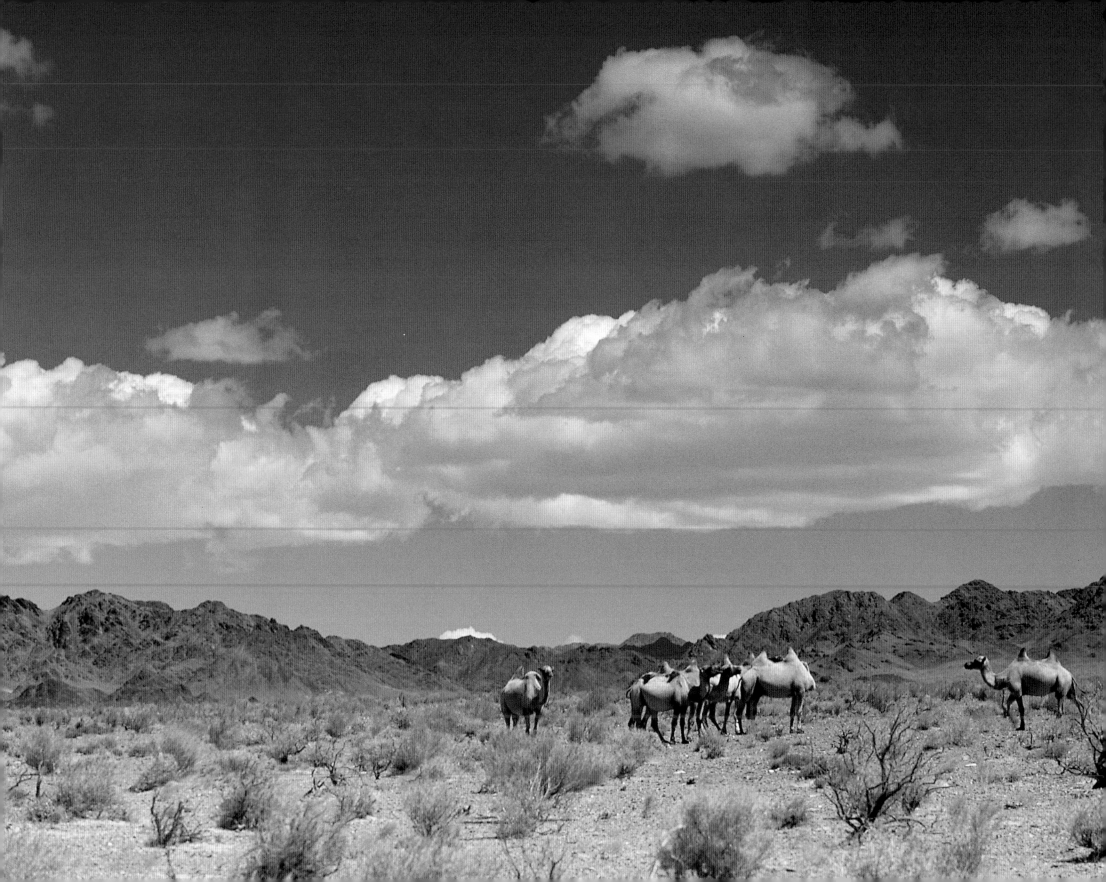

Above: The Bactrian camel weathers both the arid heat and the intense cold of the Gobi desert. Its coat is essential insulation against both extremes – not only retaining warmth in the cold but also keeping out the heat – while its physiology ensures the camel's body temperature can rise by six to eight degrees Celsius to reduce the amount of water lost through sweating. Bushy eyebrows and double lashes also protect its eyes from sand, and it can clamp its nostrils tight shut to keep out dust.

Right, top and bottom: The largest of the wild sheep is the argali, or Marco Polo sheep. These agile creatures range across much of the high tablelands of eastern Central Asia, and up to altitudes of 7000 metres (23,000 feet). The enormous horns of the rams can measure up to 1.8 metres (six feet) long. As a result of hunting, the argali are becoming increasingly rare.

Opposite: The camel is superbly adapted to the desert: its humps hold reserves of fat to sustain it while wandering the desert in search of food and water; it can go up to ten days without water; and wide padded soles stop its feet sinking into the sand.

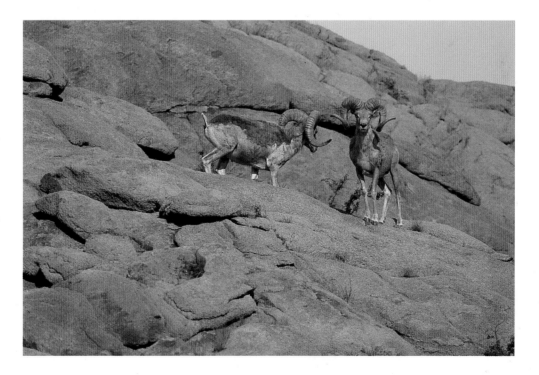

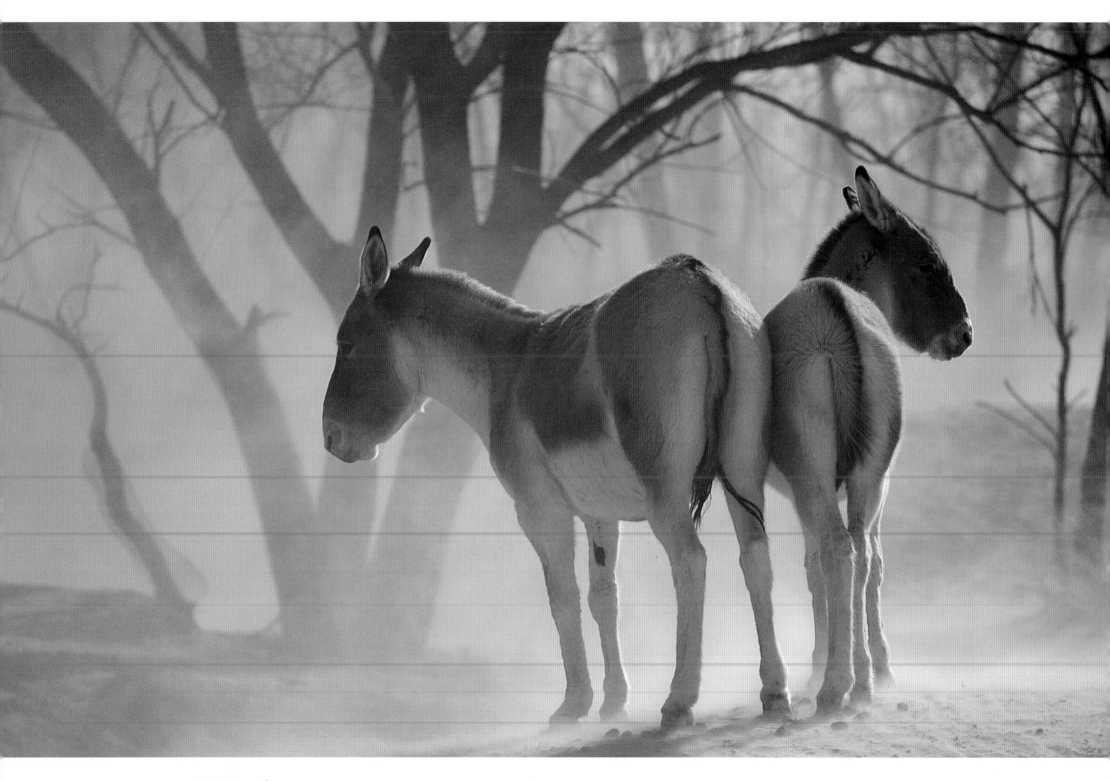

Opposite: Tibetan wild asses, or kiang, are highly social, depending on old females to lead their cohesive herds. Theirs is a tough environment, and it is only during August and September – high summer – that vegetation is plentiful enough for them to put on weight. For the remainder of the year they eke out a difficult existence.

Top right: The rare goitred gazelle lives in small groups and prefers firmer ground where it grazes tough desert grasses and browses low shrubs. This juvenile – just a few days old – has been left by its mother for the day while she wanders the desert in search of food. She will return in the evening.

Bottom right: As if life were not difficult enough on the wind-swept open steppes, in a year of unusually heavy rains the Mongolian gazelles are forced to walk in mud and water for months. Like this one, many have succumbed to death from debilitating foot rot.

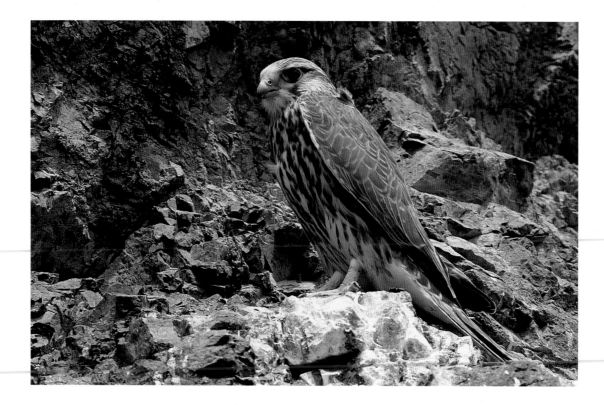

Above: Blending superbly with the rock faces of Mongolia's mountains, a keen-sighted falcon rests from its search for gerbils and other small vertebrates of the desert.

Opposite: Surveying its semi-desert homeland, a young rough legged hawk awaits its next meal – perhaps a marmot, a lizard, a smaller bird or carrion. Within a few weeks it must learn to fly and hunt for itself.

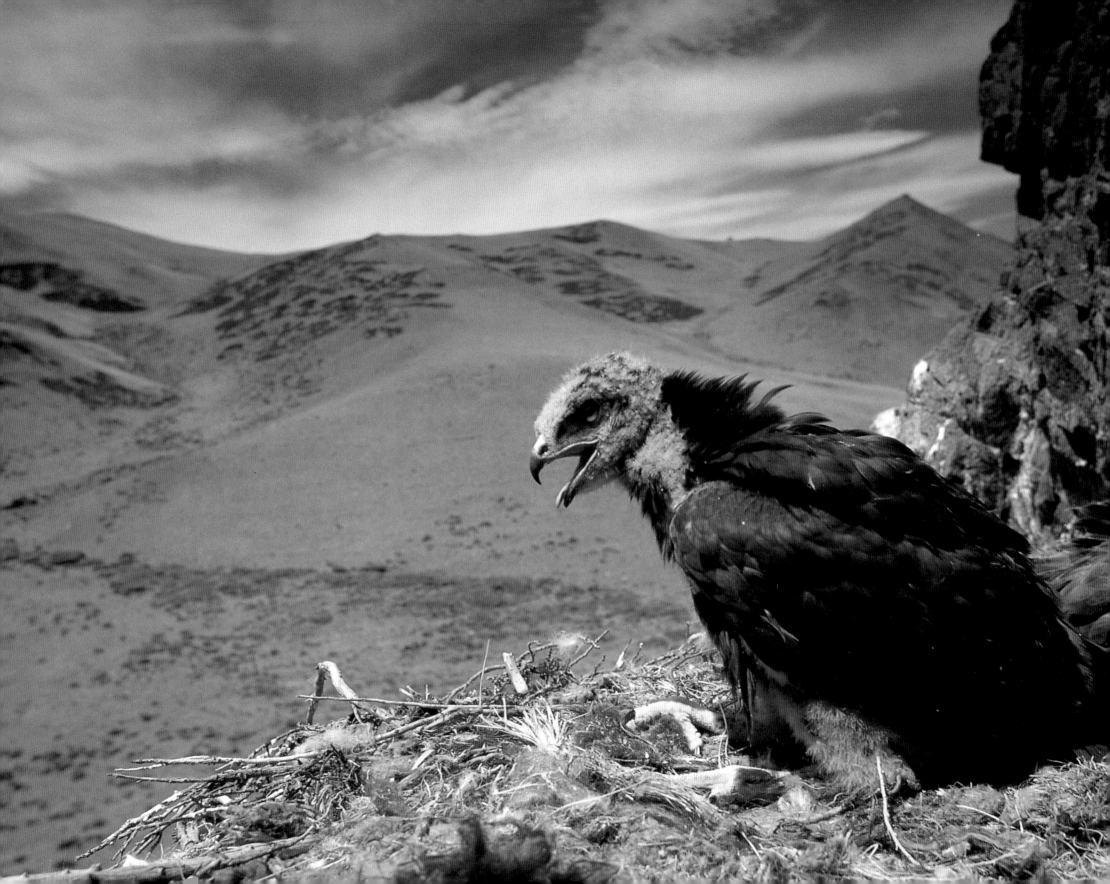

Sometimes even the harshest environment is full of surprises. Here a swath of irises, a genus found from the Arctic to the Tropic of Cancer, and common in Mongolia, flourishes in a desert landscape.

Top right: Symbols of freedom and power, the Przewalski's horse became extinct as a result of competition with domestic stock, but in 1994, from a small herd that had been maintained in captivity, the horses were reintroduced to Mongolia.

Bottom right: Mongolians call Przewalski's horses takhi, meaning 'the spirits'. These wild horses are distinguished by short upright manes, thick coats and stripes on the backs of their legs.

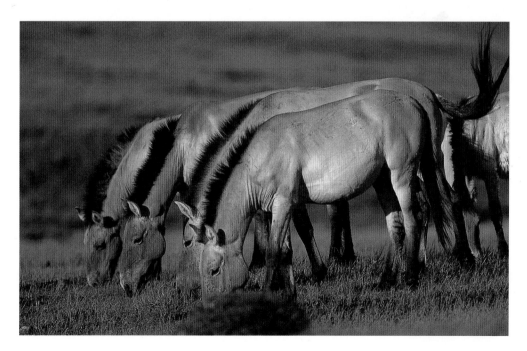

Creatures of the Thaw

Above: Night is the time many predators prefer. In the wetland world between the Japanese mountains and the sea, Blakiston's fish owl reigns supreme. Waiting patiently for its prey, when it senses a fish within reach it dives into the water like lightning and unerringly emerges with dinner dangling. The owl is not exclusively a fish eater – it enjoys frogs, too, when they are in season.

Opposite: The elegant lines of its body and the delicate tracery of its wings belie the ferocity of a red dragonfly's attack. But while the powerful mandibles of the nymph can flick out in a fraction of a second to catch prey, taking less than a minute to consume every scrap of a tadpole's body, the adult dragonfly must content itself with smaller insects.

We live on a blue planet – our skies are blue, so, too, are the great oceans. We live surrounded by water and we need water to live. But of all the water on Earth, 97.4 per cent is salty.

Of the 2.6 per cent that is fresh water, only a fraction is accessible to us. Most of it is locked away as ice in the Arctic and Antarctic. In fact, less than one per cent of all the water on Earth is available to sustain life. The very existence of the plants and animals of the world depends on those few precious drops.

Freshwater takes two different forms – solid and liquid, ice and water. In North-East Asia, where the land is covered by ice and snow for more than half the year, the influence of freshwater on wildlife is fundamental. As the seasons go by, the plants and animals that depend upon a freshwater environment must be adaptable, for their environment is constantly changing.

Just as freshwater itself changes its physical form, the environments it creates are many and varied. Lakes and ponds, wetlands and marshes, rivers and streams – the nature of water means that these habitats are never static.

The animals and plants that rely upon these inland waters must themselves be able to adapt and change as the conditions vary with the seasons. One remarkable animal, however, has somehow been able to withstand change and is almost a living fossil. The giant salamander of Japan has hardly changed at all from fossil records that date back some thirty million years, yet all around it the freshwater world has changed.

Over hundreds of thousands of years freshwater environments are constantly changing, not only their shapes but their very nature. Lakes and ponds will eventually be smothered by the deposit of silt and the

SHINICHI MURATA

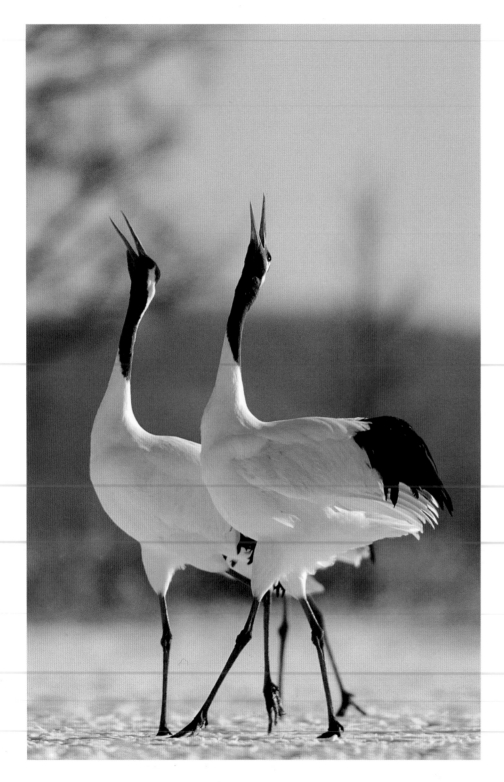

debris from rotten and decaying plants which, over centuries, will turn them into wetlands, then grasslands, and eventually into forests.

Rivers too are, by their very nature, inconstant environments, prone to both climatic and geological shifts. Even the very direction which water flows is dictated by land upheavals and by ice ages. The creatures that live in and around rivers and marshes must be able to adapt to these changes.

Ezo brown frogs have adapted to the seasonal cycles between summer and winter by laying their eggs in the shallow waters during winter. It is too cold for the frogs to find food, but by laying in the coldest time of year they are giving the tadpoles the best chance of survival when they hatch, so they can mature before the next winter.

One fish, the cherry salmon, has adapted well to this inconsistent environment. The fish has two distinct forms; in one it stays in a freshwater environment, remaining in the river of its birth. In its other form it leaves the world of freshwater to enter the sea, the saltwater world. In the northern Japanese island of Hokkaido it is possible to see cherry salmon in both their forms in the same river and the challenges they face to reproduce. Those cherry salmon that remain in freshwater are small, but those that return from the oceans are large. Each has a different strategy, each faces a different struggle. Yet because the cherry salmon has had to adopt a flexible lifestyle, it has been able to survive in the inconsistent rivers of north-eastern Asia.

Compared with rivers, freshwater lakes and their surrounding wetlands are more stable environments. This is especially true of the Kushiro Marsh in Hokkaido which has kept its characteristics as a low wetland moor for thousands of years. Yet over millennia these lakes and wetlands are destined to vanish through the succession and change of freshwater environments.

However, in south-west Siberia lies a mysterious lake that breaks all the rules, and has survived as a lake for over thirty million years. Lake Baikal is the world's oldest and largest freshwater lake, containing twenty per cent of the Earth's entire supply of available freshwater. Three-quarters of the species living in this lake are endemic, including the nerpa, the only freshwater seal in the world, as well as stick-type freshwater sponges.

Many birds escape the harsh winters of Siberia and Arctic Asia by migrating to the freshwater lakes of northern Japan that do not freeze over. Whooper swans, white-fronted geese and ducks come in their tens of thousands seeking a temporary refuge in places where the winter is less severe.

So it is that the freshwater creatures in north-east Asia adapted to the change of environments through the seasonal cycles of winter and summer. In winter, most of the freshwater, their lifeline, is locked away as snow and ice. But at the end of each winter, the spring thaw provides a rich and explosive cycle of life to the freshwater world. It is a cycle they see every year. The creatures of the freshwater worlds of North-East Asia endure the winters of ice and snow as if they know that the promise of the richness of new life awaits at the end of winter, for they are the creatures of the thaw.

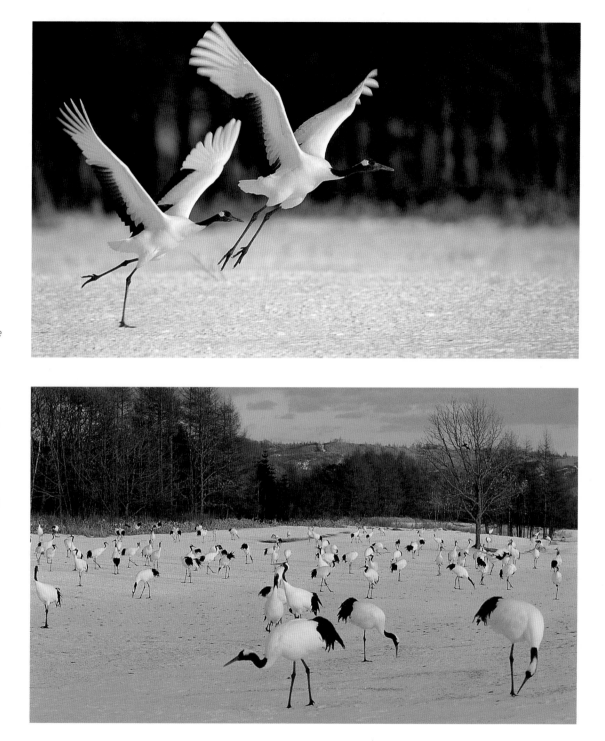

North-East Asia's indigenous Ainu people call the red-crowned crane *sarurun kamui* – 'the god of the marshes'. During late winter, long-established pairs rekindle their bonds by dancing together before returning once more to their reed marsh territories in Hokkaido to raise another generation. Grace, embodied in the dancing and displaying form of the cranes, reflects the symbolic power of this species. The only potential predator of danger to the red-crowned crane is the red fox, but flocking during winter provides safety in numbers. Each night the cranes fly to roost in shallow ice-free rivers, then as the morning warms the land they fly out to forage nearby.

Opposite: Depending on how much food they find in the river, and on the genetic structure each fish has inherited, these yamame – just emerging from egg sacs – will grow to maturity in one of two remarkably different ways. The most powerful males occupy the best feeding territories, driving off all rivals. The other males and all the female yamame take their chances and head down the river to the open sea – there they turn into cherry salmon. Less than 10 per cent of those who go to sea survive to return upstream to their breeding ground the following year, but by then they are twenty or thirty times larger than the yamame who drove them from the river.

Top right: Ezo brown frogs interrupt their wintering to spawn in shallow waters. Although it's too cold for them to find food, by laying their eggs now the frogs give the tadpoles the best chance of maturing before the next winter.

Bottom right: A living fossil, Japan's giant salamander has hardly evolved from its ancestral form of 30 million years ago. With a lifespan matching that of humans, these aquatic opportunists can grow up to a metre and a half (five feet) in length on a diet of unsuspecting fish, which are easily trapped in their gaping, cavernous mouths as they trawl downstream at a leisurely pace.

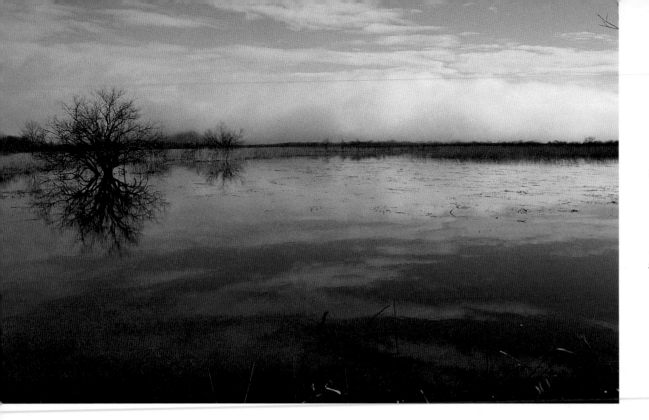

Opposite: A forest-dweller, the greater pied kingfisher dives from its perch up in the trees to catch the fish which make up almost its entire diet.

Left: Huge reed swamps with shallow pools are the hunting grounds of the red-crowned cranes. Here frogs and salamanders, fish and aquatic insect larvae provide a varied diet.

Below: The white feathers of the handsome Japanese crested ibis turn grey as the breeding season approaches. The numbers of these birds decreased dramatically during the nineteenth century, and they are now almost extinct.

Above: Playing a major role in the life and death drama of the freshwater world, the giant water bug – which at six centimetres (nearly two and a half inches) is Japan's largest aquatic insect – sucks out the nutritious body fluid of an unwary black-spotted pond frog, then discards its body. Although at the top of this food chain, the bug is becoming scarce because of the increased use of chemicals in the rice paddies it inhabits.

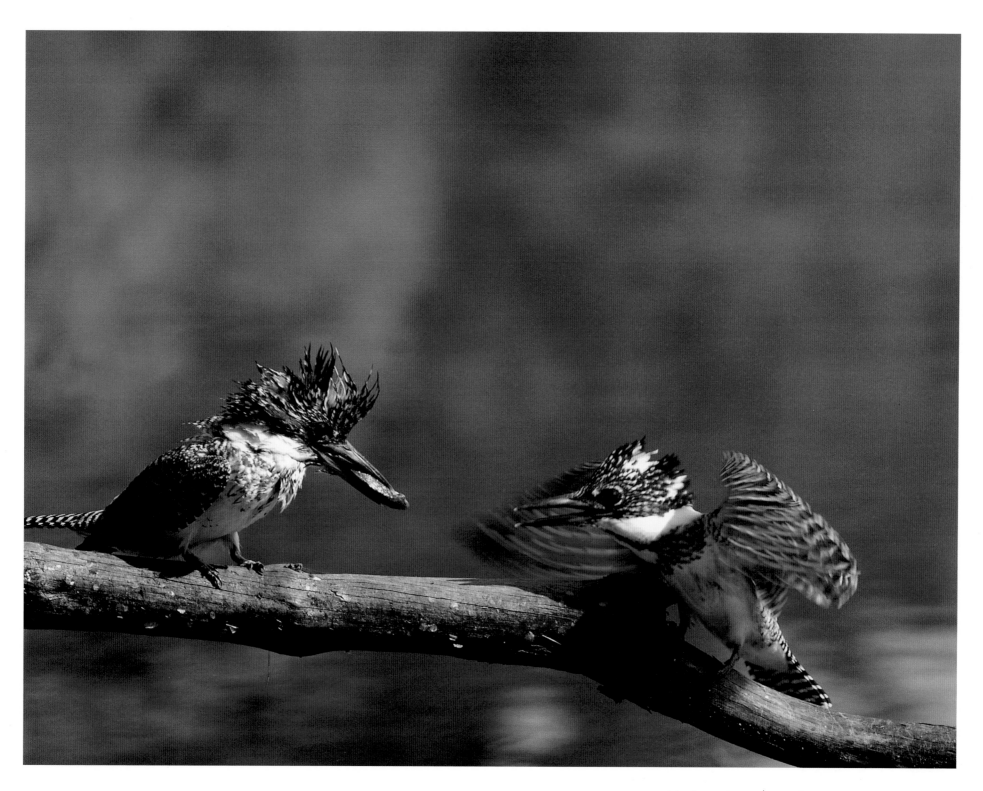

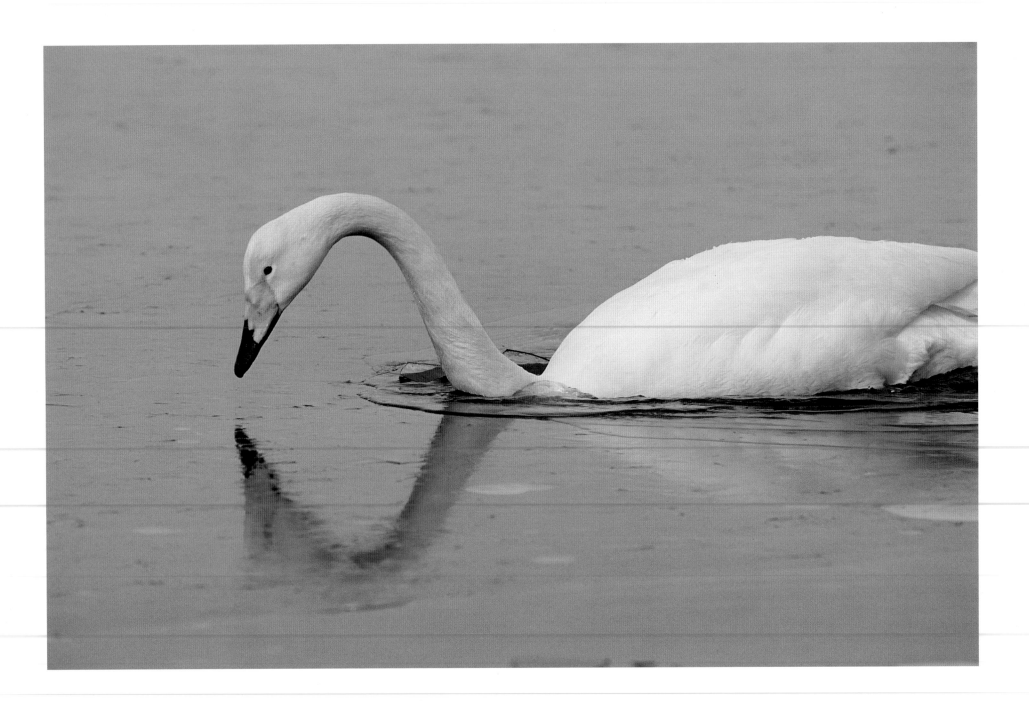

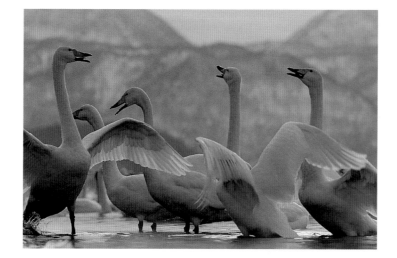

As the ponds and lakes in the northern taiga zone cool then freeze in autumn, Asia's whooper swan families gather together and migrate south to warmer regions, such as in Japan. They spend the winter in huge flocks and tempers fray occasionally, especially when other families or pairs intrude too closely as birds feed. Then the strength of the swans is noticeable in the ferocious beating of their wings and in their powerful whooping calls.

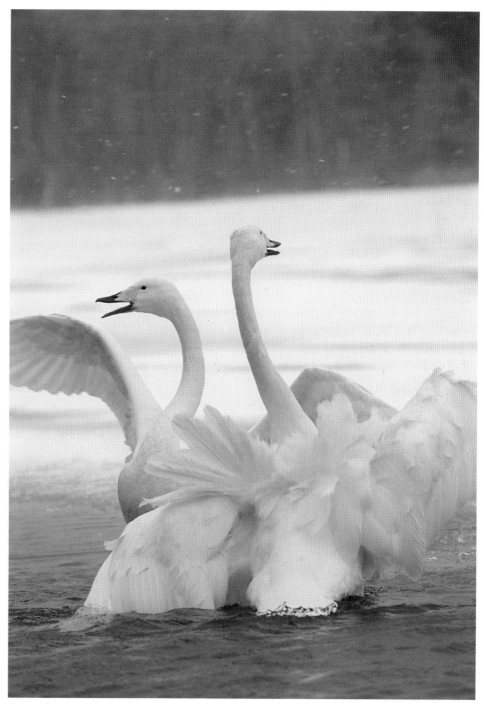

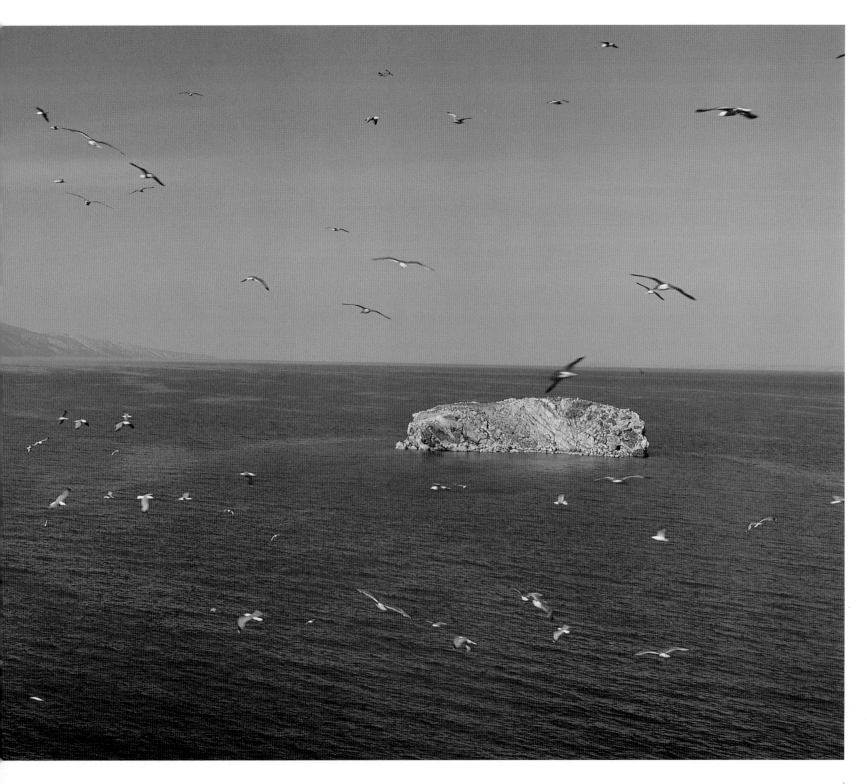

The larger gulls do well along the enormous coastline of North-East Asia. Breeding on isolated coasts and islets, gulls are also attracted to large inland lakes, such as Lake Baikal, which provide ample habitat and food for their scavenging habits. Hundreds of rivers and streams from Central Europe and Asia flow into Lake Baikal, in Siberia, the largest and deepest body of freshwater in the world. All around the lake, fascinating fauna and flora thrive in the freshwater world.

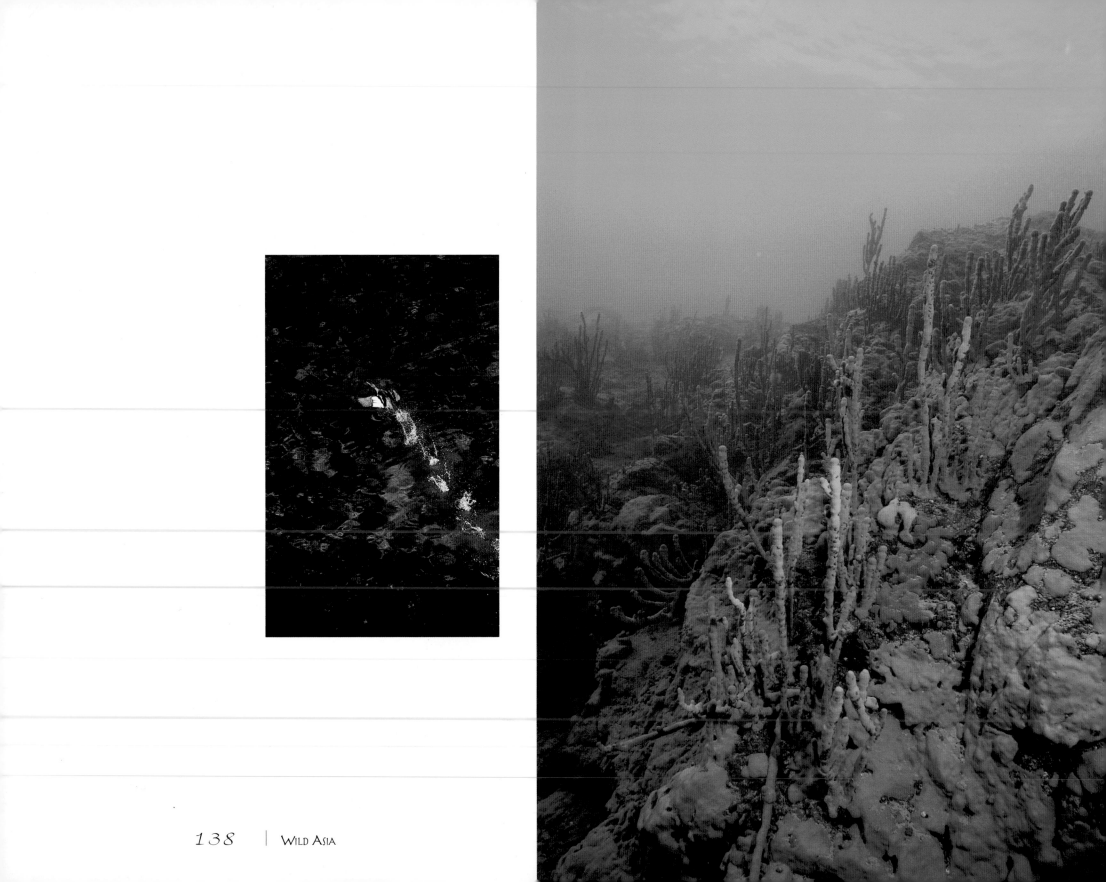

Opposite, far left: Unusually among the ducks, the red-breasted merganser is a piscivore (fish-eater), diving beneath the water in search of fish. A hole-nester, like the mandarin duck, the merganser breeds only where there are old trees with cavities close to water.

Opposite, left: Lake Baikal is known for its remarkable clarity. Here, bizarre branching sponges dominate an underwater cliff face. They are green because of tiny algae embedded in their tissue; these algae capture the sun's rays and help nourish the sponge. They flourish because of the abundant plankton in the lake which they filter from the water.

Top right: Of the fifty fish species unique to Lake Baikal, more than half of them belong to the sculpin family. The yellow-wing sculpin spawn among the rocks of the warmer shallows. Using his fins in display, and releasing pheromones, a single male may attract a procession of females, each of which will lay more than a thousand eggs.

Bottom right: There are over 300 species of amphipod in the lake. Some of these crustaceans are giants – the size of a mouse. The males often carry females around with them until they are ready to mate.

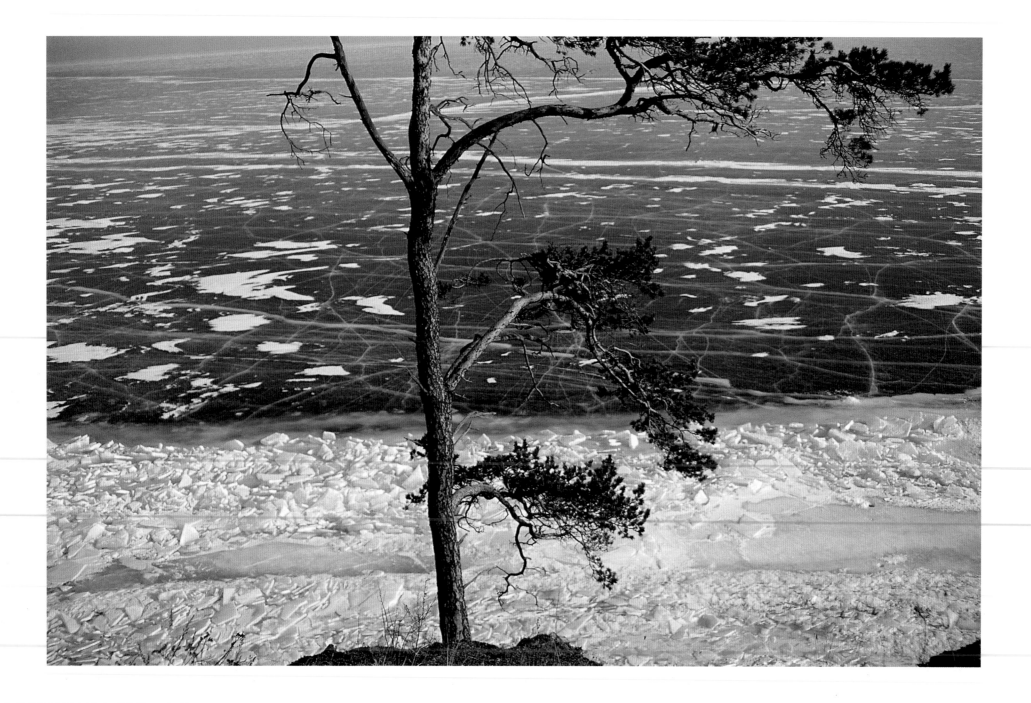

Above: The origins of the land-locked Baikal seal, or nerpa, remain an enigma. No one knows how this diminutive seal, which is less than one-and-a-half metres long (five feet) and weighs only about sixty kilograms (130 pounds), found its way into one of the world's oldest freshwater lakes. Like its Arctic Ocean relative, the seal breeds on ice. During March, the female give birth to white-furred pups in dens made on the winter ice of the lake. The breeding season over, and their pups weaned, the adult seals laze the summer away at popular haul-out spots.

Opposite: Despite its enormous depth, Lake Baikal freezes over during winter. The ice provides a secure home on which endemic seals breed, but after spring melt waves leave a scattering of ice remnants along the shore and the young seals must take to the water.

Kingdoms of the Coasts

Above: At low tide a huge community of creatures emerges to feed on the mud. Fiddler crabs cram most of their lives into the time between the tides. While females feed at frantic speed, hungry males are hampered by the super-claw they use for defence and display.

Opposite: Every April, turtle-watchers gather at known olive ridley turtle breeding sites on the Andaman Sea coast, in the Indian state of Orissa, in anticipation of one of the strangest breeding rituals in the natural world. At night, tens of thousands of these large sea turtles emerge from the sea en masse to nest on the beaches.

MICHAEL HACKING

The coasts of Asia stretch over 195,000 kilometres (120,000 miles), from the warm tropical waters of the islands of Indonesia to the freezing seas of the Russian Far East. These coasts span a huge variety of climates and habitats, and support an incalculable diversity of life. But what unites their character is their extraordinary fertility and their wide range of influence, which stretches far beyond the thin coastal line on the map denoting where land meets sea.

What appears as a frontier is a complex and constantly changing zone of reaction between the forces of ocean and earth. Above and below the water line, and sometimes between the tides, animals make a living in this turbulent world. Some are full-time residents who have adapted to life along the shoreline, others are seasonal visitors who come to the coasts at particular times in their lives, or in specific seasons, to take advantage of food or to shelter while they breed.

Through the window of Asia's coasts we glimpse the power of these coastal waters. In the tropics, earth which is washed from the land by torrential monsoon rains is caught by the immense net of mangrove forests and its productivity is harvested by the distinctive communities which make these no-man's lands their home. From India to Indonesia, these shoreline buffer zones are vital in their role of converting raw sediment (which unchanged would smother life), sunlight and air into growth – energy which is then exported to the ocean as debris from the forest.

A specialised community of creatures – including mudskippers and fiddler crabs – designed to live in and on the mud, and in and out of the water, takes part in the conversion process. Sea birds, saltwater crocodiles, monitor lizards and crab-eating macaques scavenge and clean the shores, and all these creatures structure their lives around the tides which wash in and out of the mangroves.

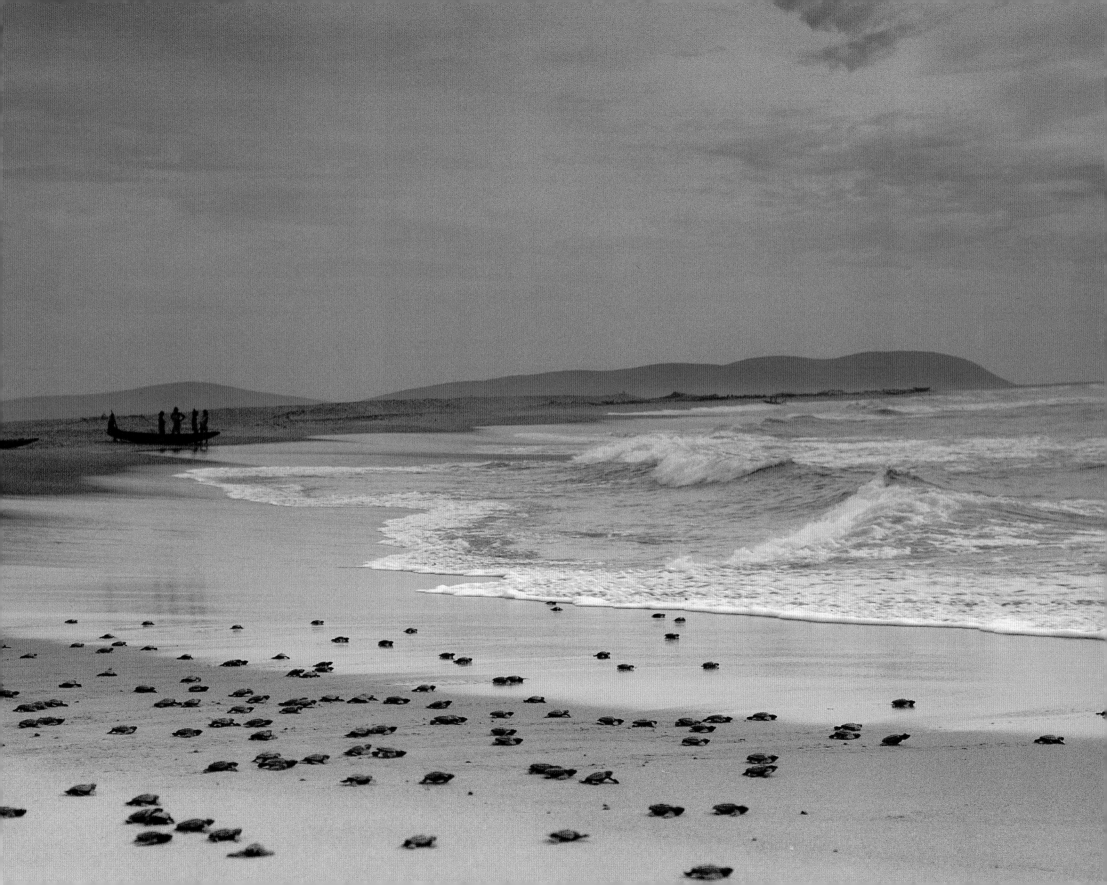

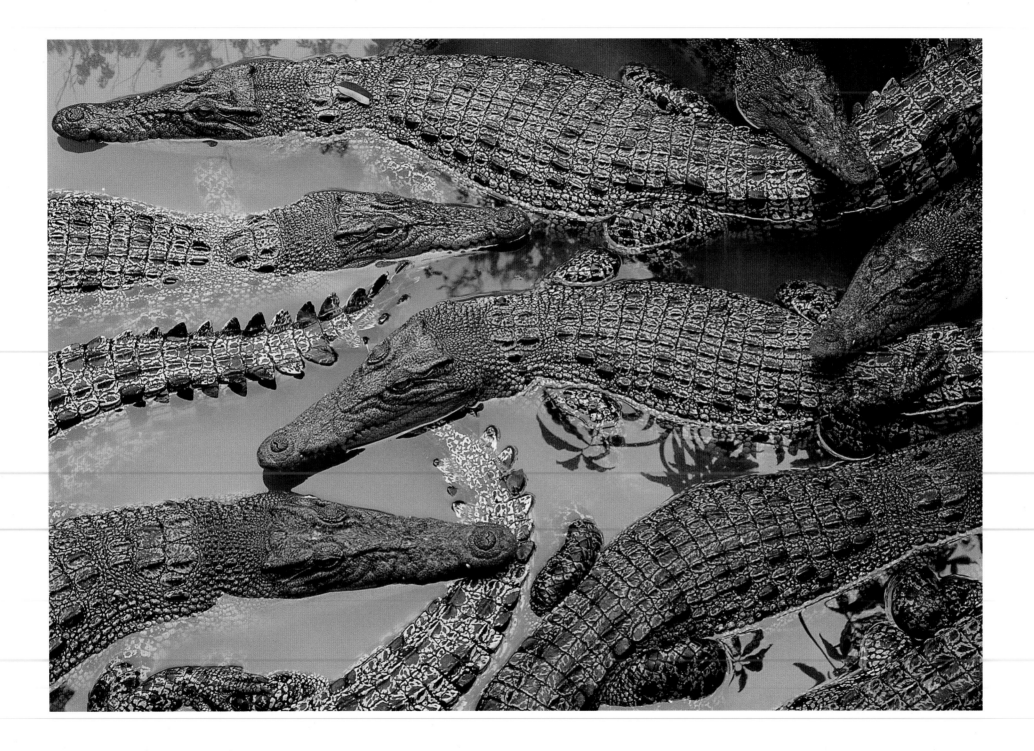

The remarkable thing about mangrove forests is that the trees themselves also cope with the rise and fall of salty ocean tides, which would kill most other plants. Their exposed root systems allow them to breathe at low tide, and then shut-down as they are covered by rising seawater.

The web of canals and creeks in mangrove forests provides sheltered waters where marine creatures can breed and raise their young. Some terrestrial animals, like Borneo's proboscis monkeys, have also become mangrove specialists; their robust digestive systems allow them to feed on the salty, tough mangrove leaves which other foragers can't stomach.

Elsewhere in Asia's tropical waters, there are also 'forests' under the sea: the spectacular coral reefs of Indonesia which shelter the greatest variety of marine life on the planet. At the heart of this extraordinary diversity is the ability of tiny coral polyps – part animal and part plant – to colonize the bare sea floor and, over countless generations, build a coast where none existed before.

Tropical fish which feed on the concentrations of nutrients around a coral reef are spectacular, but some of the strangest marine creatures are those so small that they must practice deception to hunt, and avoid being hunted. Their disguises are sometimes unbelievably grotesque, sometimes pyrotechnically colourful, sometimes intricate and finely modelled, but every one of the myriad reef-dweller species represents the rich ability of Asia's coastline to sustain life, above and below the tide mark.

Opposite: Patrolling the interface where freshwater flows out to sea and saltwater floods the land is the saltwater crocodile. This successful predator will take fish and crabs and even snatch a crab-eating macaque that is lingering too close to the water.

Top right and right: Ancestors of saltwater crocodiles, the estuarine crocodile species of the Old World, patrolled coastal lands 65 million years ago. Long ago, these members of the crocodile family adapted to hunt the fertile waters between land and sea. Despite seldom moving more than their own body length from the water's edge, they are formidable predators. Their nostrils and eyes are set high on their heads so that when lying or floating almost totally submerged they can see and breathe.

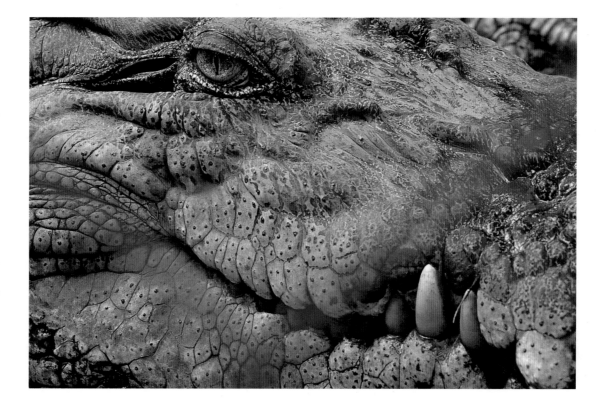

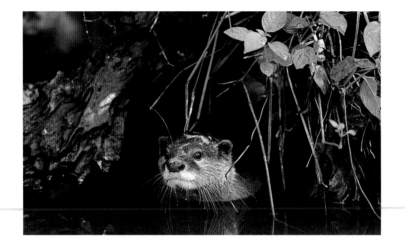

Top left: The smallest of all the otters, the dapper oriental small-clawed otter is less than a metre (three feet) in length. Highly social and communicative, it lives in loose family groups of up to twelve members. It is extremely inquisitive and has incredibly dextrous forefingers, which are used to fossick for and handle food. It frequents rivers, estuaries and coastal waters, where it lives on a wide-ranging diet of molluscs, crustaceans, frogs and, particularly, crabs – all prey that require its unusual manual dexterity. The tiny otter has large, broad cheek teeth, well-adapted to crushing the hard-shelled animals it feeds on.

Top right: With its dog-like head and large eyes alert, the flying fox comes out at twilight, all senses attuned, in search of the fruits, leaves and flowers it feeds on. It is particularly fond of pollen and nectar.

Opposite: The mangroves, which grow at the point where tropical forests meet river estuaries or on sheltered coasts, turn raw sediment into energy. From India to Indonesia they shield soft and muddy coasts against the forces of the ocean.

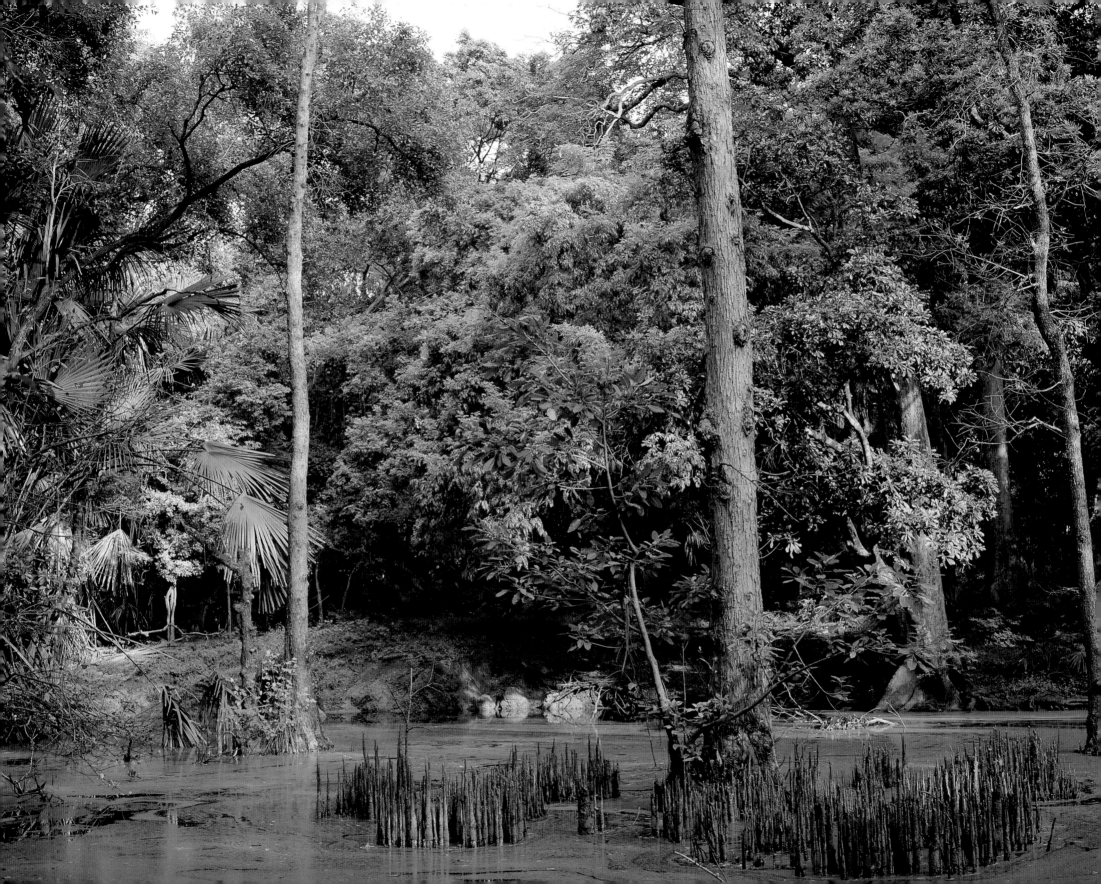

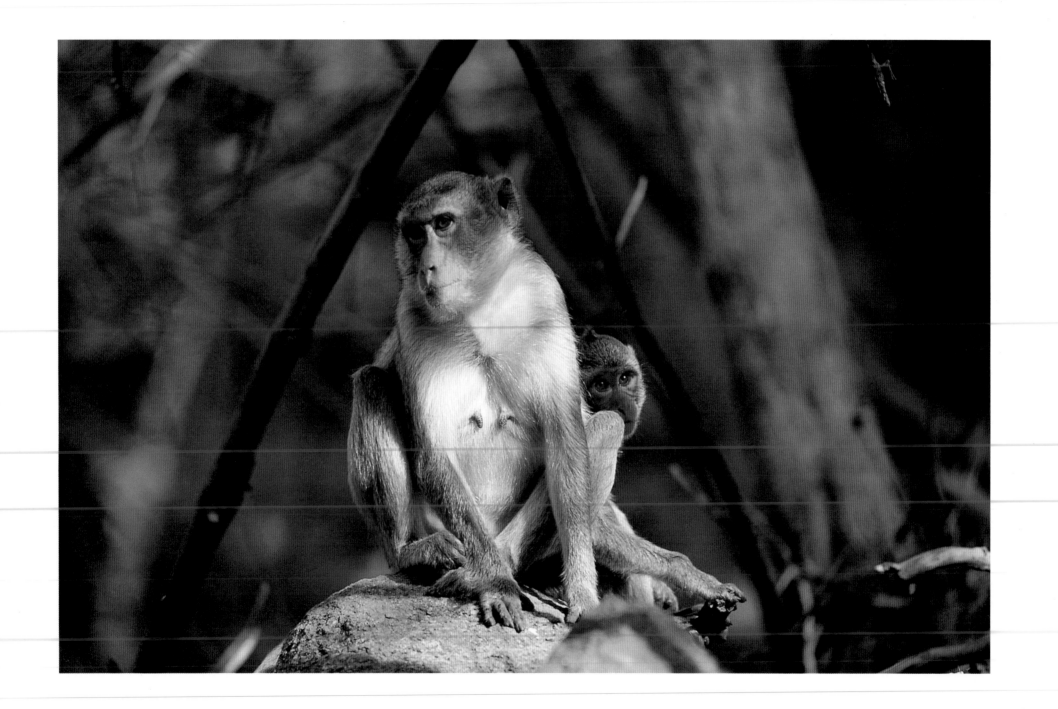

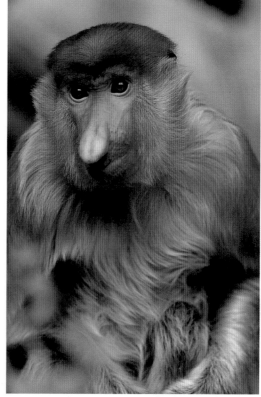

Above: The proboscis monkey, which is confined to the Bornean lowland and coastal forests, is a capable swimmer and even has partially webbed feet.

Opposite: Variously known as long-tailed, or crab-eating, macaques, these highly successful animals range widely throughout South-East Asia's primary and riverine forests, swamps and coastal mangroves. They swim well and are not averse to jumping into water, swimming rivers and foraging out on mudflats where they catch crabs. Their catholic diet consists largely of fruits, seeds, buds and leaves, but also includes crabs and other animal prey.

Above: Why the male proboscis monkey evolved with its bizarre and enormous nose remains a mystery.

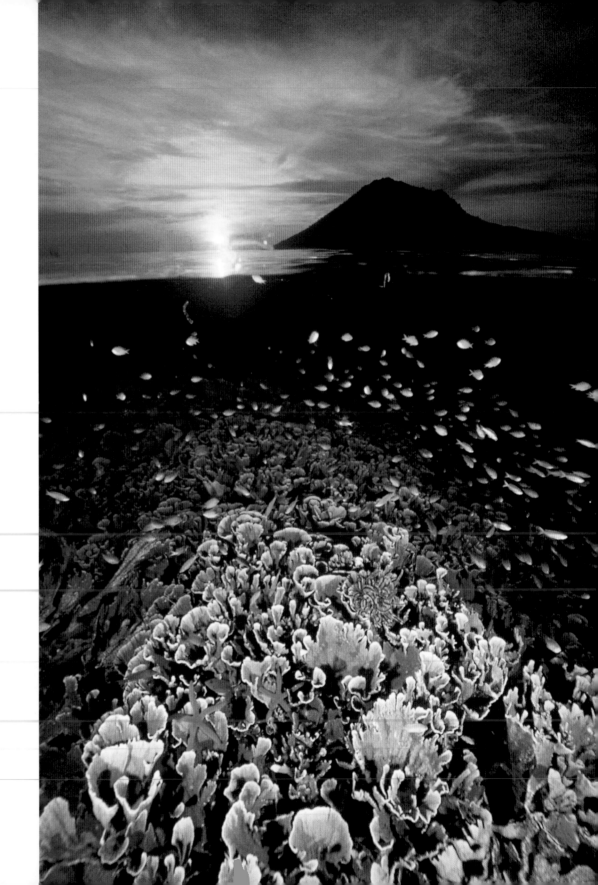

Coral reefs are the tropical forests of the underwater world. Gathering light in warm shallow waters, they are both photosynthesisers and plankton feeders. Secreting limestone they build reef upon reef, providing habitats for myriad other creatures and even building islands.

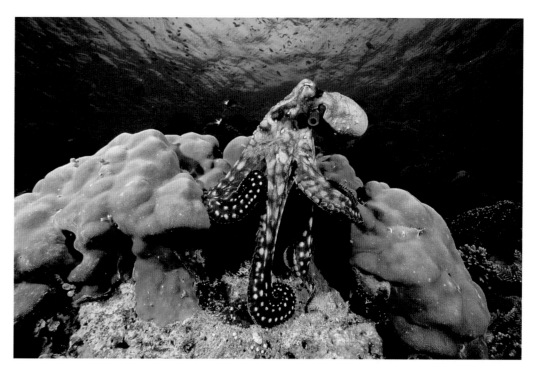

Above: Like most of the cardinal fish, this ring-tailed male holds the fertilised eggs in his mouth. While they incubate, he fasts.

Top right: The reef octopus lives on the sea floor and has the remarkable ability to change colour and merge with the background when it is in danger or in pursuit of prey.

Bottom right: The psychedelic patterns of the mandarin fish are surprisingly cryptic, enabling this small fish to hide among the intricate latticework of its coral reef habitat. Despite its bright colours, it is as well hidden as any gaudy sunbird is in the tropical rainforest.

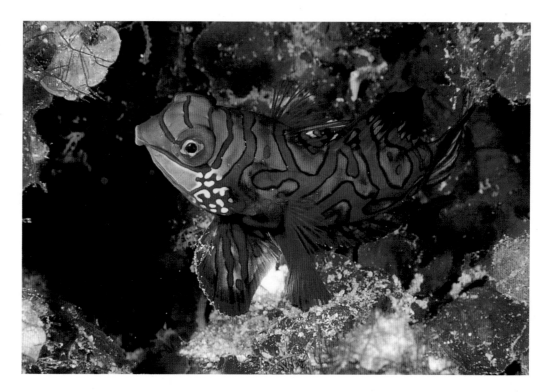

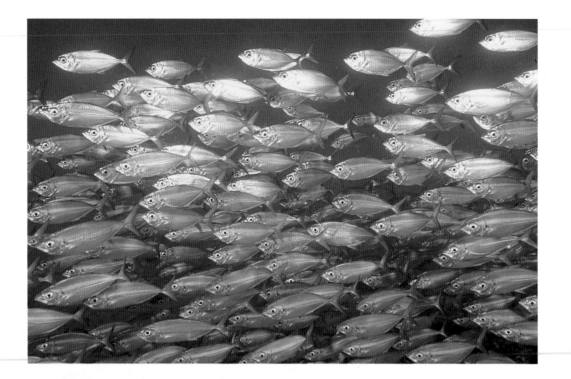

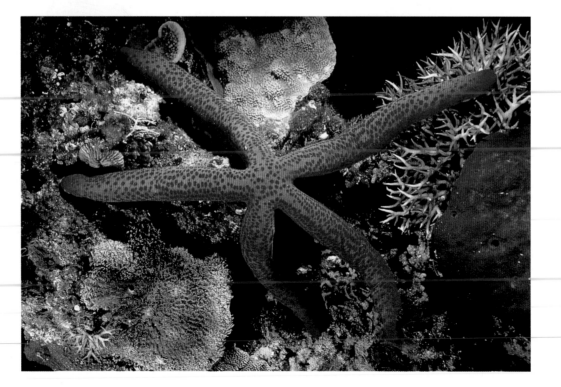

Left: A large school of ox-eye scad, one of the thousands of species living among the coastal coral reefs of Indonesia.

Bottom left: Sea stars possess a complex network of fluid-filled canals and hydraulic tubular legs which give them the mobility and strength to locate and capture prey on the coral reef.

Opposite: High tide brings banded sea snakes to the shore. These marine reptiles are extremely venomous and specialise in hunting gobi fish that hide in burrows.

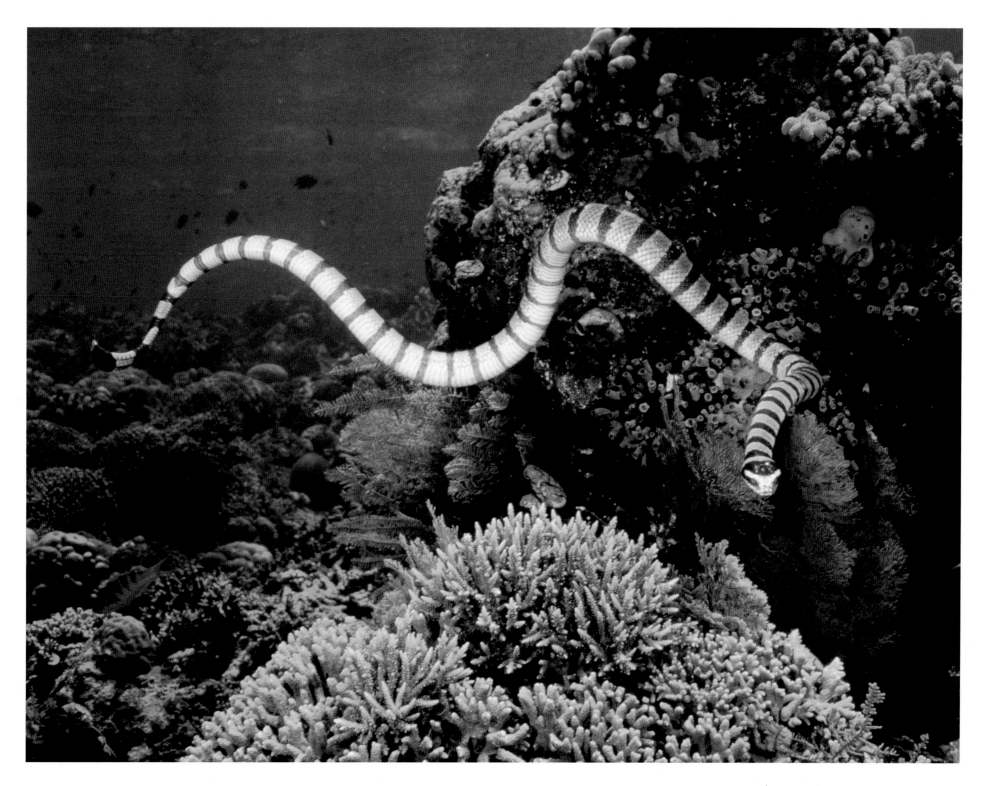

This small hairy spider crab lives among the tentacles of the caryphillid coral.

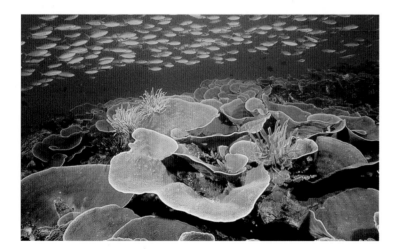

Top: Although their bright colours make them easy prey, most sea creatures avoid nudibranchs because they are quite toxic. When they are ready to breed, nudibranchs use the rather haphazard technique of finding and following each other's scented slime trails.

Above: A colony of flower-like daisy coral. Each coral has a spawning time, precisely triggered by phases of the moon, day length and water temperature, when it releases millions of eggs. Although only a tiny number of these survive, each fertilised egg has the potential to provide a spectacular addition to an existing reef.

Right: This pygmy sea horse is barely the width of a fingernail. Not only does it match its colour to its coral home – here, a gorgonian coral fan – it also models its body into the shape of the coral's bumpy polyps.

Island Magic

Above: A cold-blooded reptile, the monitor lizard is an excellent swimmer and needs to eat no more than once a month, making it a successful colonist of many isolated islands. As much at home in water as it is on land, from the moment it steps ashore, the lizard has a dramatic impact on all other animals on the island as it readily adopts the role of top predator.

Opposite: South-East Asia shatters into archipelagos of thousands of islands; some are ancient, others very recent. The active volcanic peaks of Mount Bromo dominate the eastern coast of Java, an island that became separated from mainland Asia just 10,000 years ago. The land and the seabed are constantly twisted and breached as the Earth struggles against itself.

I slands are crucibles where the raw ingredients of life are distilled into new and often fantastic forms. Each island has its own history and contains a unique collection of animals and plants, many found nowhere else. Both the founding fathers of modern biology, Charles Darwin and Alfred Wallace, owe their scientific insights to islands, for islands are, in essence, natural laboratories where the strange forces that shape life are concentrated in time.

No continent boasts more islands than Asia, and no country on Earth has more islands than Indonesia, which spills out into the sea from the tip of the continent's southeastern finger, the Malaysian Peninsula. This constellation of 13,000 islands includes all types and sizes of nature's living laboratories – among them some of the most remarkable.

Anak Krakatau is a volcanic island and one of Asia's youngest, born of fire in the early twentieth century. At first the new island was little more than a cinder-cone of hot, raw rock, a most unwelcoming place for life of any kind. However, within days of the fresh rock cooling, the first new life arrived.

Chance plays a large role in island colonisation. Winged and fluffy seeds harness the winds; baby spiders float across the waves on gossamer parachutes. There are colonists borne by the sea, while some, such as fig seeds, are carried in the guts of other castaways.

But arriving is only the first of many hurdles to be overcome in the saga of island colonisation, for the problems of surviving and reproducing must also be solved. For

JAMES HAILE

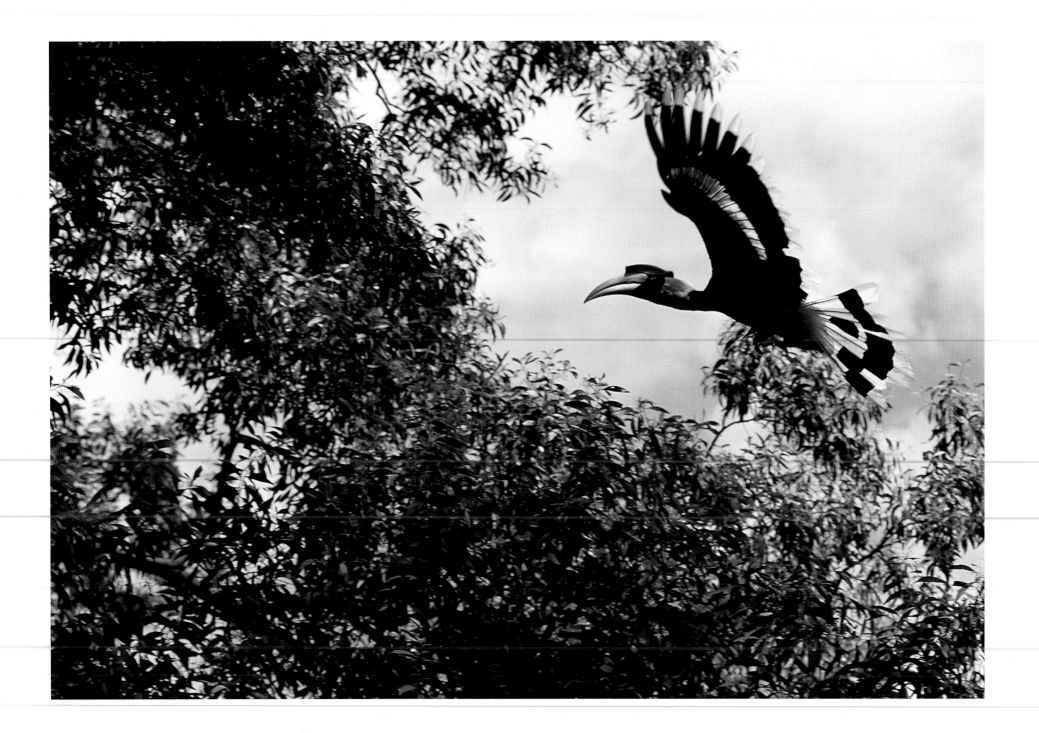

those animals that make the gamble and win, the jackpot is a land full of opportunities.

Over time the embryonic community that clings tenaciously to an infant island home grows richer and more complex. However, because of its small size and the hazards of life on an active volcano, the inhabitants of an island such as Anak Krakatau will never be able to rival the wildlife on the neighbouring tropical island of Java.

Unlike the hardy colonists of Anak Krakatau, Java's wildlife could have inhabited the island with ease. Around 10,000 years ago Java was joined to the rest of Asia by a land bridge and animals could simply have walked onto it. Then, at the end of the last ice age, the sea level rose and Java's animals and plants became castaways.

Isolated from their relatives on the mainland, island species can over time evolve into new species. Thus animals like the Javan gibbon have evolved from their original marooned ancestors. But islands do not just create new species; they are also sanctuaries for those that are no longer found on the mainland. And because Java is a relatively large island, it can provide a haven for a giant – the rarest large animal in the world – the Javan rhinoceros. The island's size also enables it to support large mammalian carnivores, something that Anak Krakatau will never do.

If age and isolation turn islands into species factories, then Sulawesi is the ultimate production line. At over thirty million years old it is by far the oldest island in Asia and, unlike any other island of its age, Sulawesi has always been isolated. With the ingredient of total isolation added to time measured in eons, island miracles occur. So, from a single species of macaque that made landfall thousands of years ago, more than five species have evolved. Sulawesi is also home to ancient animals like the tarsier that have been able to find refuge from changes that swept the continent.

On islands the rules of life are there to be broken. On Sulawesi, because there are no leaf-eating primates, a marsupial, the bear cuscus, has taken on the job. Similarly, as no tigers or leopards have ever reached these shores, the giant civet, a mysterious and elusive omnivore, has unenthusiastically shouldered the mantle of top predator. On a nearby island, the omnivorous monitor lizard has become a vegetarian, while elsewhere the same creature has been transformed into a fearsome carnivore, the Komodo dragon.

Dwarfs and giants abound on islands, and the Komodo dragon is the largest lizard in the world. This reptile epitomises the power of islands to mould and shape the raw material of life. It is living testimony to the strange forces that are island magic.

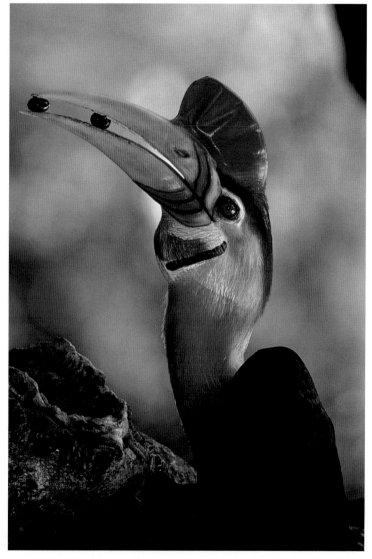

Opposite: Finding fruiting trees, such as figs, is the hornbill's special ability, and in turn the trees find ready seed-dispersers in the far-travelling birds that come in search of food.

Right: Sulawesi has the highest density of hornbills in Asia – but only the red-knobbed hornbill is endemic to this island. For safety while on the nest, the female red-knobbed hornbill seals herself inside her nest hole in a fig tree and is dependent on her mate to bring her food.

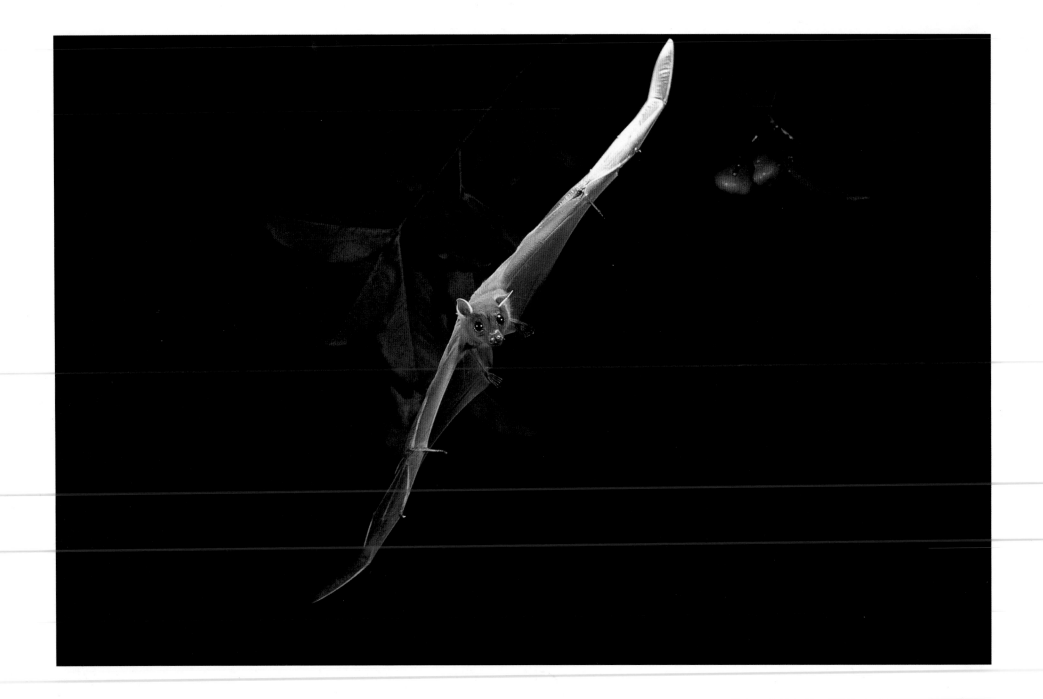

Bats are a significant presence in island forests. Feeding primarily on liquids, the short-nosed fruit bat sucks the juice from fruit and discards the seeds. Very small seeds are ingested and passed out in bat droppings, as the bats fly over the trees.

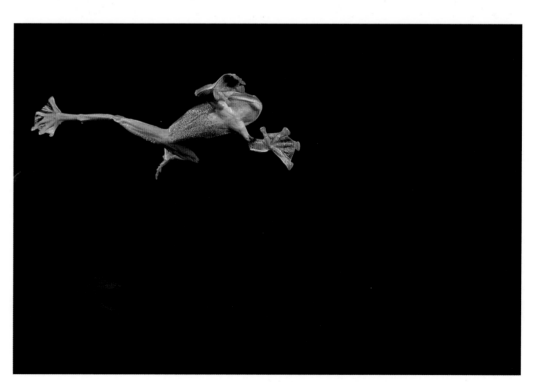

*Above: Fruit bats will fly seventy kilometres (forty miles)
or more a night in search of a fruiting tree. It is not
unusual for strong winds or perhaps a storm to blow
a bat off course far out over the sea to be cast ashore
far away from its normal habitat. This bat is endemic
to Talaud, in northern Sulawesi.*

*Top right: Because it is nocturnal and lives in the
canopy, it is rare to see the activities of the spotted giant
flying squirrel. With a gliding membrane between front
and hind limbs, it makes huge leaps from tree to tree in
search of leaves, seeds and bark.*

*Bottom right: The digits of this gliding frog's front and
hind feet are webbed, joined by a membrane of skin,
and it has flat pads on the tips. The frog uses the
membrane as a form of parachute for dropping from
branch to branch.*

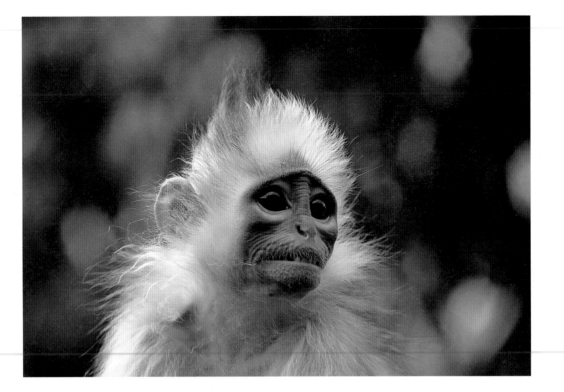

Opposite: Early macaques colonised Sulawesi, but subsequent changes in sea levels led to their further isolation on island remnants. Radiant evolution has transformed a common ancestor into at least five species in a remarkably short period. The celebes, or crested, black macaque has a distinctive pointed 'crest' on its head. Found on the northern tip of Sulawesi, it is very different to the ancestral form on the south coast.

Left: The leaf-eating monkeys – a group that includes the silvered leaf (top) and Javan (bottom) monkeys – live in small groups of females with a dominant male. The monkeys are free-loaders, giving little back to the forest. By taking fresh leaves, they rob trees of their means of absorbing light and energy and by crushing the seeds when they eat the fruit, these monkeys make it harder for trees to reproduce. The trees tolerate these charming bandits, but they fight back by introducing toxins into the maturing leaves that spoil the taste.

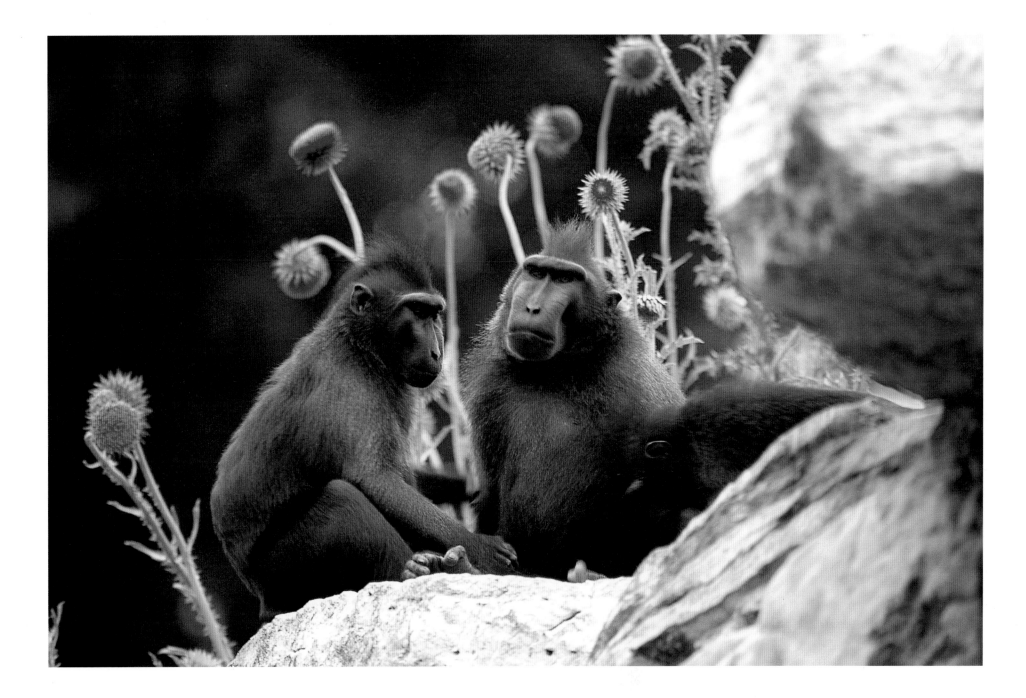

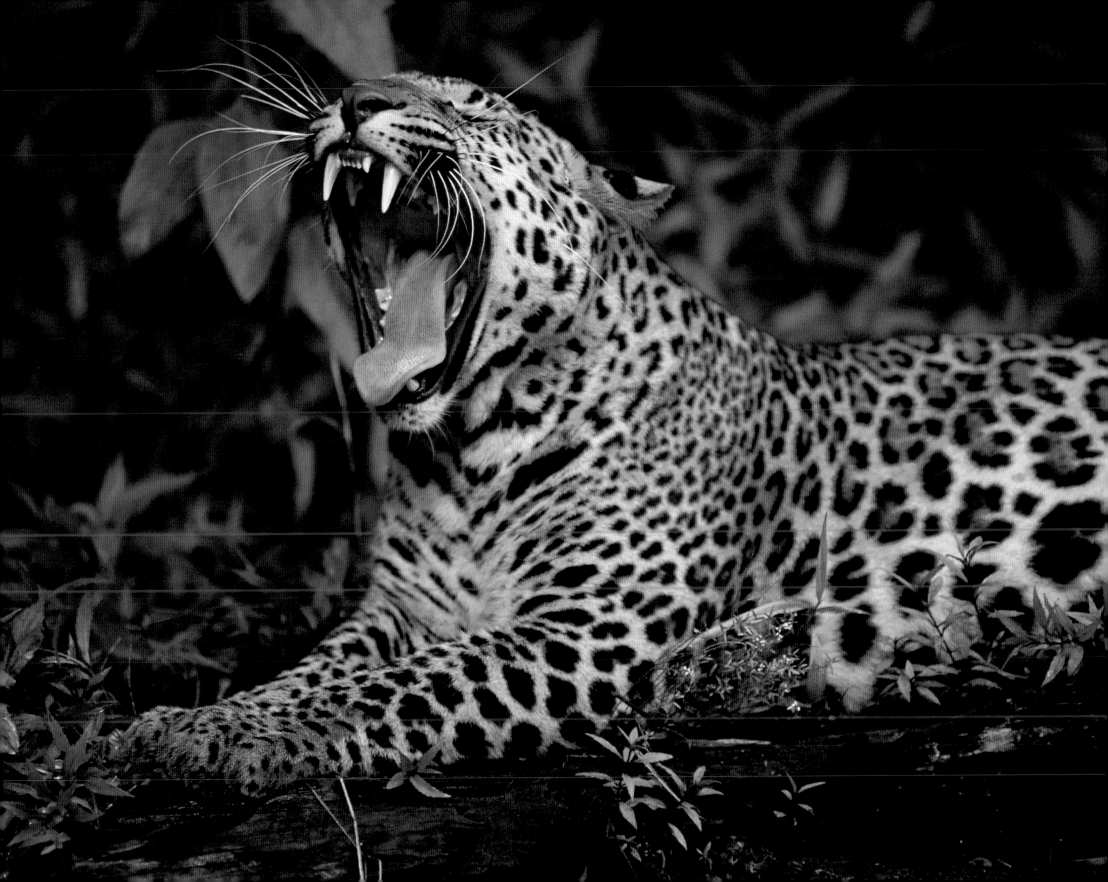

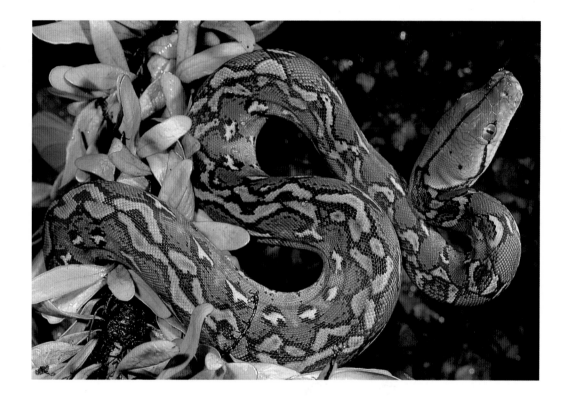

Above: Fast-growing and fast-maturing, the large reticulated python is cold-blooded and thick skinned, and survives long sea journeys relatively well.

Opposite: On Java, the top predator and most-feared animal is the Javan leopard – it is undisputed at the top of the food chain. Nothing escapes its keen eye. The leopard needs fresh meat at least twice a week, forcing virtually every other animal to adapt or die.

Right: The strangler fig is a tree of both life and death. Its many fruits provide food for an immense variety of island species, from birds and insects that feed on the fruits on the tree, to mammals which forage for the fallen fruit beneath. Yet as the fig grows skywards towards life-giving light, it entwines and strangles its original host tree. For the host, the fig's embrace guarantees death.

Opposite, top: On an island where leaf-eating monkeys are absent – Salababu Island in Indonesia – the bear cuscus has found a vacant niche and exploited it. It behaves like a tree-climbing, leaf-eating monkey. In so doing, it has evolved a stomach large enough to digest leaves, and in the process has become a giant, the world's largest cuscus.

Opposite, bottom: In contrast to the giant bear cuscus of Salababu, a marsupial on Sulawesi has evolved in a different way – it is a dwarf. A fruit eater, it has a passion for red figs.

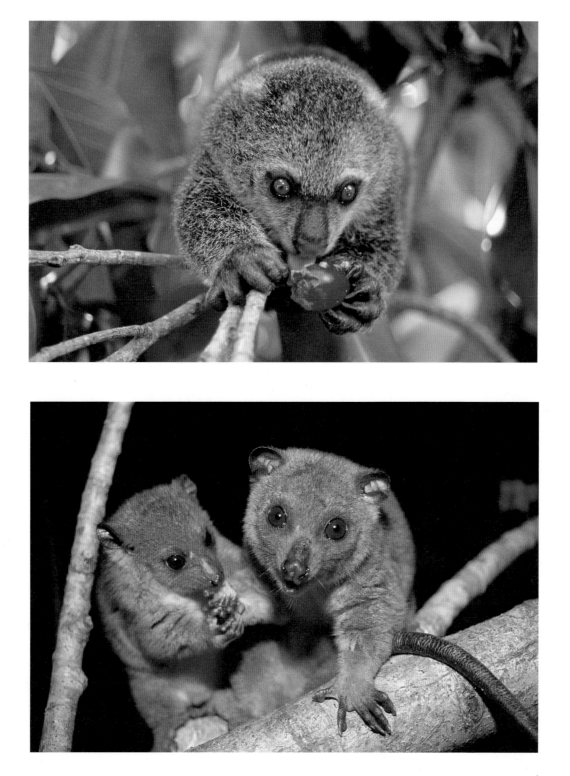

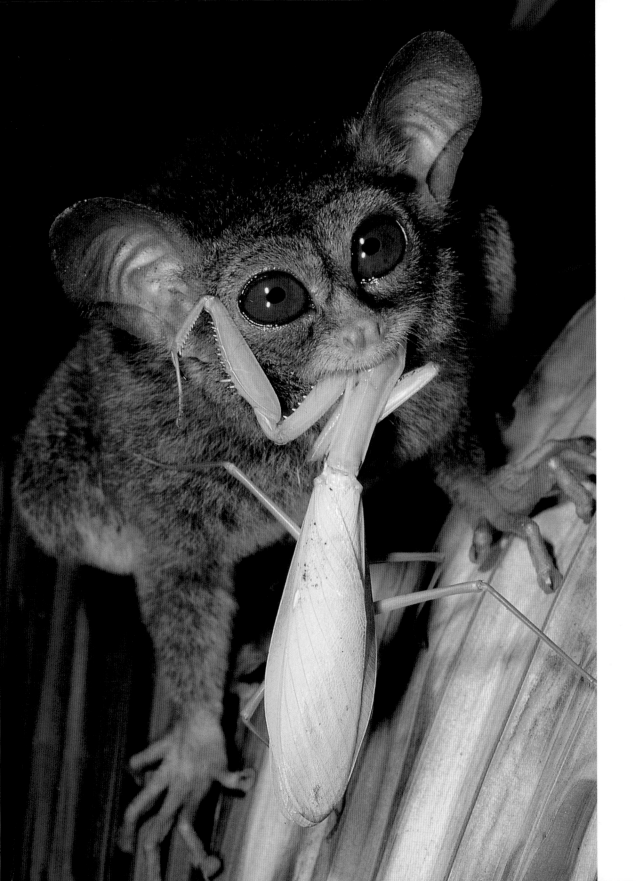

Left: Tarsiers are ancient primates related to both monkeys and humans. Long-isolated on Sulawesi, they have radiated into a number of distinct forms. Here the spectral tarsier reveals its predilection for insects. Snatched from the ground or from low in trees at night, insects make up nearly all of its diet.

Opposite: The maleo is a rare and peculiar megapode, or 'giant foot', which digs nesting holes in hot volcanic soil and near sources of hot water. It incubates its eggs underground, where they are at just the right temperature and hidden away from monitor lizards and other predators. In the two or three days it takes the chick to emerge from its underground hatching, it is ready to fly.

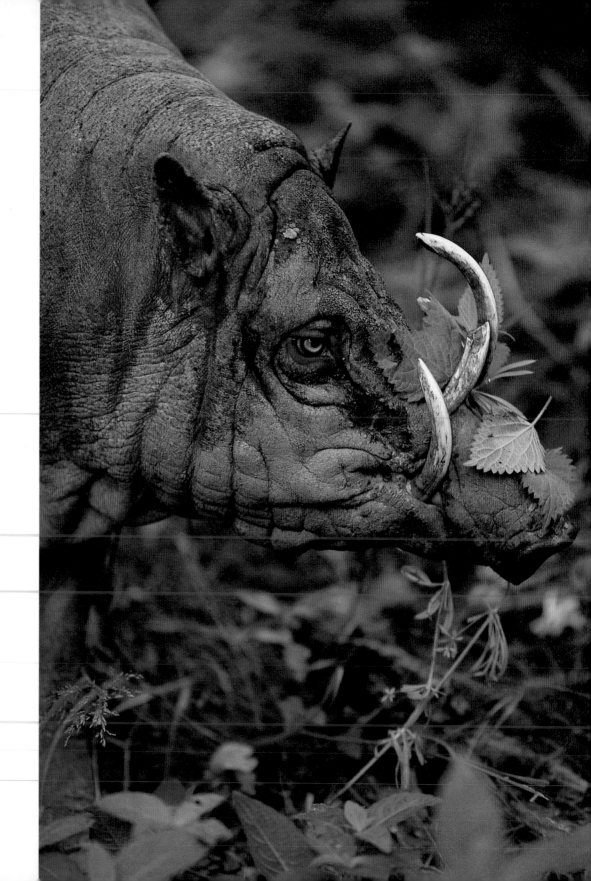

Right: The babirusa is the most bizarrely
tusked of all the wild pigs. Its grotesque
mask of fearsome curving tusks and teeth
are little more than decoration, however, and
are used by males to impress one another.

Opposite, top: The anoa, a fig-loving
miniature buffalo, finds food on a
remarkable fig tree that has evolved to
produce fruit near ground level to cater
for non-climbing vegetarians.

Opposite, bottom: In the 10,000 years that
banteng cattle have been stranded on Java,
they have changed from their mainland
relatives. They are significantly smaller
because land is limited, but bulk and
strength remain important. The bulls must
be big enough to repel a leopard.

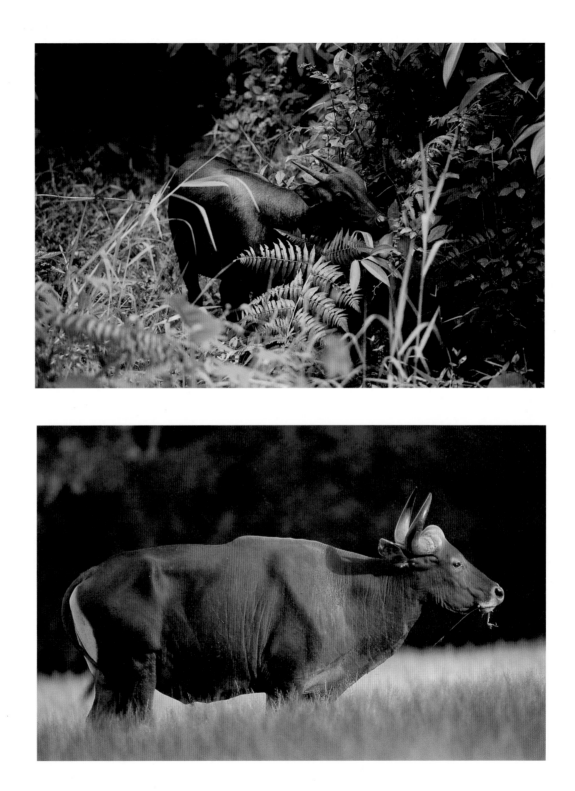

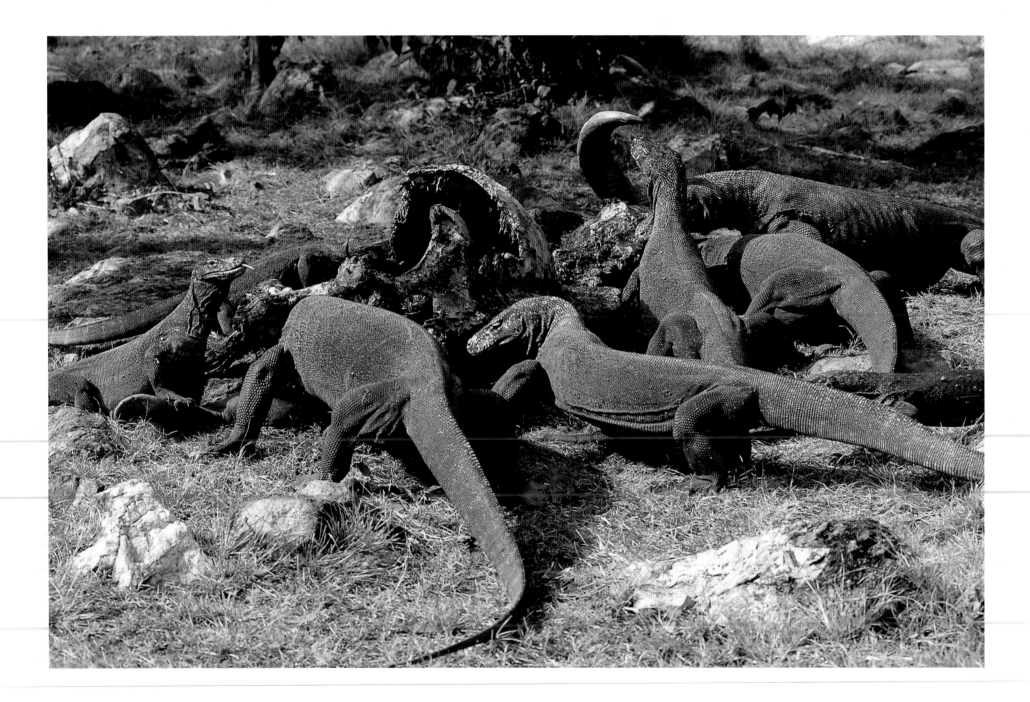

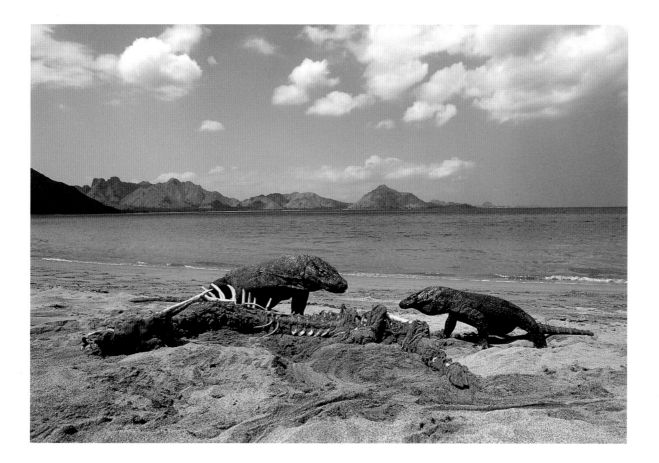

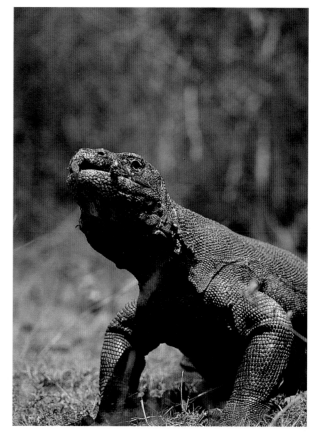

Above left: Komodo dragons carve a carcass into bite-size chunks with their razor-sharp teeth. It is a primeval scene, as if dinosaurs once more ruled the land.

Above right: This terrifying creature is simply an over-grown monitor lizard and, like other monitor lizards, when there is no food the dragon can lie low and survive for months, then re-emerge supreme.

Opposite: On Komodo, an island at the southern edge of Asia, a lizard has been transformed into a giant: the world's largest lizard – the Komodo dragon. Like the monitor lizard, the dragon can scavenge for a meal. Unlike every other lizard, it has the power to bring down animals much heavier and faster than itself.

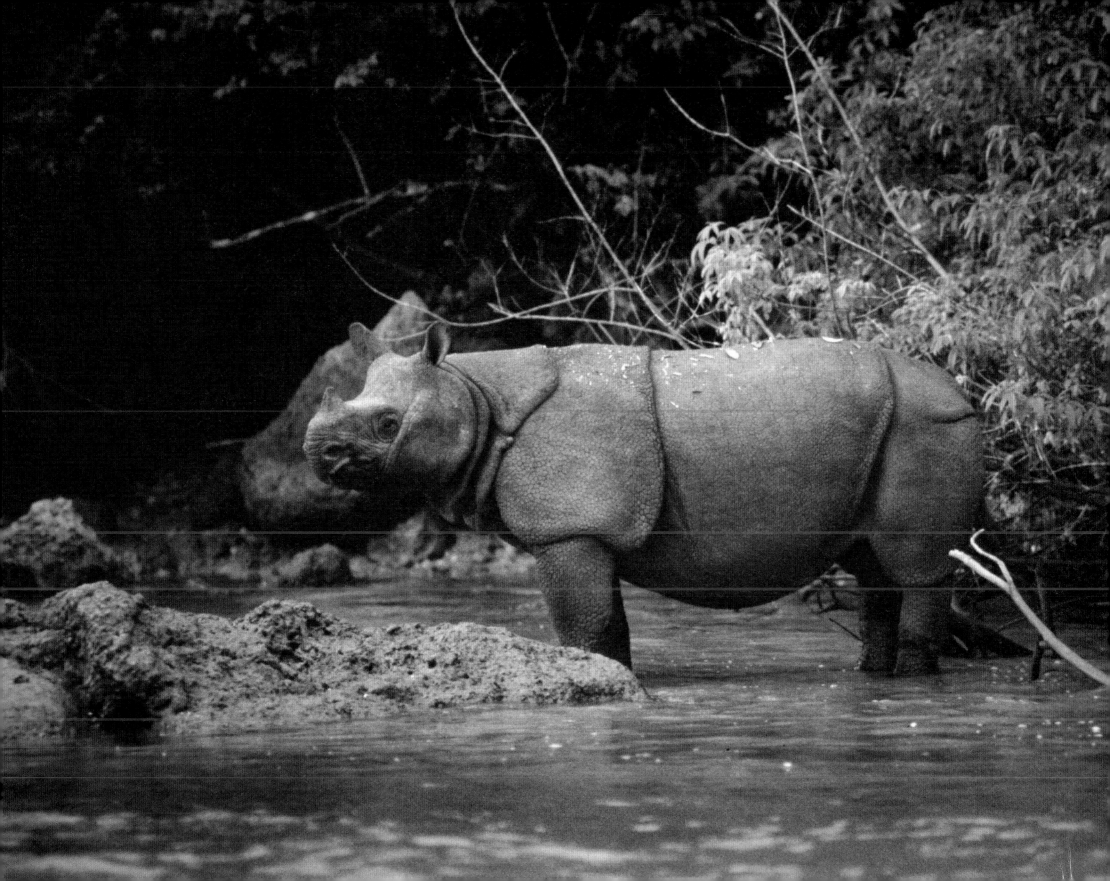

Above: Little seen for decades, Sulawesi's giant civet is thought to be rare. Related to weasels and mongooses, the giant civet grows up to one-and-a-half metres (five feet) in length. A retiring creature, it is actually Sulawesi's largest predator, but also eats fruit as well as small animals. This young male, captured by a poacher, was later released in a national park.

Opposite: The ponderous Javan rhino is the rarest large mammal in the world. Less than seventy remain in remote areas of Java. Burdened by its enormous size, it reproduces very slowly and needs a lot of space. As people put more pressure on the remaining forests, the rhino is trapped. The island is both sanctuary and prison.

Between Two Worlds

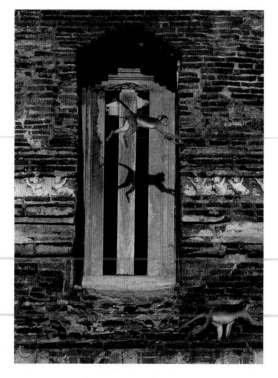

Above: Wild toque macaques live amongst ancient ruins.

Opposite: In Asia's past the lives of people and animals were so strongly linked that some animals became part of the human spiritual world. Although still revered as a symbol of strength, power and fertility, the Bengal tiger has been so decimated by hunting that now it only flourishes in the restricted territories of national parks, such as Ranthambore in north-west India.

Sharing their habitats with hundreds of millions of people, many of the species that live in Asia have had to adapt in order to co-exist with human beings. In their turn, the people of Asia have worshipped animals and plants – shaping gods in their image, looking upon them as incarnations of gods, or turning them into symbols of the spiritual and natural world. Between humans and these species close physical and spiritual relationships have developed. For instance, the sacred Hanuman langur, named after the monkey god Hanuman, roams the ancient temples of the Indian subcontinent, and the red-crowned crane, which is revered for its longevity, is provided with food during the harsh winters in its range ground in northern Japan.

Asia is not a boundless natural wilderness. In our work as film-makers we are privileged to visit the most treasured of the world's wildlife sanctuaries, but we also see first-hand the threat of growing human populations to sanctuaries and to wilderness areas that are not formally protected. We see graphic evidence that wild lands, waterways and marine environments capable of supporting the extraordinary range of Asia's wildlife are being changed, reduced or destroyed by human

MICHAEL HACKING

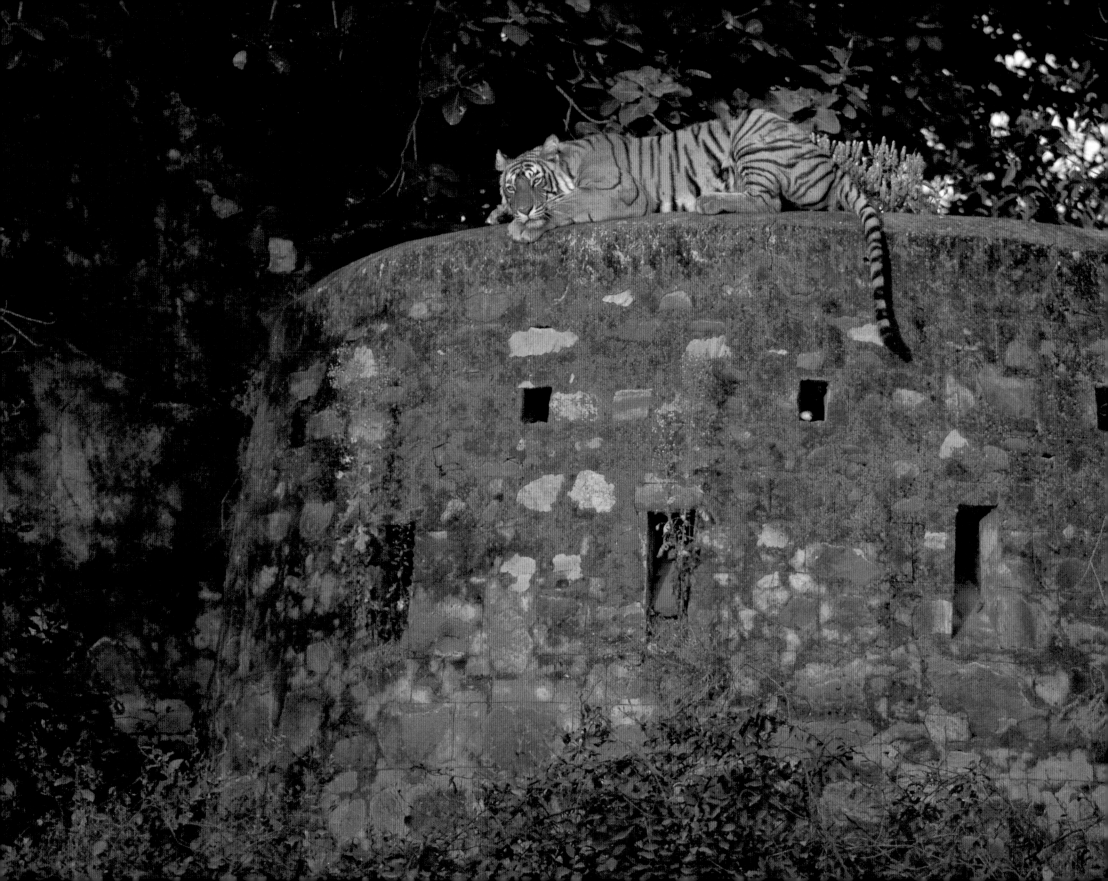

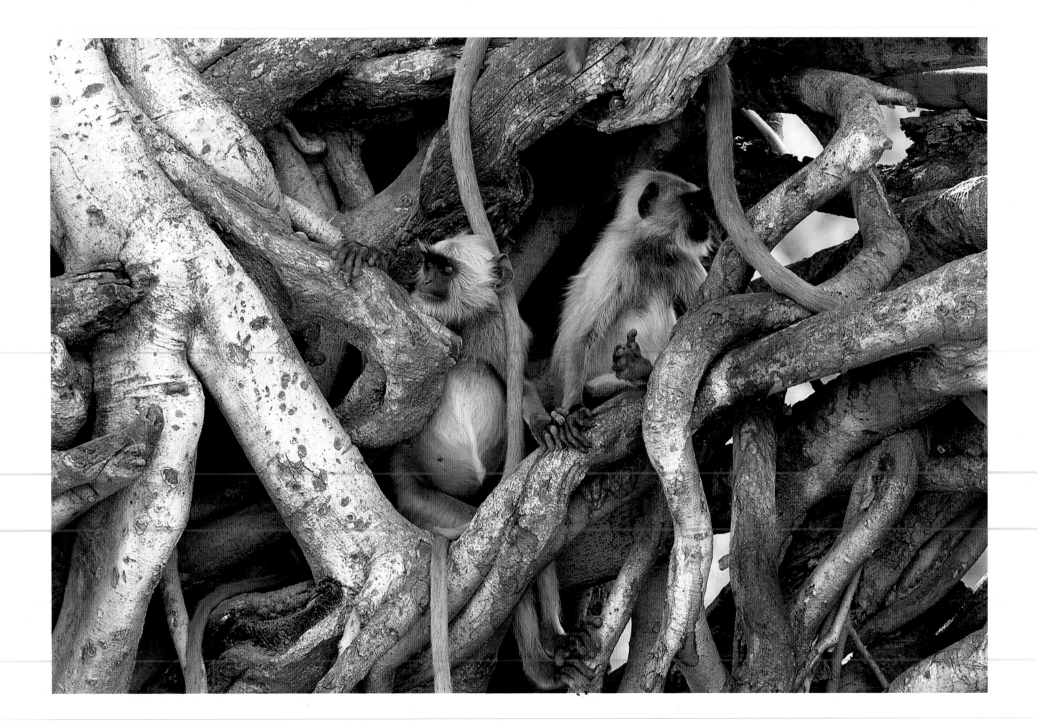

Opposite: The widest ranging of all non-human primates, the sacred Hanuman langurs of India not only live from sea level to more than 4200 metres (14,000 feet) in the Himalayas, they also inhabit just about every environment, from tropical forest and dry scrub to urban environments.

Right: We are in danger of reducing the once-rich diversity of life to the few commensal species that benefit from us and to the species, such as the langur, that are catholic in their diet and in their habitat requirements, and so able to survive in our environments.

Below: Highly adaptive, the langur is at home around the forest edge and in the human environment, being frequently encountered in towns.

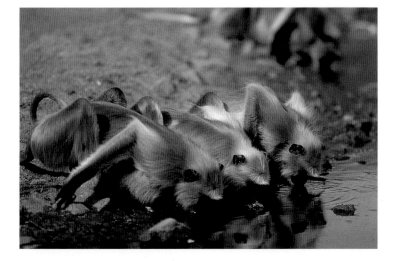

development, and at a very disturbing rate. Even for species that are highly adaptable and highly sociable – such as the golden jackal, the elephant and toque macaque – the future is precarious.

Many macaques are highly successful, living comfortably among people. Indeed many troops have been urban dwellers for centuries, feeding almost completely on human food leftovers. But their relationships with humans can be costly; as their population outgrows the food that people can provide, sometimes war breaks out between groups of macaques.

Golden jackals occupy a position almost diametrically opposite to macaques – they survive by successfully avoiding people. Highly secretive, their senses of smell, hearing and sight are fine-tuned to

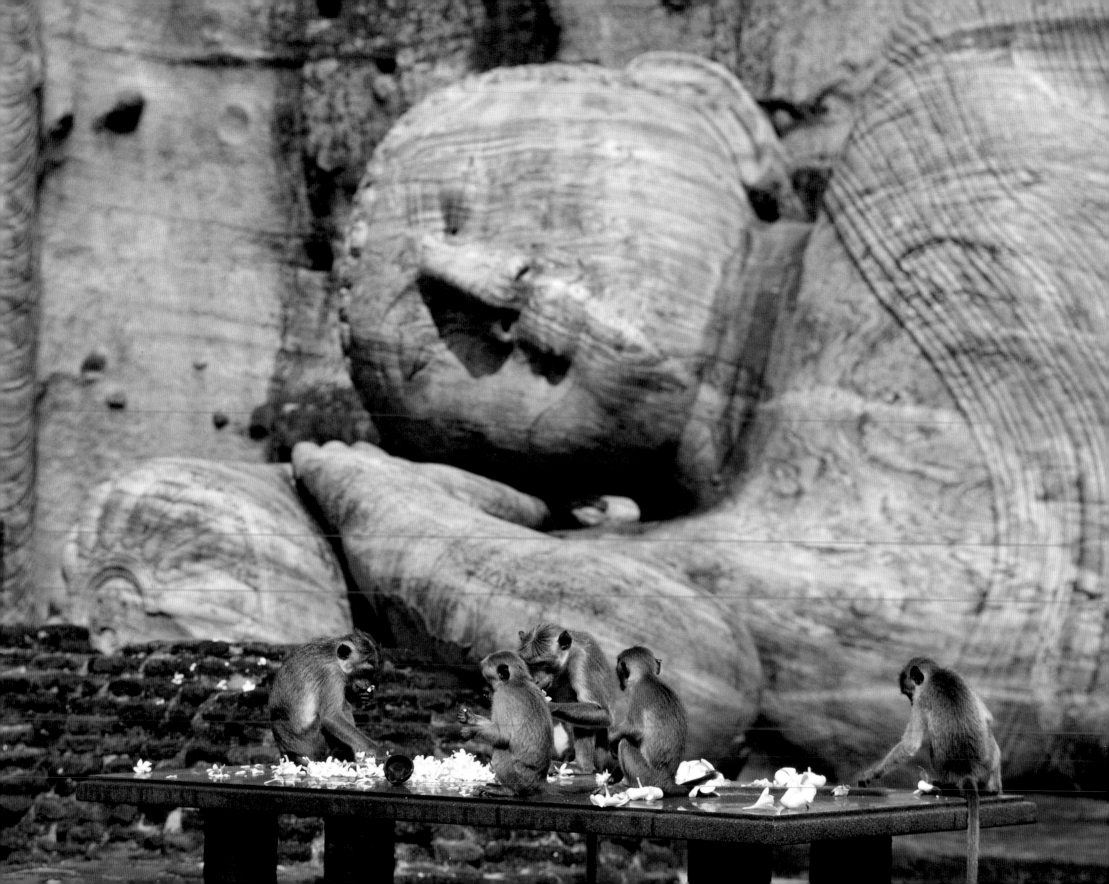

Generations of wild toque macaques have lived side by side with people – and with other primates. They even help groom their langur relatives. Adaptable and cunning, troops of the macaques live among the ruins of ancient temples and popular tourist sites. They are confident foragers, feeding from leftover lunches and offerings to a compassionate Buddha. Caught between competing, aggressive macaque troops and a shrinking natural world, there are many casualties of this risky contemporary lifestyle.

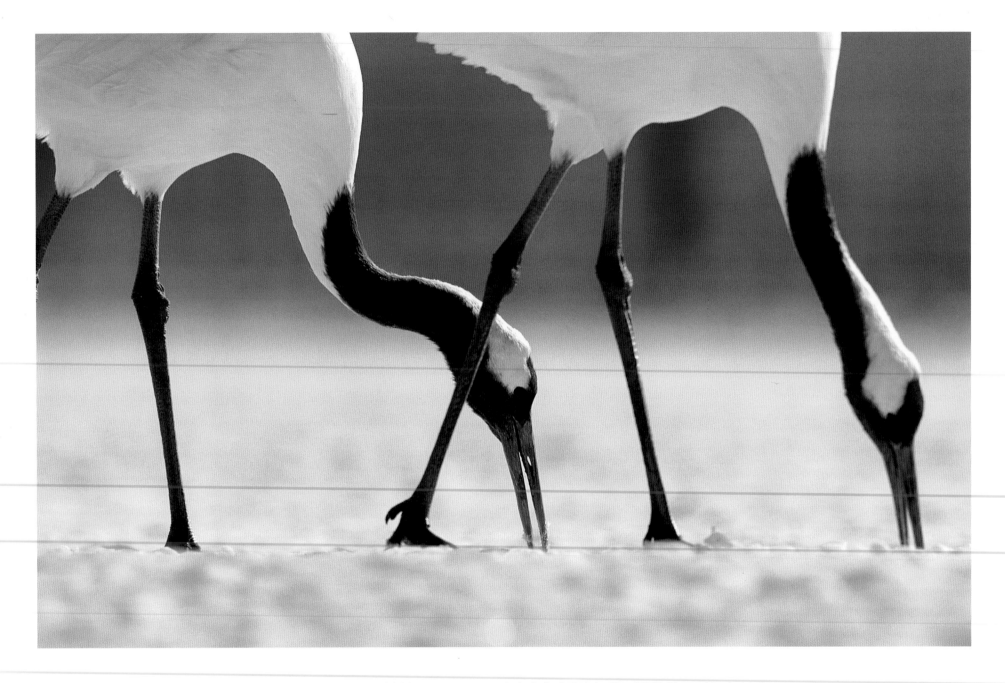

Above: The red-crowned cranes of Asia's temperate zone are looked after in their traditional Hokkaido marshland wintering ground by the local Ainu people, who put out corn for them when food gets scarce in the depths of winter. Considered to live for a thousand years and to represent longevity and happiness, images of the red-crowned crane adorn a wide range of items from Japanese wedding kimonos to sake bottle labels.

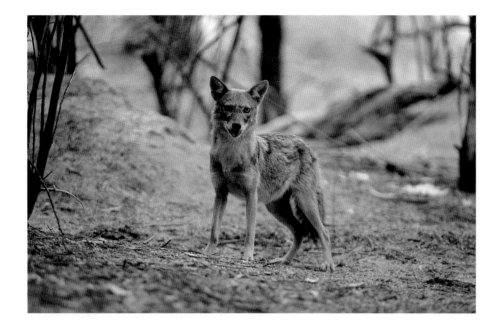

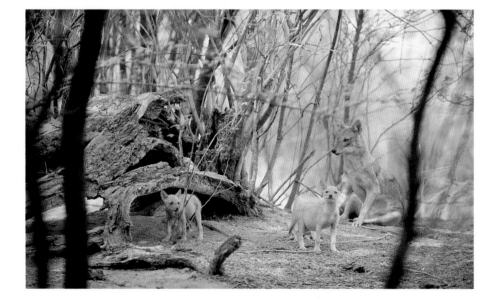

Above, top and bottom: Although people share the land with jackals, they rarely more than glimpse their lives, as they hunt and raise their families. Adult jackals often forage together, but if food is in short supply, they will fight over it. Although they share the responsibility for feeding their pups, each adult puts its own survival first – so the dominant male usually takes the first of lean pickings.

detect any kind of threat. Considered neither iconic nor charismatic, the jackal has been forced into marginal lands as large-scale cultivation occupies more of the countryside and gradually reduces its natural hunting grounds. It has become harder for the jackal to find food and water, and to raise a family. But even in impoverished habitats, it is a resourceful hunter and forager, and is supported by a strong family structure.

However, there is another animal, well known and charismatic, whose family structure is not sufficient to guarantee it a future. Elephant families are renowned for the care and compassion they show each other and their young, but all over Asia they are in trouble – there is a sad conflict between rural people protecting their crops and elephants seeking food. In Sri Lanka, for instance, more than one hundred elephants die each year. But in cultures where people worship the elephant-headed god Ganesh there are grounds for optimism. There have been many elephant conservation initiatives, including expensive elephant 'drives' to move large groups of elephants away from developing areas; elephant 'corridors' allowing animals to migrate between areas of wilderness; homes for displaced elephants and rehabilitation centres.

No one can predict the outcome of the struggle between human physical and political imperatives and the needs of wild animals, but there is no doubt that somewhere in the equation the human need for wonder, compassion and spiritual belief will play a part in deciding the fate of the myriad and wondrous species of Asia.

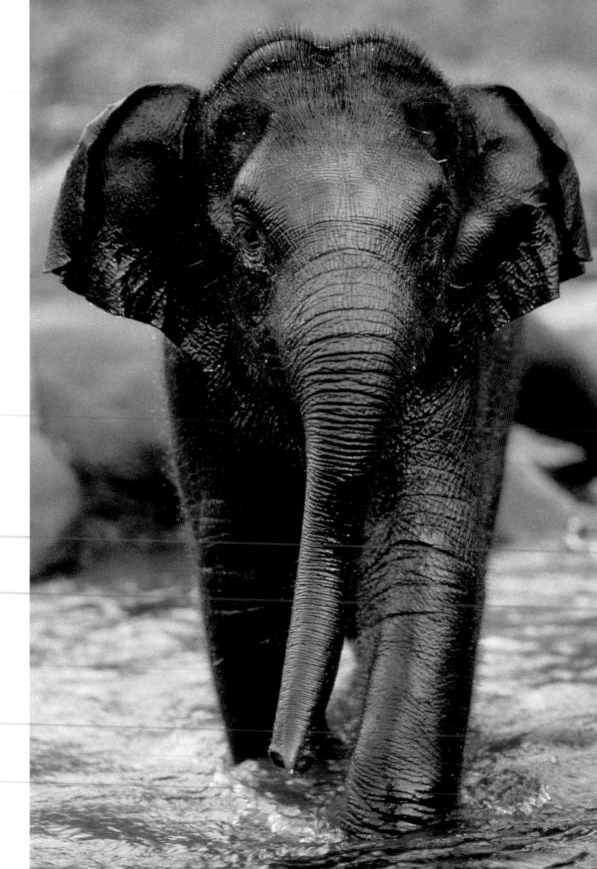

Right: Elephants have to put in long hours to obtain the food they require. Among their preferences are the roots of lake-shore grasses, which they carefully excavate and gather into mouthfuls.

Opposite: The male elephant takes no part in rearing his offspring: his youngsters are raised in the stable matriarchal society of the herd, learning from their mother, aunts and older sisters.

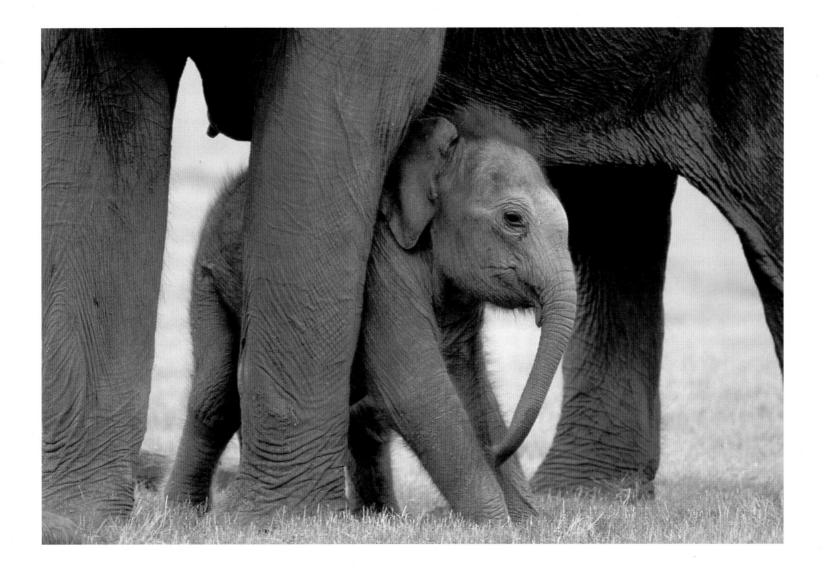

Right: An adult elephant's trunk extends its reach well above the ground and is very adept at plucking favourite food.

Opposite: The elephant's strength hauled millions of tons of stone for dams and temples, harvested timber from the forests, and lent its power to human ambitions to raise the mightiest shrines of the Buddhist world. And in Buddhist mythology, the elephant is believed to uphold the universe.

Konrad Wothe

GAVRIEL JECAN

Konrad Wothe

Konrad Wothe, born in 1952 in Munich, Germany, discovered his enthusiasm for photography and nature when he was eight years old. Soon he built a simple wooden camera by himself, and later he won several prizes in scientific competitions with the construction of a mirror-reflex camera and a 360-degree panorama camera.

After grammar school he worked as a cameraman for the German wildlife filmmaker Hoinz Sielmann. Then he studied biology at the University of Munich, earning his degree in 1979.

Since that time Konrad has worked as a freelance professional wildlife photographer and filmmaker. His work has led him to India, South-east Asia, East Africa, Madagascar, Canada, the United States, South America, Russia, Antarctica, Japan and to many places in Europe.

He has won several first prizes in the renowned BBC wildlife photographer competition and his work has appeared in many magazines and books – in 1996 he published the book *Orang-utans*.

In 1999 he was awarded German Wildlife Photographer of the Year, and a category in the prestigious BG Wildlife Photographer of the Year awards.

Art Wolfe

Art Wolfe's nature photographs are recognised throughout the world for their mastery of colour, composition, and perspective. Over the course of his twenty-five year career, he has worked on every continent and in hundreds of locations.

Hailed by William Conway, President of the Wildlife Conservation Society, as 'the most prolific and sensitive recorder of a rapidly vanishing natural world', Art has taken an estimated one million images in his lifetime and released over forty books.

In 1998 he was named Outstanding Nature Photographer of the Year by the North America Nature Photography Association and in 1996 Photographer of the Year by *Photo Media* magazine.

In April 2000 he was awarded a coveted Alfred Eisenstaedt Magazine Photography Award.

Mitsuaki Iwago

Born in Tokyo in 1950, Mitsuaki Iwago has been involved with photography since he was a child. After graduating from college, he pursued a career in photography and gained a reputation as one of the world's foremost wildlife and nature photographers. In 1981, he received the Kimura Award, one of the most prestigious awards for photography in Japan.

From the Galapagos Islands to the Serengeti Plain, Mitsuaki has taken award-winning images in more than seventy countries for the past twenty-five years. His work has appeared in numerous magazines, including *National Geographic*, *Paris Match* and *Life*.

He is the author and photographer of several books, including the worldwide best-seller *Serengeti: Natural Order on the African Plain*, *Mitsuaki Iwago's Kangaroos*, the spectacular *Mitsuaki Iwago's Whales*, *In The Lion's Den* and *Snow Monkey*.

Mitsuaki has also been working in the realm of video to produce a programme entitled 'Mitsuaki Iwago's Nature World', in partnership with NHK.

CONTRIBUTORS

MINDEN PICTURES

Art Wolfe

MINDEN PICTURES

Mitsuaki Iwago

Mark Brazil

Currently working as professor of biodiversity and conservation at Rakuno Gakuen University in Hokkaido, Japan, Mark Brazil is also a consultant for Japanese, British, American and New Zealand television companies making natural history programmes.

Mark travels extensively in search of wildlife, and writes for newspapers, magazines and books on subjects ranging from natural history to travel. He writes a regular Wild Watch column for the *Japan Times* newspaper, a column called On the Wild Side for *Insight Japan* magazine, and his photographs have appeared in a wide range of publications. Mark's previous books include *A Birdwatcher's Guide to Japan* and *The Birds of Japan*.

Alison Ballance

Alison Ballance is a zoologist and a producer/director for Natural History New Zealand. She was producer of the episode *The Arid Heart*, about Asia's deserts, in the *Wild Asia* series. This involved several filming trips in the climatic extremes of the Gobi and Thar deserts and the Rann of Kutch.

For her earlier film *To Save the Kakapo*, Alison and her crew spent four years filming one of the world's rarest birds and working on some of New Zealand's rugged offshore islands.

Alison's first book, *Hoki,* the story of a kakapo, was a finalist in the 1998 New Zealand Children's Book Awards and she is also the author of a series of educational books about habitats.

Shekar Dattatri

Always fascinated by wildlife, at just thirteen years of age Shekar Dattatri began volunteer work at Madras's famous Snake Park. An initial interest in wildlife photography evolved into wildlife filmmaking and, after gaining a degree in zoology, he began working with a documentary filmmaker.

In 1989 Shekar began a two-year project filming in the rainforests of southern India. The resulting documentary won critical acclaim, including a special Jury Award at the Jackson Hole Film Festival, a major prize at the Sondrio International Festival and Best Nature Film Award at Tokyo's Earthvision Festival. Subsequently, he has worked with many of the world's leading producers of wildlife documentaries.

Alan Erson

Over the last ten years, Alan Erson has established himself as one of New Zealand's leading television documentary makers – writing, directing and producing a number of acclaimed films on a wide variety of subjects. As well as wildlife documentaries, he has made biographical, social history, political and sporting films. He has also directed television dramas and made several short films.

Michael Hacking

Michael Hacking was born in Britain and emigrated to New Zealand in 1974. Having always had a love of natural history, Michael found New Zealand an ideal place to pursue a long-standing career that combines filmmaking with the outdoors.

He has been associated with Natural History New Zealand since 1990, as a director, writer and producer and was producer of two episodes in the *Wild Asia* series, *Kingdoms of the Coast* and *Between Two Worlds*.

Michael was producer/director/writer for the award-winning production *Kiwi* and director/writer for a documentary on Thor Heyerdahl.

James Haile

Born in Britain, James Haile has travelled extensively, taking part in various expeditions and archaeological excavations. After reading zoology and anthropology at Oxford University, James worked for Partridge Films and the BBC Natural History Unit researching and developing film ideas.

In 1996 he moved to New Zealand where he works as an assistant producer with Natural History New Zealand. He researched and developed the story for the *Island Magic* programme in the *Wild Asia* series, as well as directing several film shoots for it in South-east Asia.

Jeremy Hogarth

Jeremy Hogarth has specialised in natural history television programmes since 1975. After training at the London Film School, Jeremy worked as assistant film editor for the BBC and as film editor on natural history programmes for the Australian Broadcasting Corporation, before pursuing an independent career as a producer/ director and writer of natural history documentaries.

He has filmed in many countries on every continent except Antarctica, including Pakistan, India, Bhutan, Thailand, Japan and Indonesia. He has won dozens of awards internationally, including wide acclaim for his films *Kimberley-Land of the Wandjina* and *The Big Wet*.

He acted as series producer for *Wild Asia* as well as programme producer for two episodes, *The Realm of the Red Ape* and *A Forest Through All Seasons*.

Shinichi Murata

Shinichi Murata is chief producer of Japan's renowned NHK Natural History Unit Science Division. After gaining a BA in forestry from Tokyo University, he joined NHK in 1981. In 1996 he became involved with the Wild Asia project, and in 1999 was promoted to the role of Chief Producer for NHK.

An award-winning producer, he has many major awards to his credit, including a WWF Wildlife Film Festival award, a Jury Award from the Hi-Vision Film Festival and awards for his film *Satoyama*. *Creatures of the Thaw* is his first project undertaken in conjunction with Natural History New Zealand.

Rod Morris

Rod Morris has been making wildlife programmes for two decades, and is a senior producer at Natural History New Zealand as well as a widely published natural history photographer. He has produced many award-winning documentaries including *Land of the Kiwi*, *Black Stilt* (gold medal winner, 1984 New York Film and Television Festival), *Kakapo Night Parrot* (Best of Festival, 7th Wildlife Film Festival, Missoula, Montana), and *Dragons of Komodo*. Rod's photographs have been published in the Canon Endangered Wildlife series as well as numerous books and publications around the world.

Mervyn Aitchison/NHNZ pages 7, 19, 83 (bottom), 117, 121 (top), 176, 180, 181

Ardea London pages 27 (top), 36 (left), 108

Alison Ballance/NHNZ pages 116 (top), 119 (left), 121 (bottom)

Fred Bavendam/Minden Pictures pages 9 (daisy coral), 18 (bottom), 150, 151 (all), 152 (all), 153, 154-155 (all)

Robert Brown/NHNZ page 183 (all)

Alain Compost pages 9 (pandanus tree), 20 (bottom), 21 (middle), 76, 78, 79, 84, 85, 86, 87, 142, 146 (right), 147, 158, 160, 161 (all), 162 (all), 164, 168, 171 (bottom), 172, 174

Eric Dragesco/Ardea London page 36 (top right)

Cam Feast/NHNZ pages 3, 73

Tim Fitzharris/Minden Pictures page 37

Toshiji Fukuda/Nature Productions page 39

Bob Gibbons/Ardea London page 33 (right)

Joanna van Gruisen/Ardea London pages 26, 27 (bottom), 28 (top), 29, 31, 33 (left), 35 (right), 109, 143

Chiaki Hamaguchi/Nature Productions page 68 (top)

Takahisa Hirano/Nature Productions page 59 (left)

Jeremy Hogarth/NHNZ pages 20 (top), 72

Michio Hoshino/Minden Pictures pages 40, 48

Roy Hunt/NHNZ page 145 (all)

Masahiro Iijima/Ardea London page 25

Masahiro Iijima/Nature Productions page 62 (top)

Shigeki Iimura/Nature Productions page 133

Mitsuhiko Imamori/Nature Productions pages 70 (right), 71, 127, 132 (bottom left)

Eiji Ishii/Nature Productions page 41

Mitsuaki Iwago/Minden Pictures pages 12, 15 (bottom), 21 (bottom), 43, 50, 51 (left), 61 (top), 94, 101, 132 (right), 173 (right), 179 (top), 186, 187

Mark Jones/Minden Pictures pages 77 (bottom), 91 (top right)

Tatsuhiko Kobayashi/NHK/NHNZ pages 17, 38, 42, 44 (all), 45

Adrian Kubala/NHNZ page 36 (bottom right)

Ana Lockwood pages 9 (baby elephant), 93, 97 (top and bottom right), 99, 185

Ana Lockwood/Shekar Dattatri page 98

Malcolm Ludgate/NHNZ page 167 (bottom)

Shiro Matsuoka pages 17 (top left), 57, 60, 64, 65 (right and bottom left), 69, 70 (bottom left)

Mark Moffett/Minden Pictures pages 88, 89 (top left and bottom right), 91 (bottom right and top left)

Rod Morris pages 9 (top), 81, 83 (top), 156, 157, 165, 169, 171 (top), 173 (left), 175

Shinichi Murata/NHK/NHNZ page 132 (top)

Yutaka Nihimura/Nature Productions page 65 (top left)

Minoru Okuda/Nature Productions page 63

Takao Otsuka/Nature Productions page 131 (top)

Mick Reece page 32

Tracy Roe/NHNZ page 115 (top)

Tui De Roy/Minden Pictures pages 13, 159, 166, 167 (top)

Atsushi Sakurai/Nature Productions pages 10, 66, 130

Michael Single/NHNZ pages 22, 34-35

Izumi Uchida/NHNZ pages 14 (top), 56, 59 (right), 67, 61 (bottom)

Ryu Uchiyama/Nature Productions page 131 (bottom)

Mike Watson/Ardea London page 28 (bottom)

Art Wolfe pages 8 (bottom), 14 (bottom), 18 (middle), 21 (top), 23, 24, 28 (middle), 30, 47, 58, 68 (bottom), 80 (all), 89 (top right), 90 (bottom left), 96, 97 (left), 100, 102, 103 (all), 104 (left), 105, 106, 107, 110, 111, 112, 114, 115 (bottom), 116 (bottom), 118, 119 (top right), 119 (bottom right), 122, 123, 124, 125 (all), 140, 144, 146 (left), 148, 149 (all), 163, 170, 177, 178

Konrad Wothe pages 16, 17 (top right), 18 (top), 46-47, 49, 51 (top and bottom right), 52-53, 53, 54 (all), 55, 136-137, 138 (all), 139 (all), 141 (all)

Konrad Wothe/Minden Pictures pages 14 (top), 62 (bottom), 70 (top left), 74, 75, 77 (top), 82, 104 (right), 120, 128, 129 (all), 134, 135 (all), 182, 184

Sumio Yamamoto page 126

Shin Yoshino/Minden Pictures pages 92, 113, 179 (bottom)

INDEX